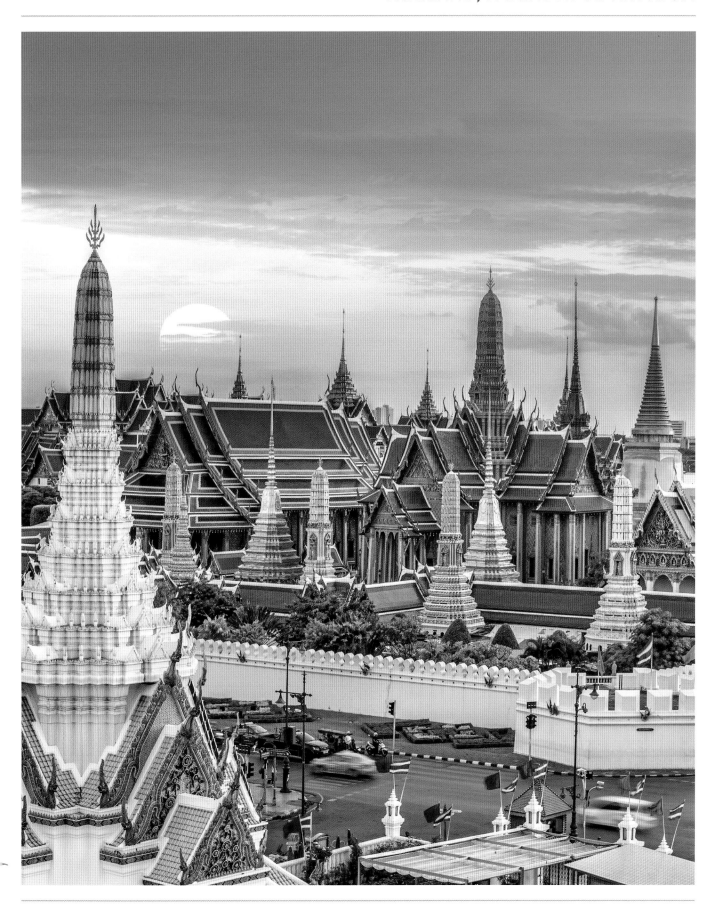

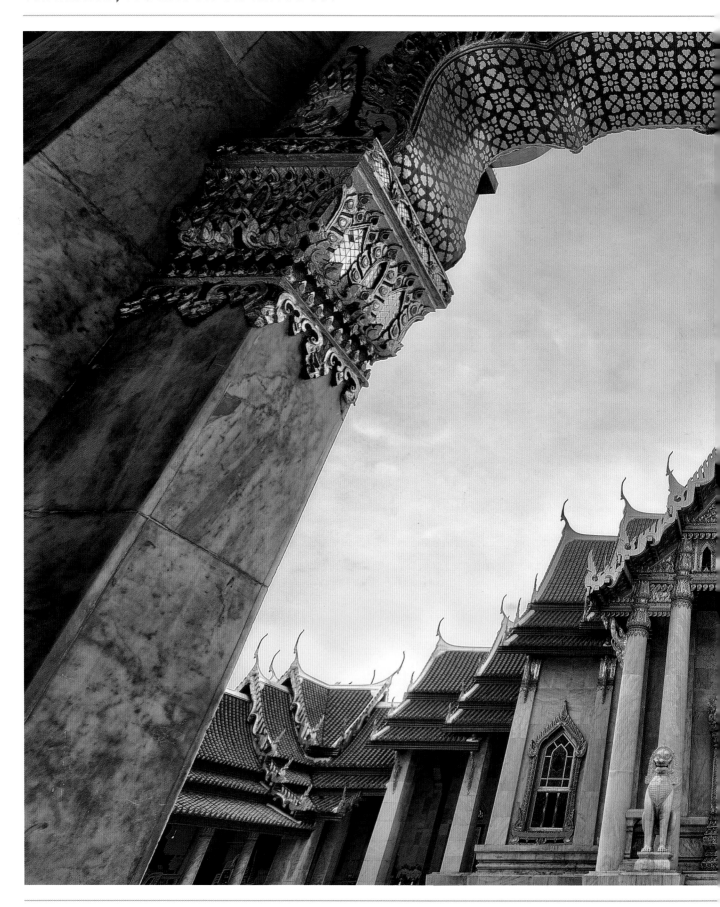

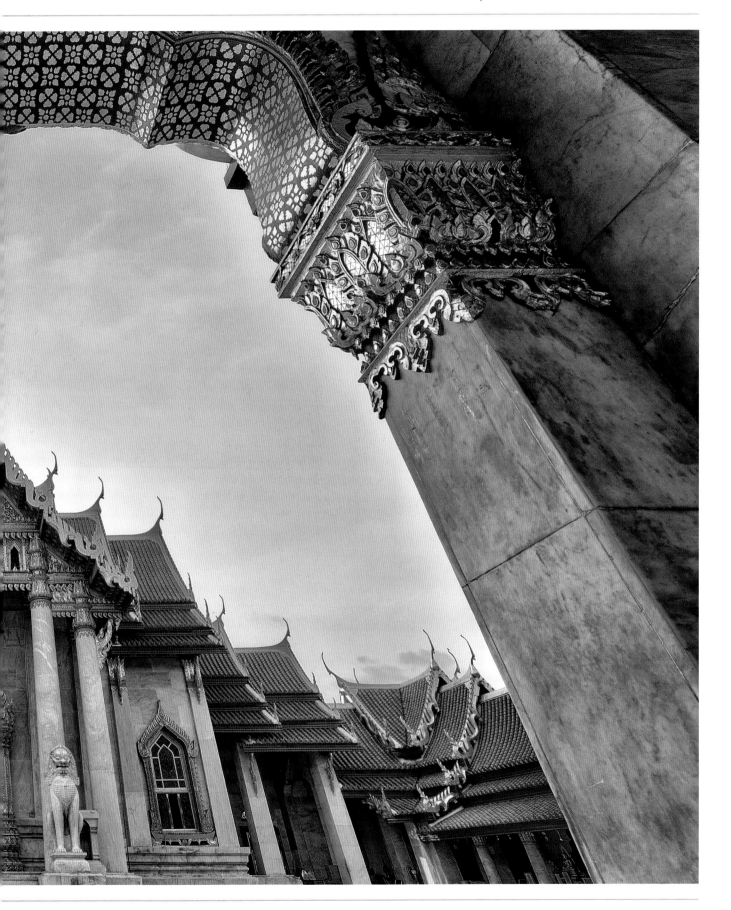

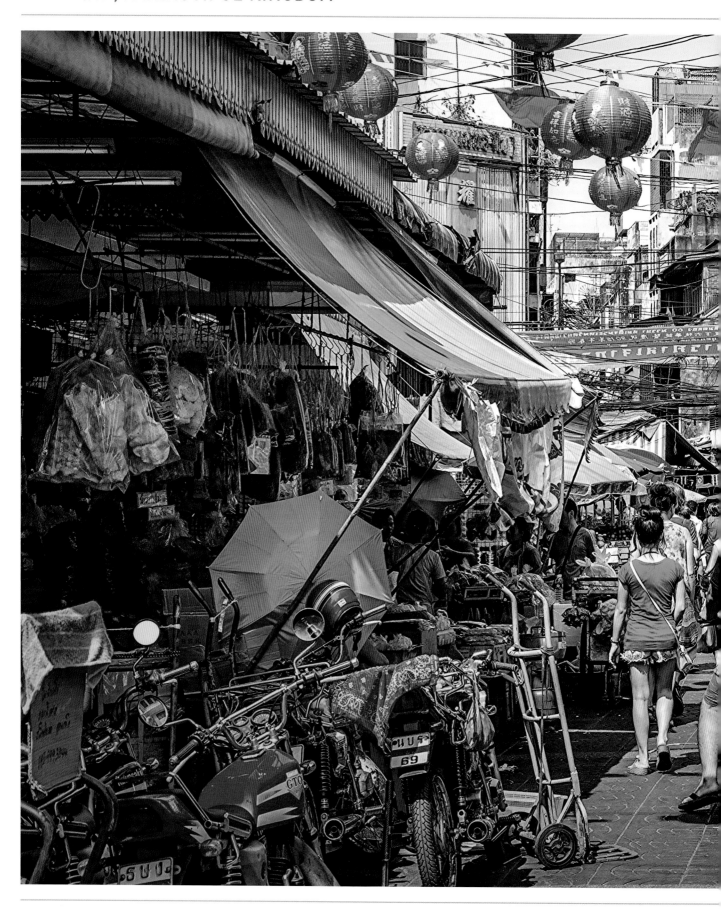

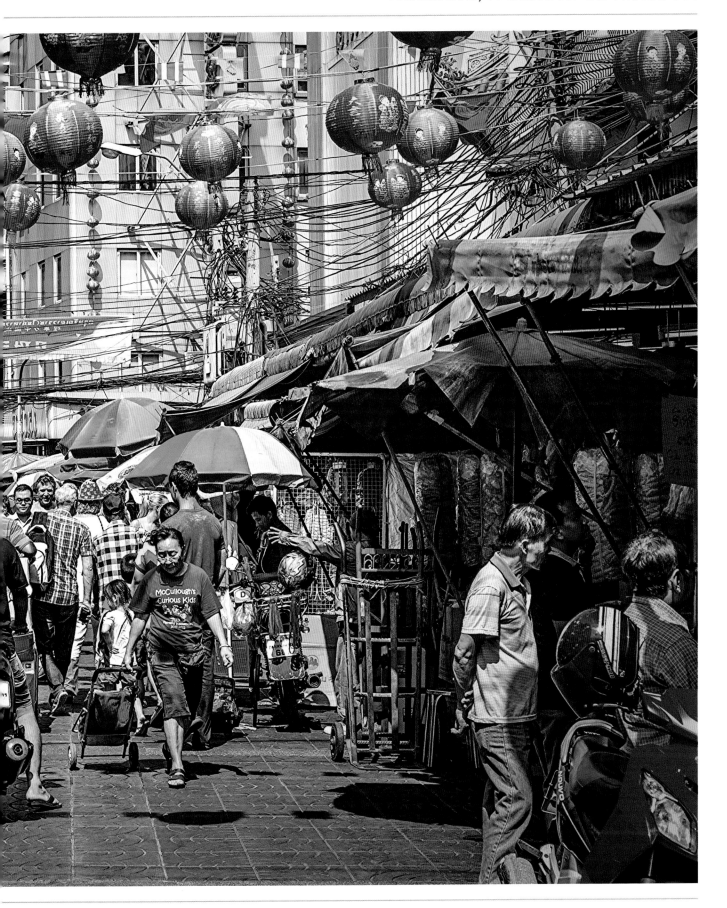

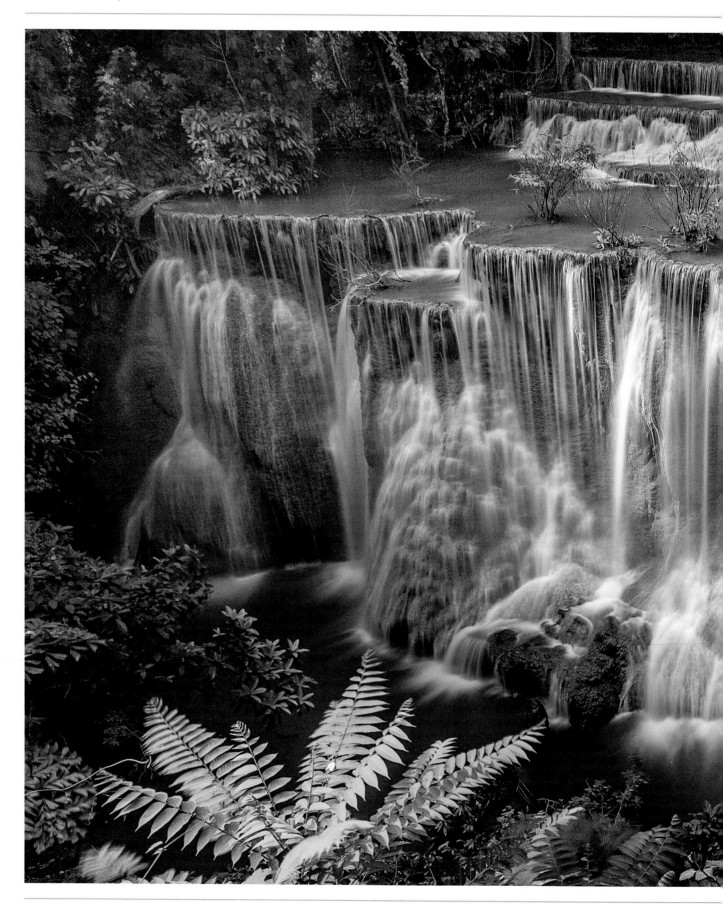

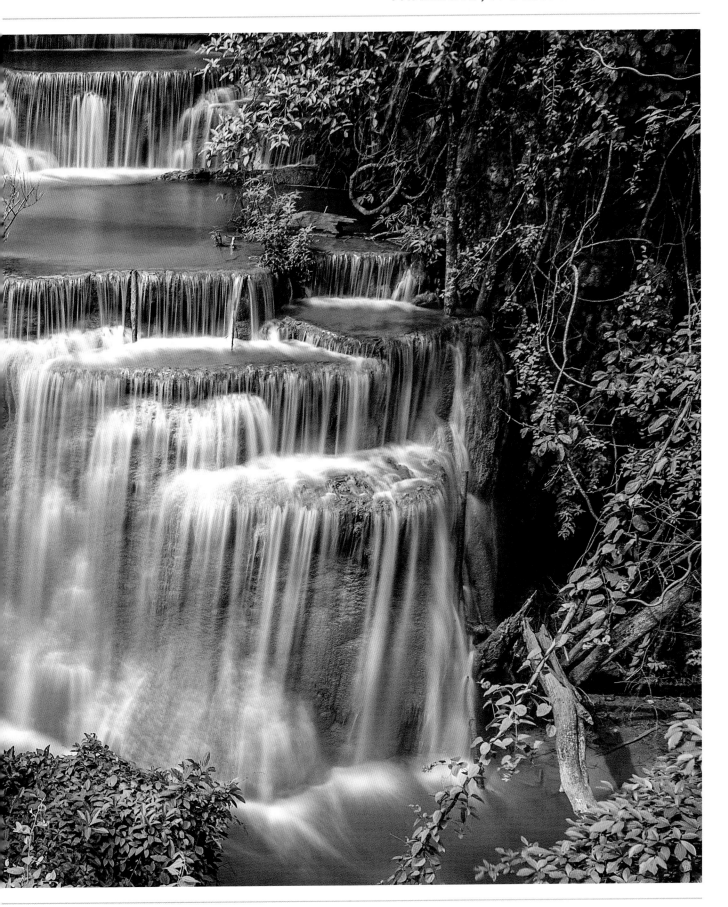

Sawadi! Welcome to the "Land of Smiles". Eternal summer, wide sandy beaches, friendly people, golden temples and tropical nights await visitors to Thailand, which is a land of diversity, be it geographical, cultural, ethnic and economic. More than 20 per cent of the population is concentrated in Bangkok. The country's heart beats in the center. The north is still home to various Hill tribes whereas the tropical south is inhabited by Muslim Malays. The ethnic Thais themselves make up about 80 per cent of the population. Their language has affinities with South Chinese dialects but their script probably derives from Indian writing. The vast majority of Thais are Buddhists, adherents of the pure doctrine, the "School of the Elders" (Thera-vada). They are believed to have emigrated to what is now Thailand from the Chinese province of Yunnan around 1050. Sukhothai

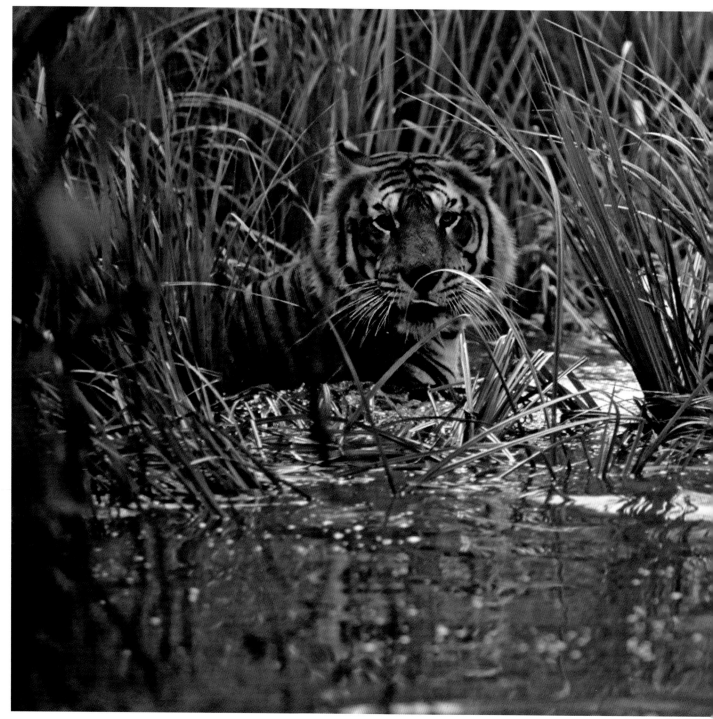

and Ayutthaya are the two important royal cities; their rulers shaped the history of the country from the 13th and 14th centuries and the cities are now UNESCO World Cultural Heritage Sites. Bangkok did not become the capital of modern Thailand until Ayutthaya was destroyed by the Burmese. Bangkok is pivotal and the key to the kingdom, a vibrant and dynamic metropolis bristling with ultramodern high-rise office buildings and beset with chronic traffic congestion, home to colourful markets and magnificent cultural monuments such as the Royal Palace Wat Phra Kaeo and Wat Pho. This illustrated book, with magnificent photographs, not only takes you away to Bangkok's bustling streets, but also to magnificent temples, through dense jungles and secluded bays, and shows you how enchanting this country really is. The geographically arranged illustrated chapters might help you to discover the beauty and diversity of Thailand.

There are still majestic bengal tigers roaming around the forest and jungle landscapes in the far north of Thailand. These noble cats are protected as hunters and the deforestation of their habitat is greatly endangering the population.

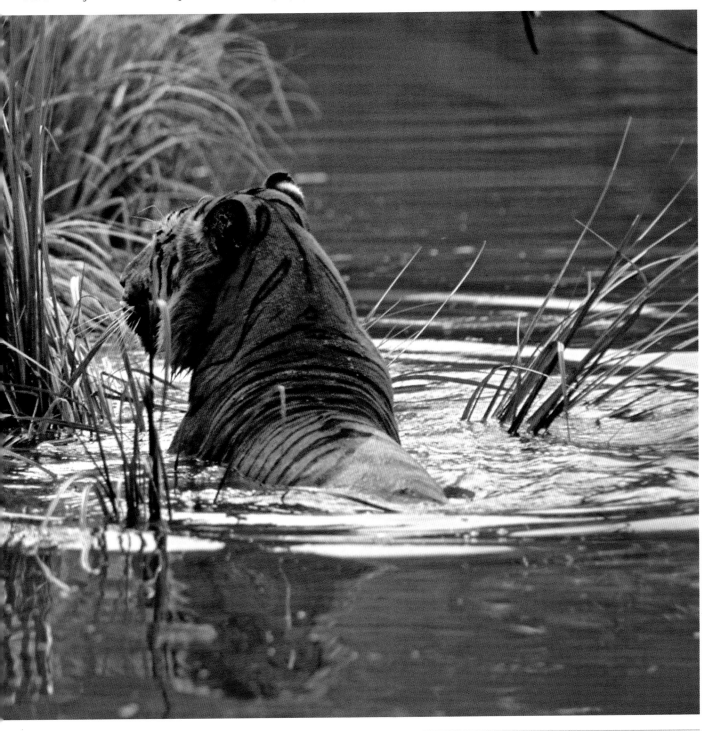

TABLE OF CONTENTS

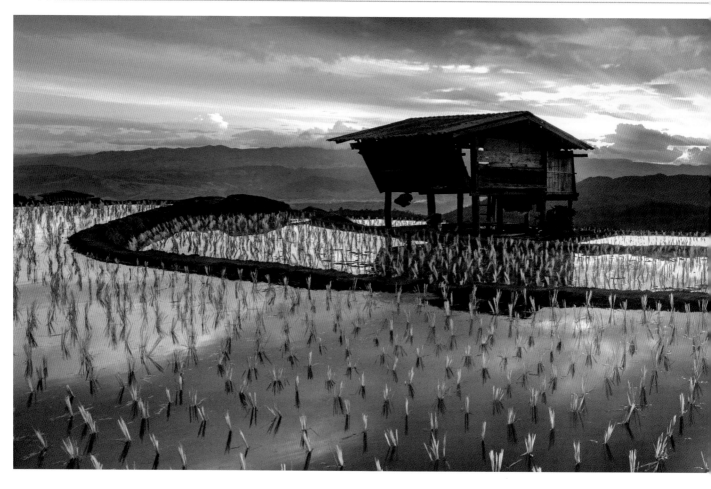

Above: Rice terraces in the Chiang Mai province. Wet rice cultivation does not harm the rice plants since they are able to adequately vent their roots.

Images on the previous pages:
P. 1: The head of a lying Buddah in Wat Pho, the largest and oldest temple complex in Bangkok, which is also famous for the cultivation of traditional medicine.
P. 2/3: Wat Benchamabophit, also known as the "Marble Temple", is located in the Dusit district of Bangkok.
P. 4/5: This statue in Wat Umong, a 700-year-old temple complex in Chiang Mai, is coloured green by mosses and lichens.
P. 6/7: Bangkok's Chinatown is a network of food stalls, small jewellery shops and busy wholesalers.
P. 8/9: The Huay Mae Khamin waterfall, which is located near the Erawan National Park, gushes over seven levels.

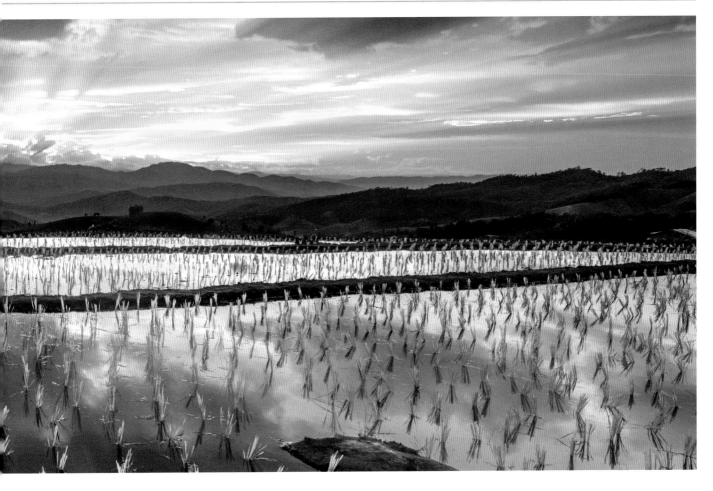

BANGKOK

Bangkok is colourful, turbulent, loud, bustling, chaotic and – utterly beautiful. It has a population of six and a half million, or including greater Bangkok more than ten million. A booming country is ruled from here. The King lives here and all large companies are based here.

Bangkok is, however, a city filled with constant congestion, beggars and it also has a Red Light district. Skyscrapers, luxury hotels and shopping malls dominate the modern cityscape. The temples on the river are home to contemplative monks, soothsayers and healers.

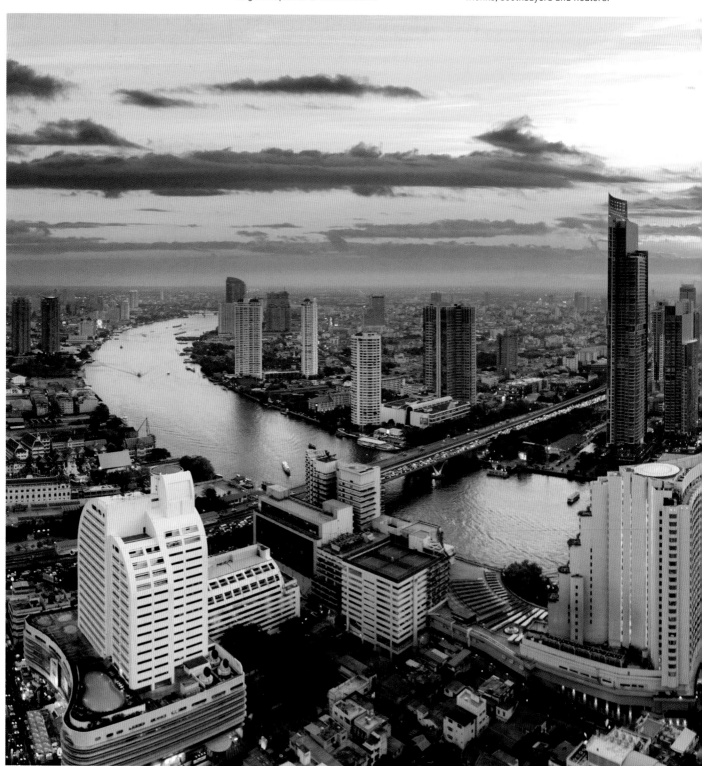

The Chao Phraya is known in English as the "River of Kings" due to its historical significance. It meanders through the city of Bangkok reflecting temples, palaces, high-rise buildings and luxury hotels in its waters.

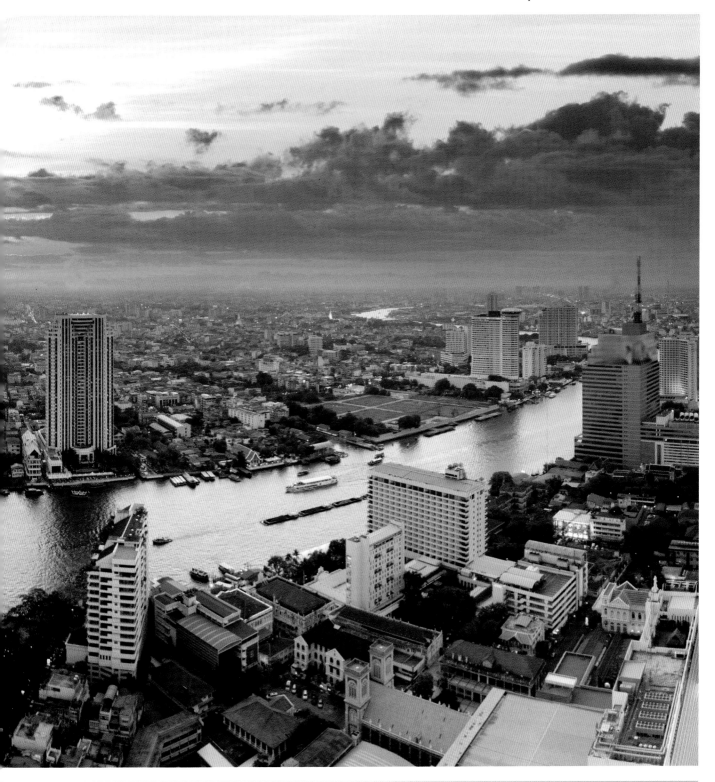

BANGKOK SKYLINE

What a spectacular skyline! If you have not visited Bangkok for a few years, you will experience a huge culture shock. Where wooden fishermen's huts and possibly one or other multistorey buildings once stood, now spectacular office towers rise high into the sky just a few metres from the banks. The city of Bangkok continues to grow, as a few skyscrapers are completed each year. The Chao Phraya remains the most striking sight.

The river divides Bangkok into two halves and is the only transport route that enables rapid progress in the city, because the metropolis is heading towards a collapse of its transport connections. But in the early evening the river is quieter, as business pauses until dawn arrives. This is the time that Bangkok's nightlife slowly comes to life.

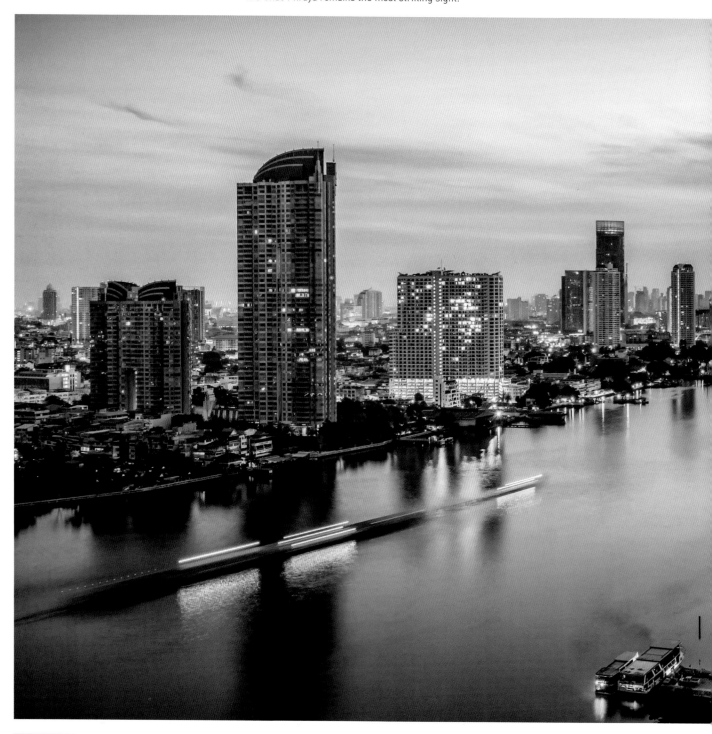

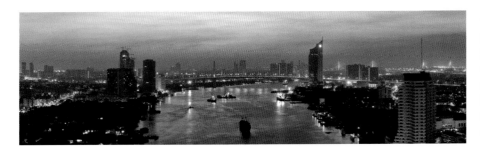

The impressive colour play of the world city of Bangkok is reinvented when the sun disappears from the horizon as the city comes alive with vibrant ever changing colours. Even the dirty corners of the city become a little more invisible. Every night Bangkok shines anew with millions of colourful lights that give Thailand's capital a distinctive glow.

GRAND PALACE

In 1767, after Ayutthaya, the old capital, had been destroyed by the Burmese, the Siamese withdrew to Thon Buri (then a town, now a Bangkok district). There Chao Phaya Chakri ascended the throne in 1782 as King Rama I to found the Chakri Dynasty, which still rules today. In the first year of his reign, Rama I moved the seat of government across the river to a site on the east bank. The Grand Palace complex, enclosed on all sides by a wall 1900 metres long and covering a surface area of 218,400 square metres, was built there. The name Bangkok used in the west for the capital derives from the east-bank village of Baan Makok, which had a mainly Chinese population. Krung Thep, the abbreviated form of the city's official name, which has made the Guinness Book of Records as the world's longest place name, means "City of the Angels".

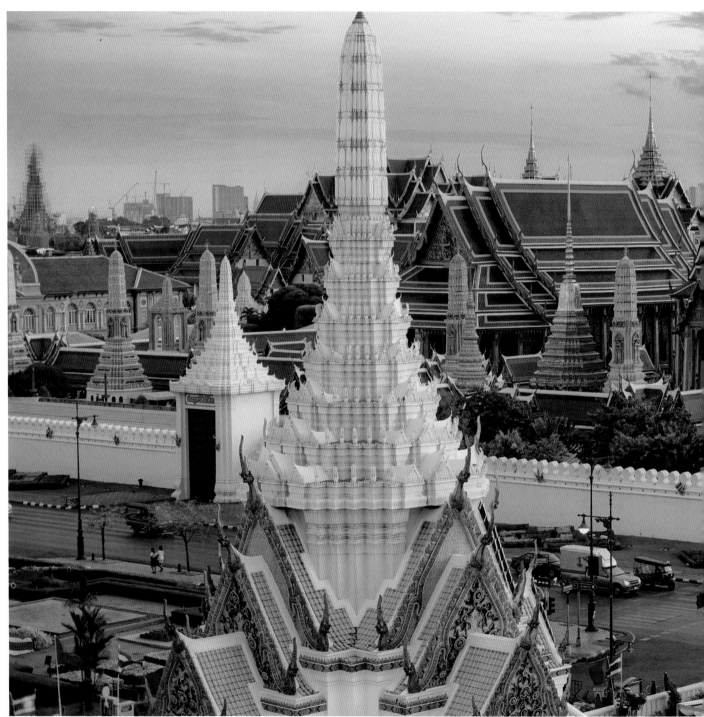

Once the Great Palace District of Bangkok used to be its own city: to this day, the richness in colour and shapes, the magnificent décor of the more than 100 buildings inhabited by fabulous creatures and mythological figures, overwhelms every visitor who comes to see the historical site. A 1900 metre long wall surrounds the city within the city, where Thailand's most sacred temple, the Wat Phra Kaeo, stands with a golden chedi.

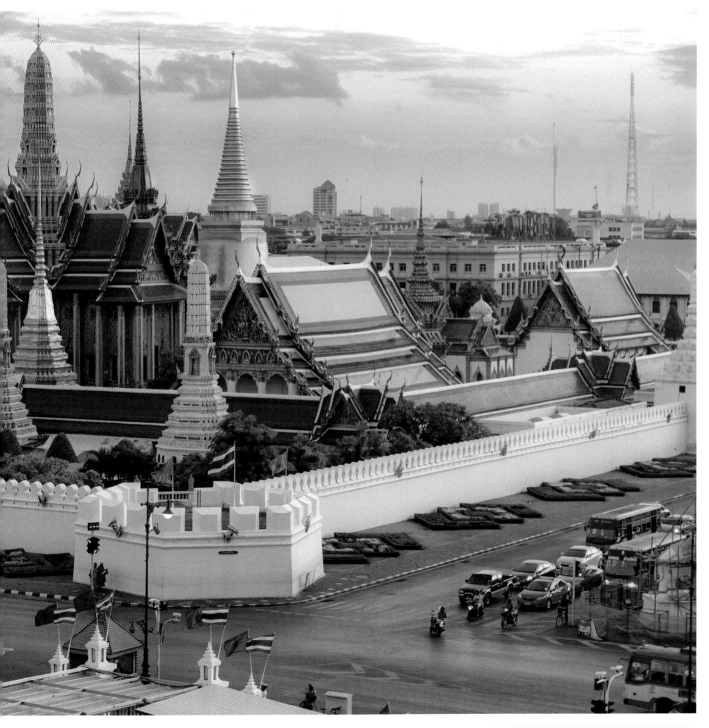

GRAND PALACE: WAT PHRA KAEO

The architecture of the most important temple complex in the Grand Palace was modelled on the old royal palace at Ayutthaya: Wat Phra Kaew – a temple reserved for the King and his Buddhist private devotions and ceremonies. Thailand's most venerated Buddha statue, the iconic Emerald or Jade Buddha, is housed in its main building. This sculpture, which is only 75 centimetres high and carved out of a single piece of nephrite (a less pre- cious type of jade), is thought to have come either from India or what was then Burma via Ceylon and Cambodia, where it was discovered, although camouflaged with plaster, by an abbot in Chiang Rai in 1434. Once recognized for what it was, the dark green treasure took a circuitous route to reach Bangkok, where it has stood in What Phra Kaew since 1778. The King changes the statue's apparel three times a year at a festive ceremony.

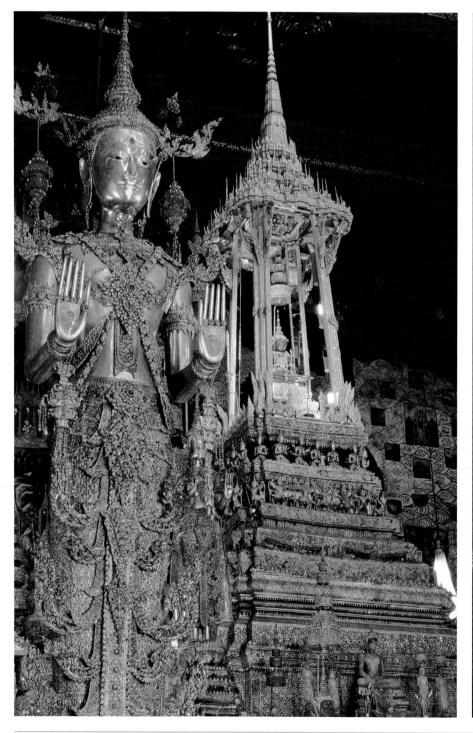

The over 100 richly ornamented temples, pagodas and statues were commissioned by King Rama I in 1782 on the occasion of the founding of Bangkok and were completed about 100 years later. The Phra Ubosot is the center, and is where the National Shrine and the Emerald Buddha are located. The famous figure measuring around 75 centimetres is placed in a glass box high above visitors heads.

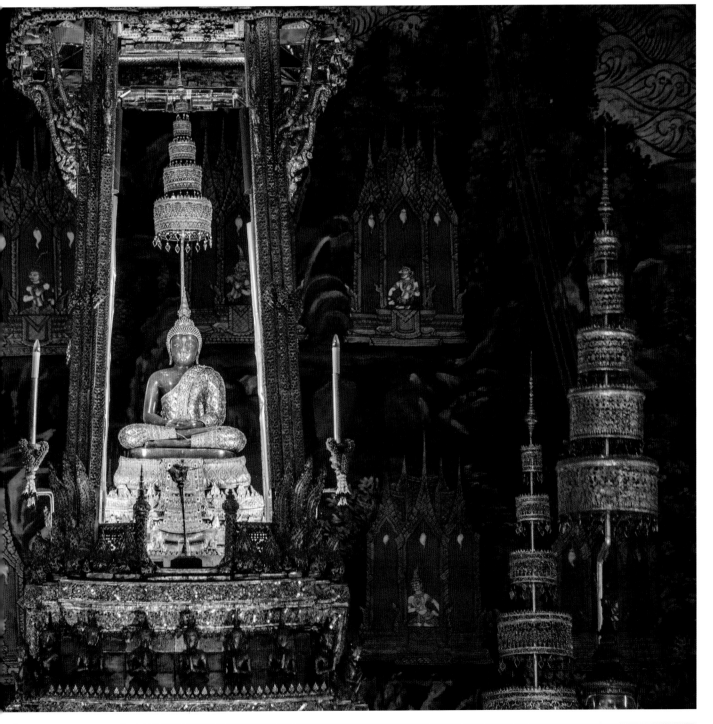

BUDDHA AND THERAVADA – DOCTRINE OF THE ELDERS

Buddhism began with a historical person, Siddhartha Gautama, a nobleman's son, who is believed to have lived in the 5th to 4th centuries BC. His teachings, initially only transmitted orally, are based on "four noble truths" – life is full of suffering, the cause of suffering is greed, liberation from suffering can be obtained and this can be done by following the "Noble Eightfold Path" (the correct mindfulness and understanding,

speech, actions, livelihood, efforts, thoughts and concentration) to reach the ultimate goal: the release from self-centered existence into the bliss of Nirvana. The first systematic attempt at writing down this formal canon of the pure doctrine was made in the 1st century BC in what is now Sri Lanka, from where the teachings of the Theravadins – adherents of the school of the Elders – reached Thailand. Theravada Buddhism, which is named

after them, is divided into three categories known as baskets – which is why the canon is also called the "Three Baskets" (Tripitaka). It contains the Buddha's rules for monastic establishments, his orations and his "higher" (philosophical) doctrine. The Buddhism practiced in Thailand also incorporates elements of Brahmanism and even shamanism. In most temples apotropaic amulets are sold to ward off misfortune.

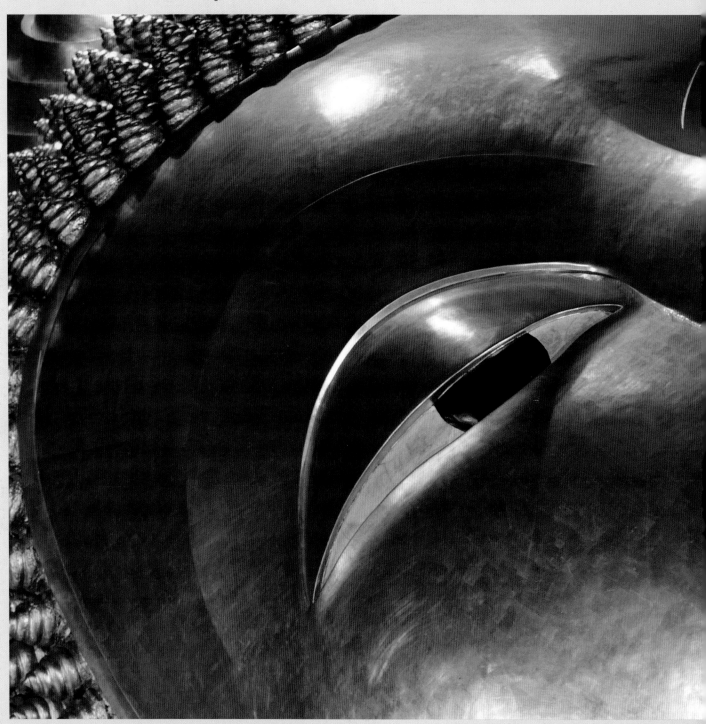

The Buddhist culture has created a rich temple and monastic architecture: Monasteries serve as places of retreat and meditation.

In the temples, sculptures of Buddha or Bodhisattvas are revered. Large image: Head of the giant Buddha lying in Wat Pho, the largest and oldest temple complex in Bangkok, which is also famous for the cultivation of traditional medicine.

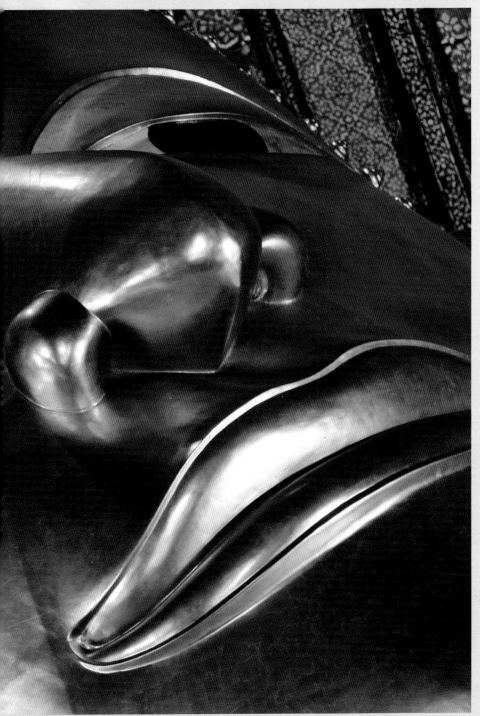

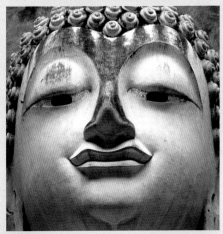

GRAND PALACE: CHAKRI MAHA PRASAT

The mighty Chakri Maha Prasat is surrounded by lush greenery. An impressive building in which the architects have made a lot of effort into breathing a lease of new life into the mighty building through gilded ornaments and turrets.

Thai people and visitors like to sit on the lawns and would be amazed if they knew that the Chakri Maha Prasat once consisted of eleven buildings, of which only three are still preserved. King Chulalongkorn built the palace, which was completed in 1882. Bricks from Ayuttha were partially used as the material for the building. Only the reception areas are still used today, all other rooms are largely empty. The most interesting part of the building is the throne hall, where state banquets were held. The walls of the hall are decorated with four paintings. They depict receptions from past centuries.

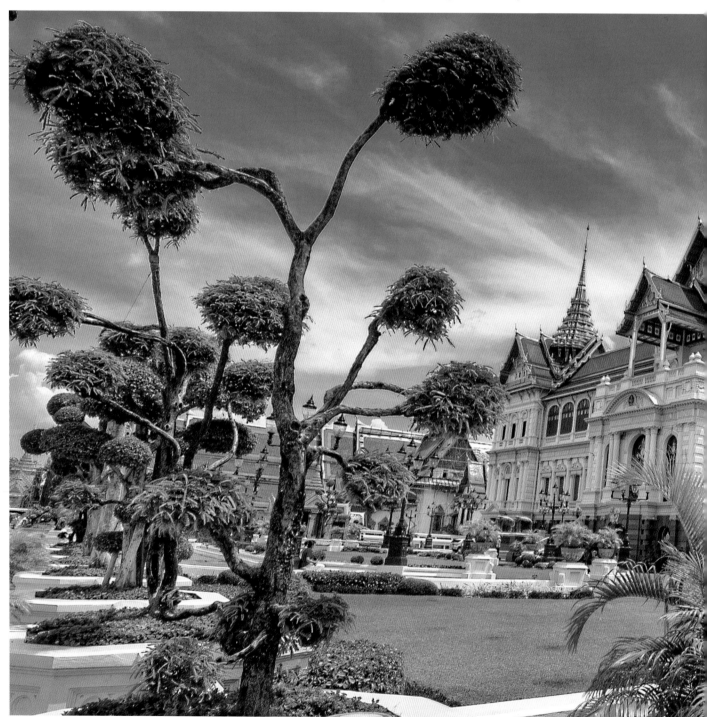

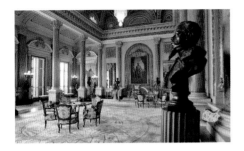

Exquisite furniture and opulent wall decorations are what characterize the interiors of the Chakri Maha Prasat (left).
Even today representative state visitors are welcomed and entertained here. You can feel a little of the splendour and glamour of old Siam, especially after glancing from the windows of the palace out towards the gold-glittering temple district.

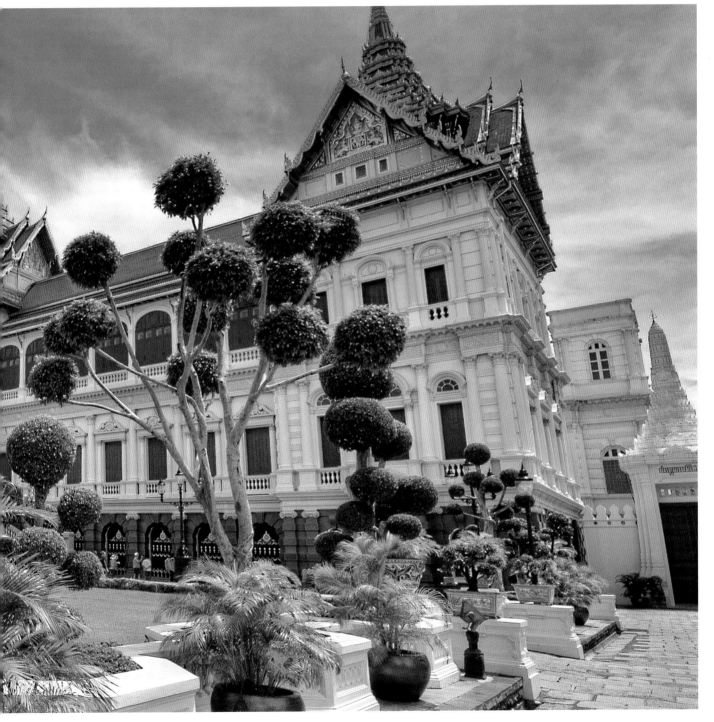

WAT PHO

Not far south from the Grand Palace lies Wat Pho, the largest and oldest (founded in the 16th century) temple complex in Bangkok. It boasts the largest Buddha statue in Thailand. Measuring 45 metres in length and 15 metres high, this statue which is completely covered in gold leaf, depicts the Buddha laying down shortly before he attained Nirvana. Nirvana means "extinction" in Sanskrit (also: "cessation of being"); however, that does not necessarily imply an association with ideas of death and transience. Nor is it a place like paradise but is rather an experience entirely of this world: An entrance into a state of enlightenment (Bodhi), freedom from the endless cycle of life (death, life and rebirth: samsara). The historical Buddha, Siddhartha Gautama, attained this state at the age of 35 while seated beneath a Bodhi Tree – he went on to live and teach for another 45 years.

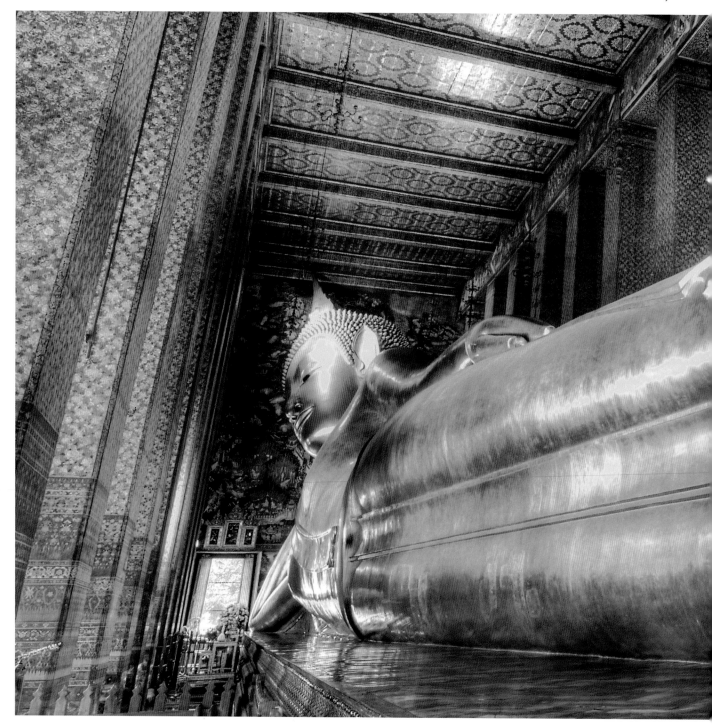

Wat Arun rises above the river like a mountain temple. It, too, is guarded by temple demons. Modern temple dancers commemorate an ancient tradition, a Buddha gallery displays fine statues and the lying Buddha in the main temple building represents an invitation to all visitors to meditate.

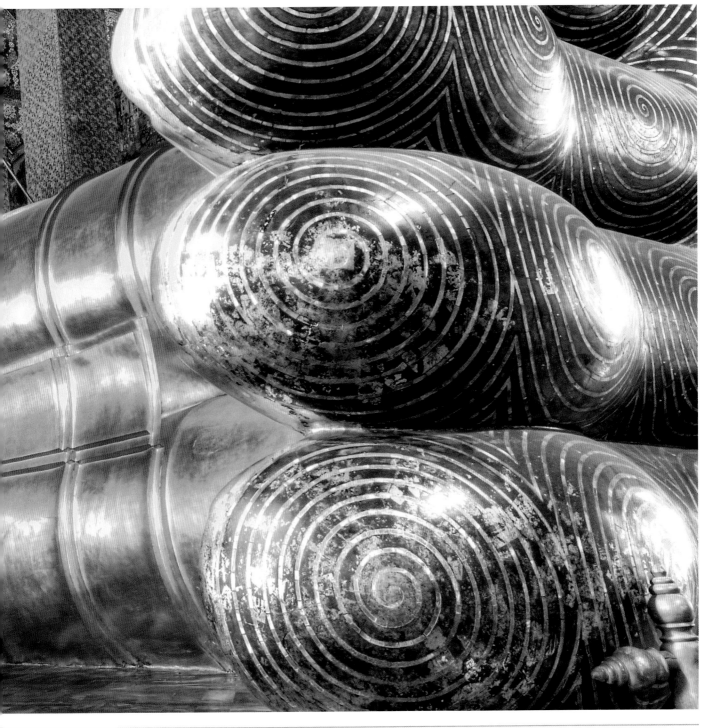

WAT RATCHANATDARAM AND LOHA PRASAT

What a charming name! The "Temple of the Royal Niece", Wat Ratchanaddaram in the Thai language, was to be a place where Debsirindra could meditate undisturbed. Her uncle Rama III had dedicated the monastery to the later queen and wife of Rama IV.

Today the center of Bangkok is no longer peaceful, but the temple complex is still captivating with its completely unusual structure. The Loha Prasat with its golden tip is the replica of a building which was built in 150 BC. It was far ahead of its time: the roofs are covered with bricks made of solid bronze, an imposing 120-metre side length and 1600 stone columns are the foundation for the nine-storey building. The height of the temple is 36 metres and the 37 metal chedis are also unusual for Thai architecture, with a Burmese umbrella perched on top.

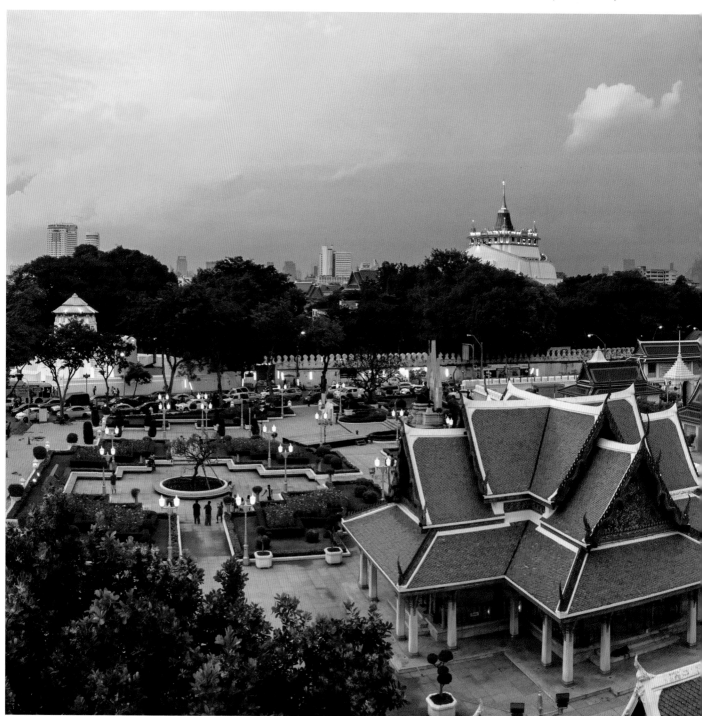

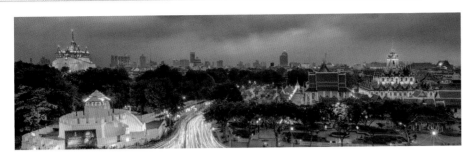

Evening entertainment around the Wat Ratcha-natdaram and the Loha Prasat. When dark clouds promise a thunderstorm and cooler temperatures, the contrasts between the cheerful, multicoloured temple complex and the grey city behind it become even clearer. Especially in the early hours of the evening a visit to the temple is characterized by a particularly magical atmosphere.

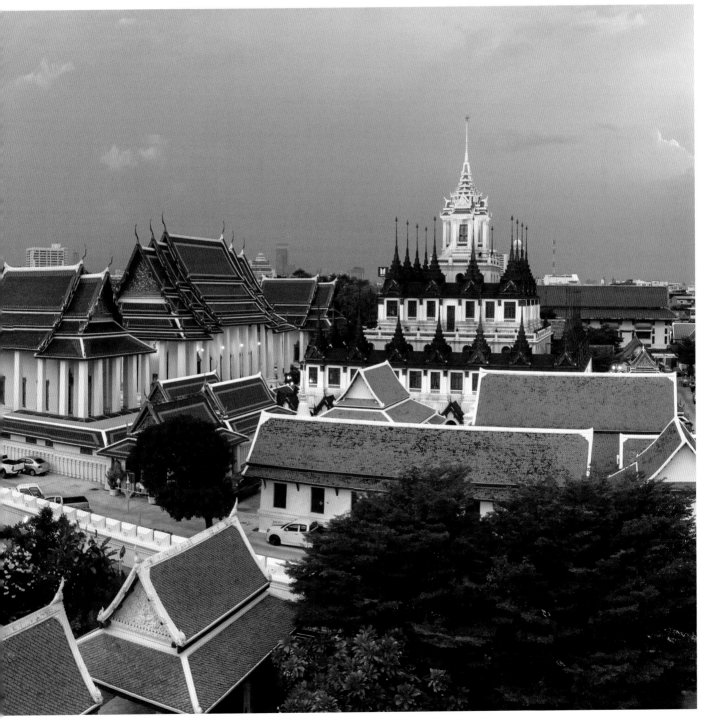

CHATUCHAK WEEKEND MARKET

For some it is 1,13 square kilometres of terrible hustle and bustle and for others it is a paradise with 10,000 stalls and shops.

The Chatuchak Weekend Market is the largest market in all of Thailand and is well-attended. Silk cushions, toilet brushes, raincoats or spaghetti strap tops, incense sticks and fake DVDs – you can find everything amongst the seemingly planned chaos. Between 200,000 and 300,000 customers come to the market from Friday to Sunday – for strolling, haggling and buying.

Since the temples and Buddhas are as important to the Thais as the food stalls are, they are always busy, as nothing is as important as freshly prepared food. Every few metres shrimp, tofu, exotic things like grasshoppers or vegetables sizzle in the woks – and the lemongrass and ginger smell amazing.

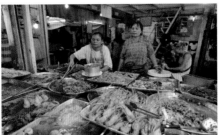

The Chatuchak Market was originally planned to be a flea market. The former Thai Prime Minister Plaek Phibulsongkhram opened the first weekly market in 1948. The idea was that, over time, these so-called flea markets would develop throughout the country. Nowadays there are also daily markets in Thailand, where fresh vegetables and fish are sold.

ERAWAN SHRINE

Traffic noise, lights, street vendors – and then suddenly an oasis: the Erawan Shrine. Worshippers walk in measured steps through the small area, squeezed between two main streets, a sea of colourful flowers lying in front of the little golden shrine, and the the Thai people kneel in front of the statue of the divinity of Brahma – partly with incense sticks in their hands, immersed in it all. It seems as if they can block all the noise out for a few short moments. The history of the shrine is, on the one hand, tragic and, on the other hand, typical of the religious world of Thailand. After multiple accidents and even when the marble-laden ship sank during the construction of the Erawan Hotel in 1956, the workmen ceased their work. An astrologer advised Brahma to build a shrine. Immediately after its completion the accidents also stopped.

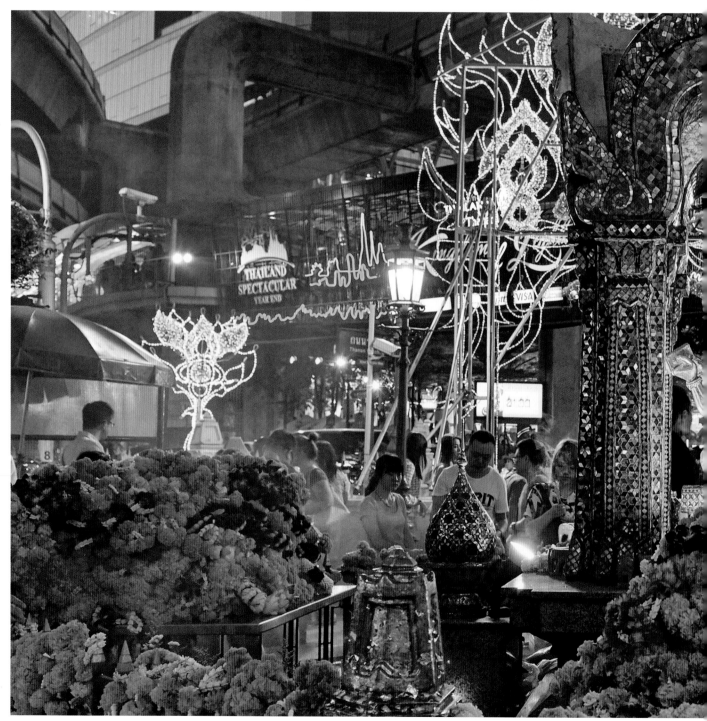

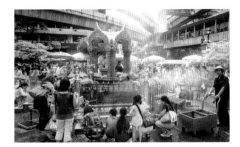

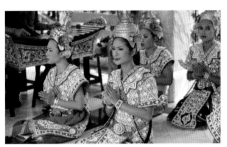

For those who wish for something must first offer a gift: Money, flowers or wooden elephants. The legendary god is only satisfied, however, if after fulfilling the wish, he is also offered a traditional dance. Four dance groups with up to eight dancers (left) and a small orchestra are waiting for worshippers at the Erawan Shrine – and their donations.

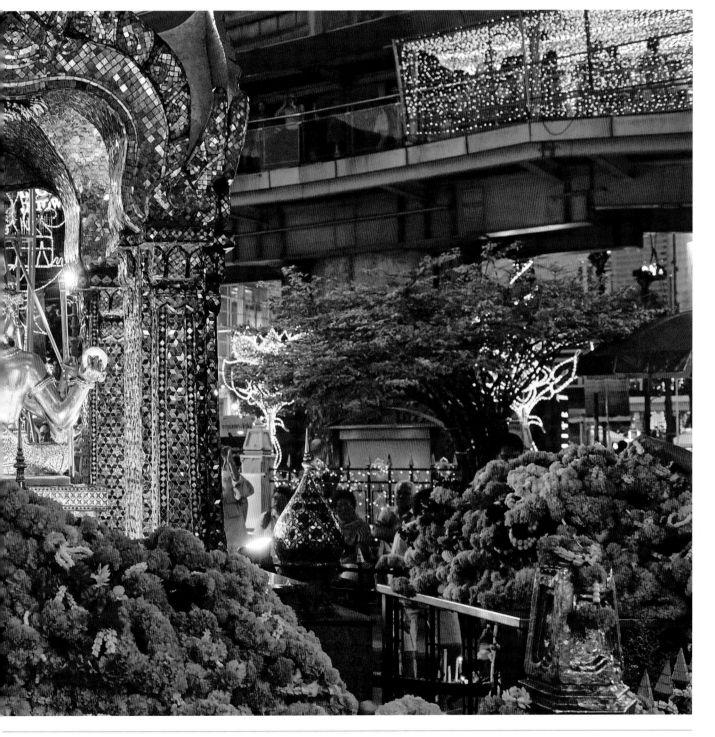

THAI BOXING: THAILAND'S NATIONAL SPORT

It may be merely the stuff of legend but the idea that Naresuan, King of Siam in the 16th century, succeeded in freeing himself from captivity as a prisoner of war in Burma by beating the enemy's champions in hand-to-hand combat has something intriguing about it nonetheless. It is true in any case that the Kingdom of Siam introduced conscription in the 16th century and men trained not just in military combat with sword and lance but also in the martial arts without weapons, instead using their whole bodies against their adversaries. Today, Thai boxing (Muay Thai) is Thailand's national sport and aficionados' enthusiasm can only be compared to that shown by football fans in Europe. Moreover, a lot of money is made in betting. Boys planning professional careers in Thai boxing usually begin training at the age of eight; by the age of twenty-five, most boxers have thrown in the towel. Each match – staged to the accompaniment of ecstatic music – begins with combatants showing respect (Wai Khru) for their teachers and a ritual dance (Ram Muay). Boxers are known as Nak Muay, a round lasts three minutes and a match has a maximum of five rounds. A boxer left lying on the floor must be up on his feet again by the count of ten or the match is over. The victor traditionally kisses the loser's feet, a custom likely not to win acceptance in the west.

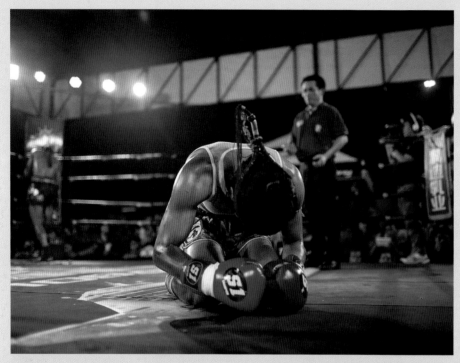

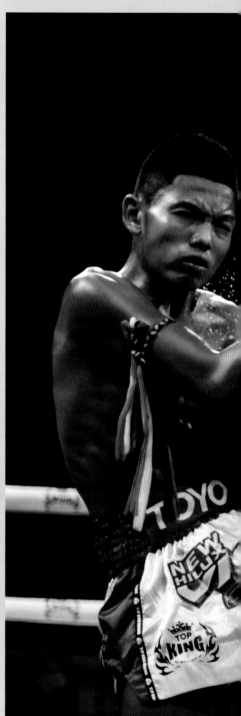

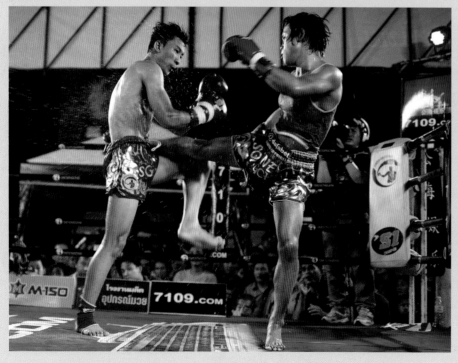

Thai boxing is risky but certainly not a sport without rules: biting, hitting below the belt and head-butting are prohibited. All normal boxing techniques and then some, such as kicking, jabbing with the elbows and knees and even clinching one's opponent are allowed.

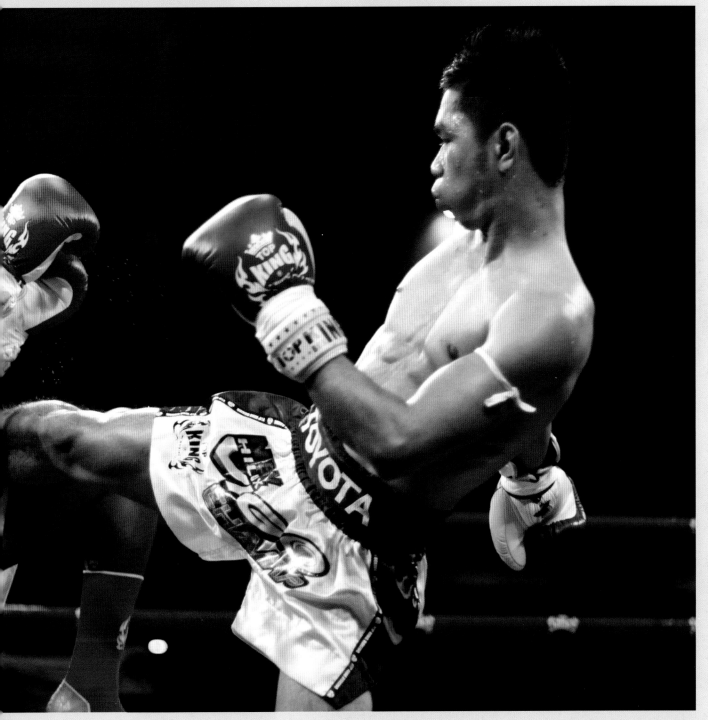

The history of the Chinese community predates Bangkok's primacy as the capital of Thailand: even before King Rama I moved his seat of government across the river from Thon Buri on the opposite bank of the Chao Praya in 1782, Chinese street merchants were living on what are now the grounds of the Grand Palace. When they had to yield to the king's plans for the site, they retreated to the locale that is now Bangkok's Chinatown: at Odeon Circle a gate marks the entrance to Yaowarat Road (the Express Boat to Chinatown leaves from Ratchawong Pier) and from there it's best just to walk and go with the flow – straight into a world of myriad colours, shapes and smells. There are a lot of sights to see here too – Wat Traimit, is but one example, boasting a Buddha statue 700 years old and made of pure gold – but the real attraction is Chinatown itself.

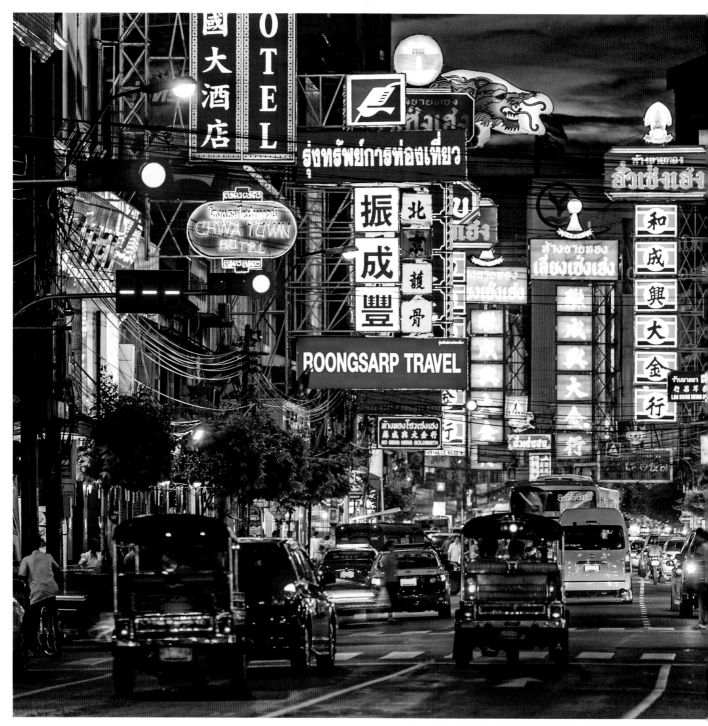

A Chinese kaleidoscope: On the roadside are temples, as well as food stalls offering tasty food, flower vendors wait for customers, lanterns, sticky sweet buns and incense sticks are layed out on display (picture strip above). Craftsmen and market vendors characterize the picture as well as Chinese illuminated signs and the smell of chili fills the air: Chinatown!

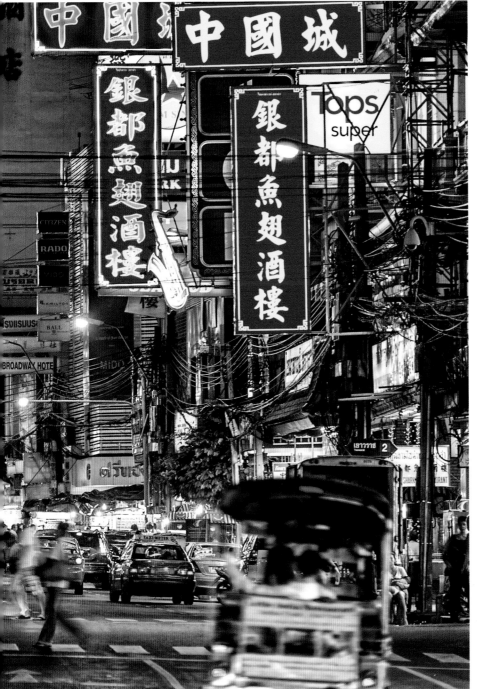

THANON SILOM

Silom Road is considered the "Wall Street of Thailand". It is one of the most important financial centers in the country, the largest corporations of the Kingdom of Thailand, such as the Bangkok Bank and many insurance companies have their headquarters located here. It is quite interesting for visitors, that just in this financial center, in a district with designed shopping centers with high-gloss facades, the craziest corner of all of Thailand can be found. The two streets, Soi Patpong 1 and Soi Patpong 2, are blocked in the evening due to traffic. Traders decorate their stands with T-shirts and fake Rolex watches, food stalls cook up quick curries, and on the pavements scantily clad girls attract visitors, at best, into the pubs. They wait in the harmless Gogo bars on the ground floor or are in the more special shows on the upper floor or in the rear buildings.

At a first glance, Bang Rak only has skyscrapers and shopping centers to offer. The main attraction is the lush greenery: Lumphini Park is one of the largest and most popular nearby excursion destinations for the Thai people.

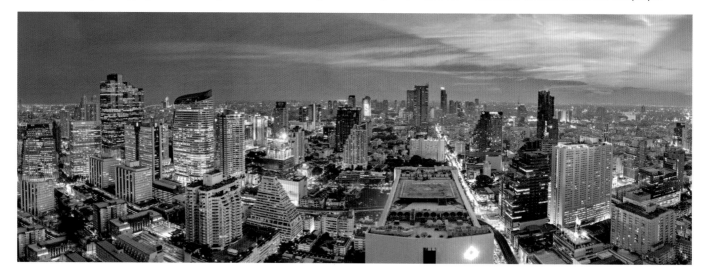

SATHON

Two of Bangkok's tallest buildings are located in Sathon, one of 50 districts of Bangkok.
The Met is 228 metres high, and the Empire Tower 1 measures 227 metres in height.
Sathon, also known as Sathorn, has developed into one of the most important business areas of the southern city center. Embassies such as the German or the Austrian representations are also based here. The Thanon Sathon, which gave the district its name, is one of the most frequented streets of Bangkok. Like most other streets of the capital, it was once a romantic khlong, a waterway that stretched towards Chao Phraya. Visitors to the Wat Yan Nawa can dive into a completely different world than the high gloss façades. The ancient temple from the countrie's Ayutthaya period contains unique chedis, which are modelled on the Chinese junks, which is a lovely contrast to the modernity of Sathon.

Architecture cannot be arbitrary in Thailand. Once it was seen in the construction of the magnificent temples; but today even passages and bridges are often impressive.

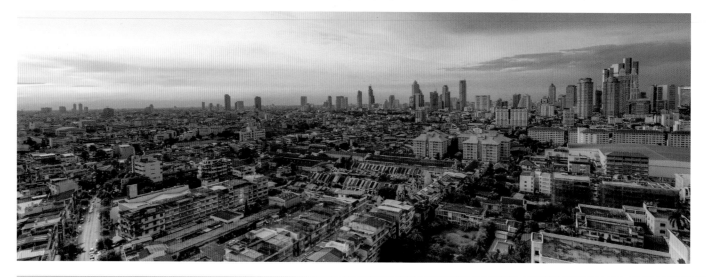

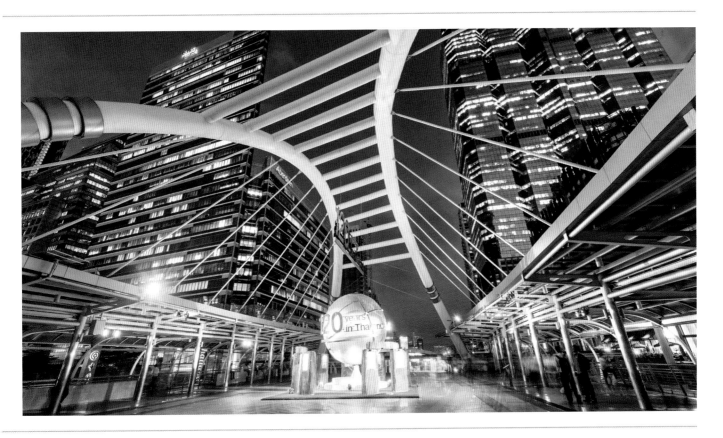

KHLONG TOEY MARKET

It was once a slum district, but today the head chefs from luxury and posh restaurant also buy their produce at the Khlong Toey Market. You can't get chicken feet, lobster, crayfish or pig heads any fresher than it is here. Trading laughter and haggling take place at the market from six o'clock in the morning until two o'clock the following morning. The large market hall selling fish and meat is covered, but it is not air-conditioned, so just like in ancient times, a lot of ice must be used to keep the produce fresh. Vegetables and fruit are traded outside the hall or under canopies. Exotic specialities which are not normally available can be haggled for early in the morning. Later, when the first shops are done haggling, the traders like to take a little time to go to the temple to thank the gods with a donation for the successful start to the day.

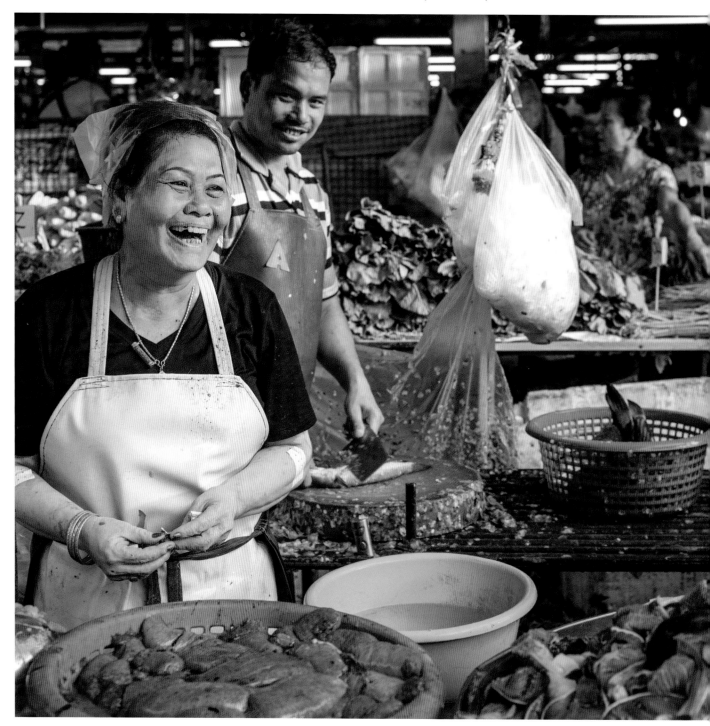

A market in Thailand is not restricted to a single group of products. Therefore, not only meat and vegetables are traded on the Khlong Toey Market. Spice mixes in exotic colours, plates, sieves, cups, but also T-shirts, trousers and incense sticks are part of the initially chaotic appearance. The time for prayer will find visitors as well as vendors alike.

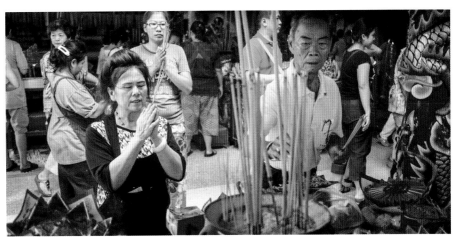

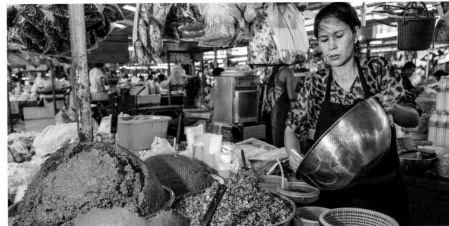

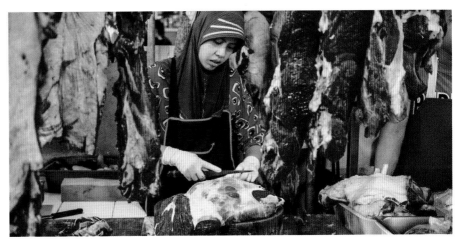

WAT ARUN

The imposing temple tower of Wat Arun on the banks of the Chao Phraya is a Bangkok landmark. Even early European travellers to Siam marvelled at its beauty. When King Taksin was being rowed along the river one morning, he gave Wat Arun its present name: "Temple of the Dawn". King Rama II subsequently had an 86-metre-high tower, flanked by four smaller towers, built in the Khmer style. The façade decoration consists of thousands of shards of Chinese porcelain: although to some it might seem peculiarly pointillistic when seen up close, the overall visual impact the decoration makes from a distance is stunning. Visitors can ascend the terraces of Wat Arun to a height of 20 metres via a steep, narrow stairway. The view from the top is superb, encompassing the entire temple context, the largest bend of the River Chao Praya and Wat Phra Kaew.

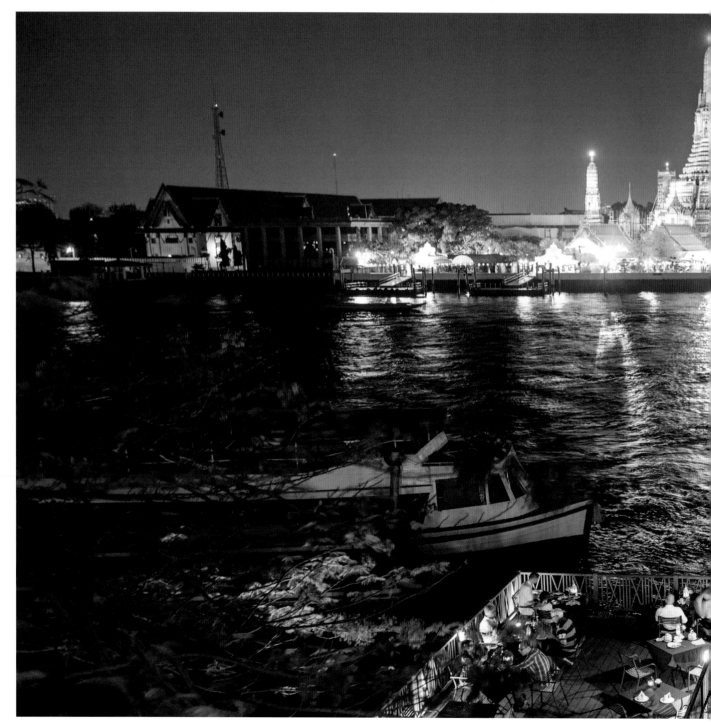

The monumental Wat Arun rises over the river in the district of Thonburi. The center of the complex is the 80 metre high pagoda, which is also called "The Central Prang". At each of the corners are smaller prangs, dedicated to the wind god Phra Phai. The seated Buddha in the central sanctuary invites you to worship (left).

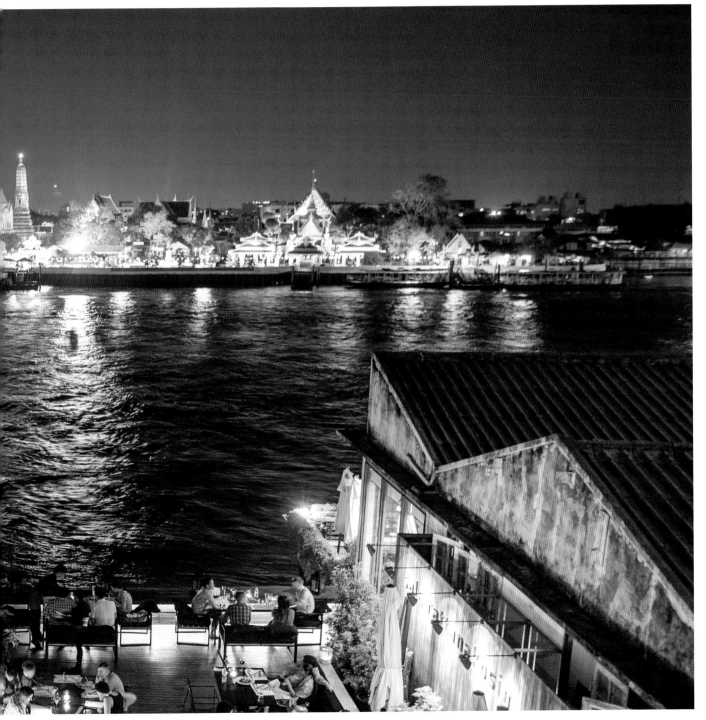

THONBURI KHLONGS

The many canals (khlongs or klongs) that once criss-crossed Bangkok earned the city the epithet "Venice of the East". In the past fifty years, however, many of the old canals have yielded to the building of streets or have simply been filled in to reduce the ever-present threat of rampant cholera epidemics. A few of these old Bangkok waterways have survived but the traditional "floating markets" – male and female vendors selling their wares from narrow boats – are no longer held in the city itself. The best way to experience something of what the vendors in their boats must once have been like is to visit the klongs on the Thonburi side, that is the west bank of the Chao Praya, in the early morning. If you are curious about what is going on, you are advised to take a boat from the quay at the Oriental Hotel and taxi across to the big and little waterways of Thonburi.

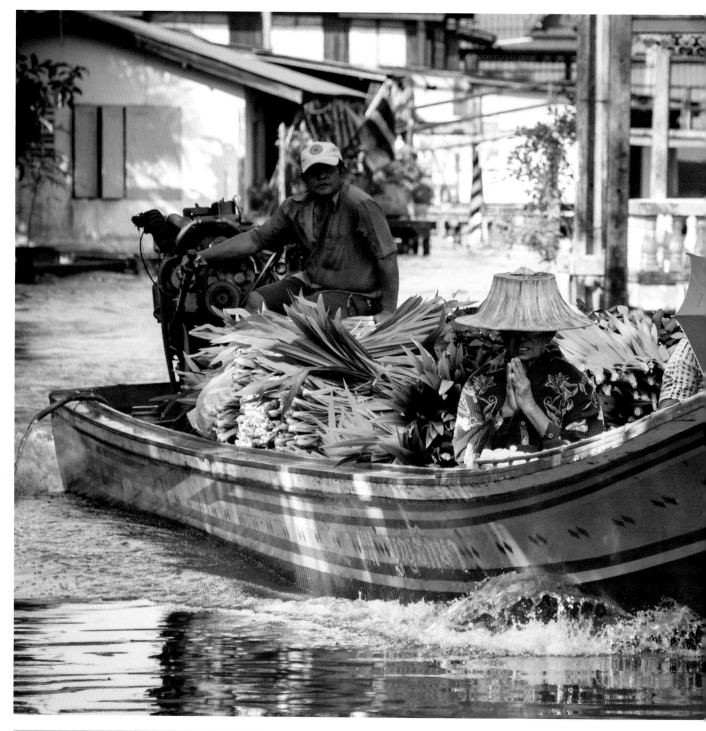

To visit a real "floating market" today, you have to travel to the area around Bangkok, to Damnoen Saduak, about 5 kilometres west of Ratchaburi. The market only appears tradition ally during the early hours of the morning - the tourist buses arrive from 9 am – but a ride on a water taxi through the Khlongs of Thonburi is also enjoyable even without the market.

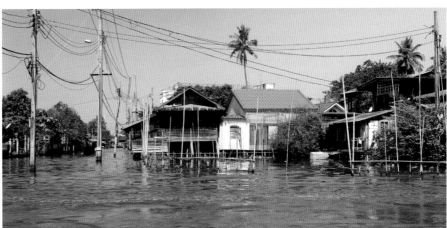
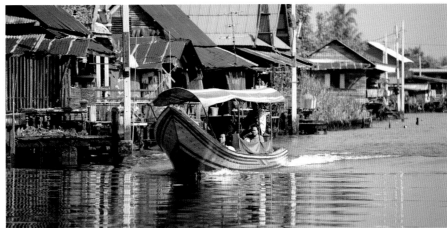

BANGKOK'S NEIGHBOURING PROVINCES

The capital city Bangkok is characterized by the hustle and bustle and modernity with all its challenges. The neighbouring provinces, on the other hand, are quite different. Life is quiet, people have time to chat with strangers and the rural lush green landscape is a feast for the eyes. The old royal city of Ayutthaya is also a stark contrast to the Grand Palace in Bangkok.

There are only ruins left, which recapture the old splendours. But even the remains are partly still so well preserved that they radiate the dignity of the sanctuaries.

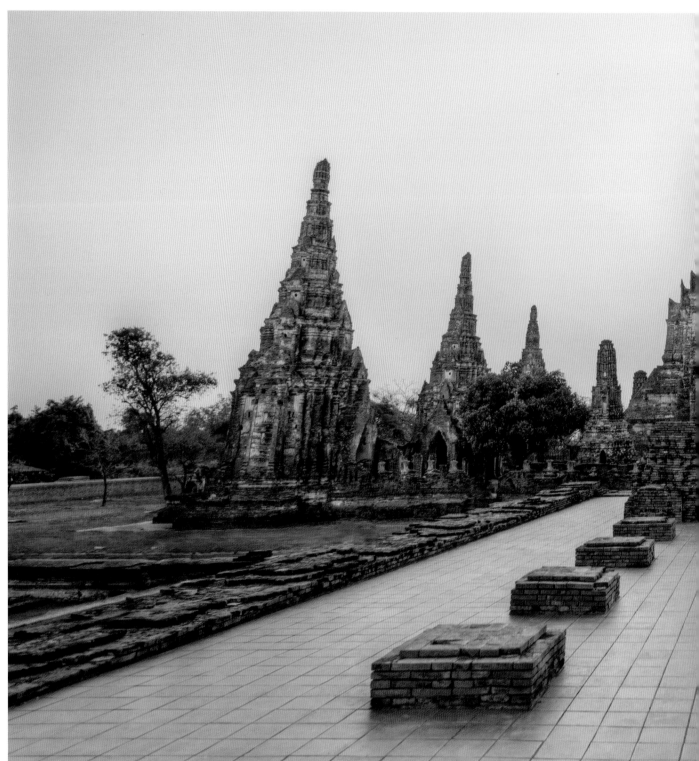

The ruined cities in the north of Bangkok are witnesses to the past, which have become historical parks. The vast dimensions of the ancient royal courts of Ayutthaya (below) and Sukhothai amaze all visitors and make even several day visits an experience of a lifetime.

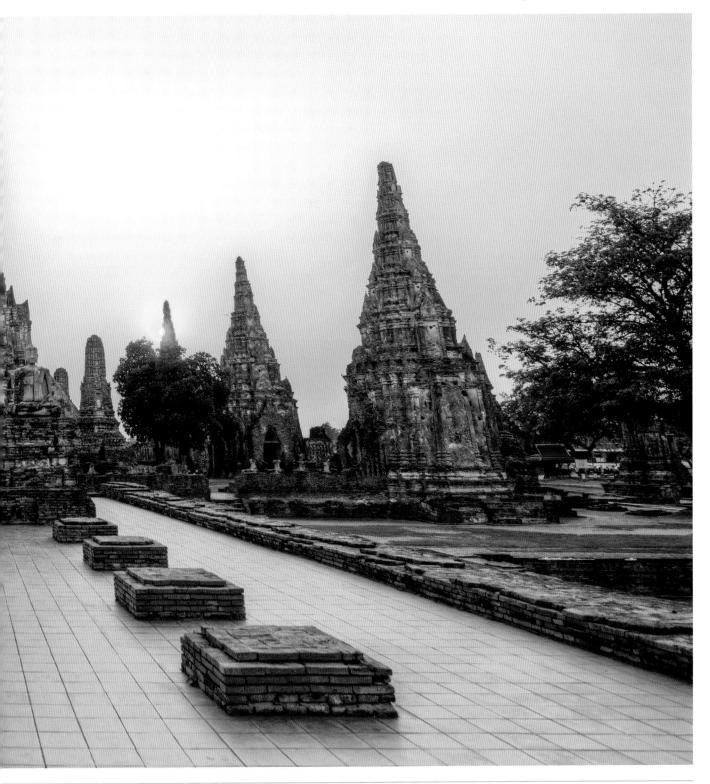

ERAWAN MUSEUM

Even the staircase is a celebration of colours, playfulnes, shapes and monumentality. The Erawan Museum is something that every tourist must visit because of its architecture. It is located in the province of Samut Prakan in central Thailand at the mouth of the Chao Phraya, which stretches to Bangkok.

Ten years of construction work took place after the foundation stone was laid in 1994, before the impressive building was constructed. The museum is also impressive from the outside. The round building is crowned with a 150 tonne, three headed elephant, which is 39 metres long, twelve metres wide and is accessible. Thai antiques have found a place in the Erawan Museum and the surrounding car park. The main building houses antique Chinese porcelain on the ground floor and Buddhist antiques on the top floor.

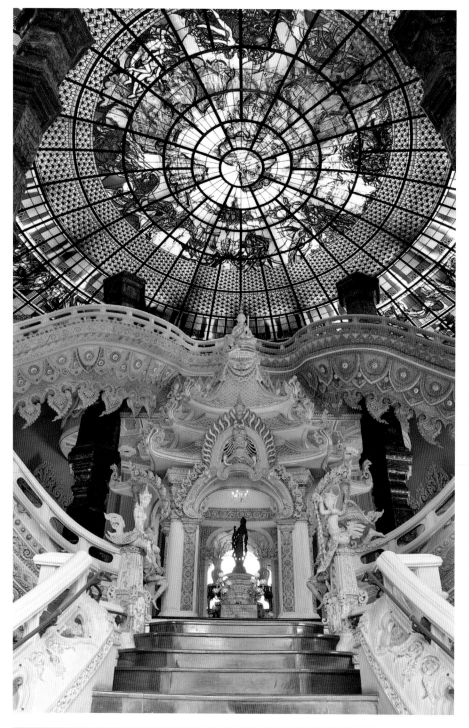

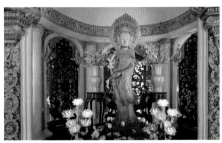

The painted glass roof of the Erawan Museum above the spectacular staircase is the work of the German artist Jakob Schwarzkopf (1926-2011, bottom left). He was also responsible for the ceiling of the upper floor which displays the universe (lower right). From the outside the museum building is a spectacular sight with the gigantic elephant statue standing on the roof (far left).

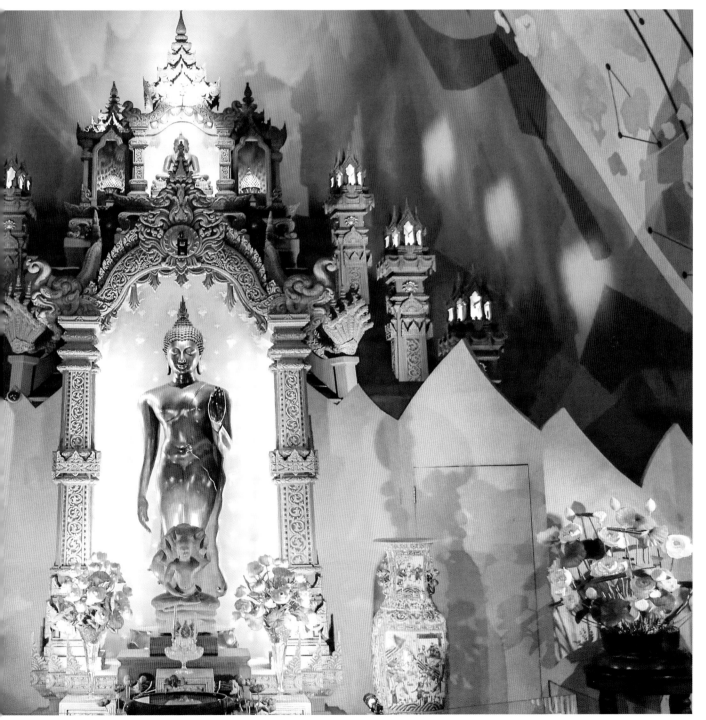

WAT PHRA DHAMMAKAYA

A rush of orange: the Wat Phra Dhammakaya accommodates up to 10,000 monks at the same time for meditation. The site around the Wat has grown over 400 hectares over the course of time. The main building is very modern and has little to do with a temple of traditional Thai embossing. It offers a superlative, which is difficult to beat: The Wat contains a total of 700,000 Buddhas that are more than 20 centimetres in size, and 300,000 others can be seen outside the building. Nevertheless, the doctrine of Dhammakaya Buddhism, which is mediated in the temple, is very controversial.

The Order agressively promotes donations and is repeatedly involved in criminal investigations regarding the origin of the personal assets of the governing abbot Phra Dhammachayo. The community also has branches in Germany.

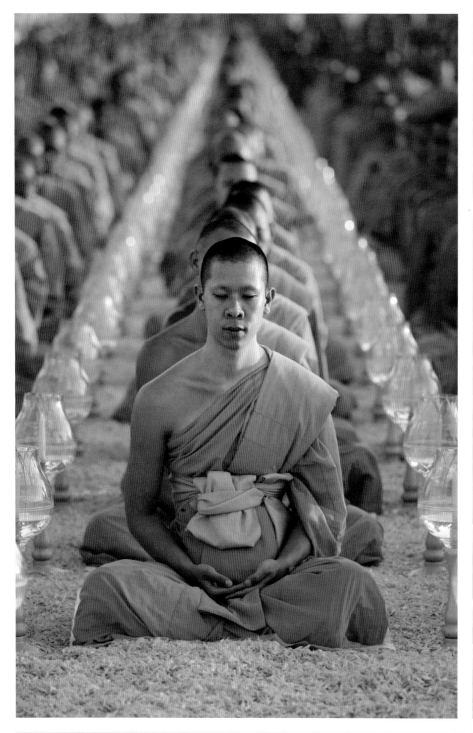

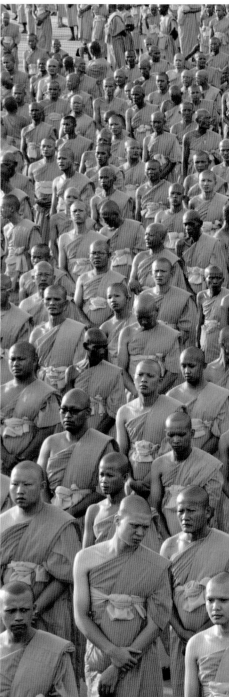

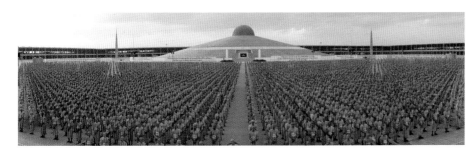

Relaxation, breathing control and the repetition of the mantra "samma araham" are the main procedures for the Dhammakaya meditation. It is to make the direct entrance into Nirvana possible. Since the meditation is faster to learn than others, traditional exercises and also the study of the teachings of Buddhism is not provided. It is popular, especially among students in Thailand.

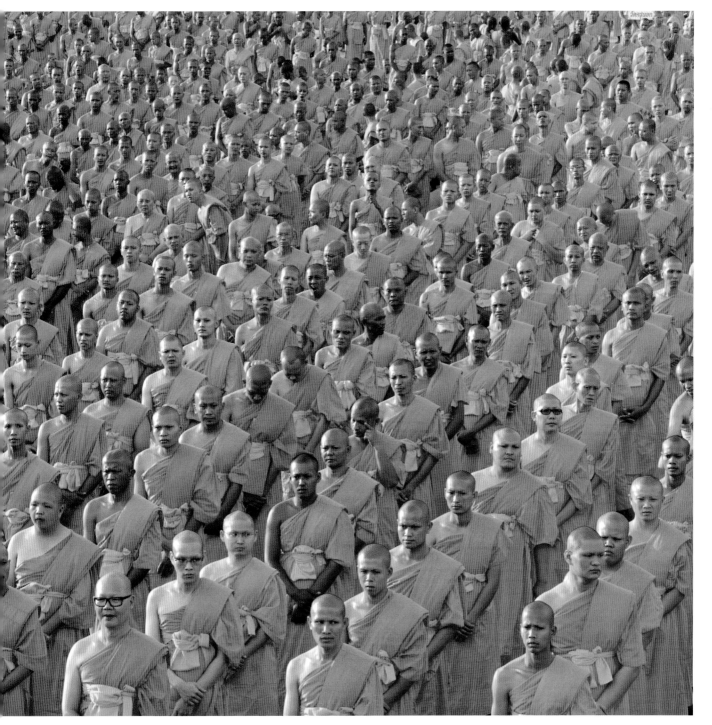

IN A LAND OF MONKS

Throughout Thailand, every morning monks with shaved heads walk through the streets in their bright orange robes, begging bowls in hand to receive alms. Every Thai man is expected to spend some time in a monastery at least once in his lifetime. Even the King has gone begging for alms from house to house. Rich families view it as a great honour if a son enters a monastery. For the poor, being a monk provides a welcome opportunity for upward mobility. In Thailand there are over 30,000 monastic establishments and about 450,000 monks live in the country, many of whom have taken vows for life. Nuns, however, do not enjoy the same status as their brothers.

Even though their heads are also shaven bald and they are dressed in similar robes, theirs are white ones since white is the colour reserved for non-initiates (ordination is a male privilege in Thailand). Monastic life is simple: abstinence and meditation, with each day usually spent reading learned writings and working in the temple. A monk is not permitted to own more than his robes, his begging bowl and a few personal effects. His public duties consist in officiating at birth ceremonies as well as weddings and funerals, organising religious festivals and teaching in rural regions – the monk must be seen as an integral part of life in Thailand.

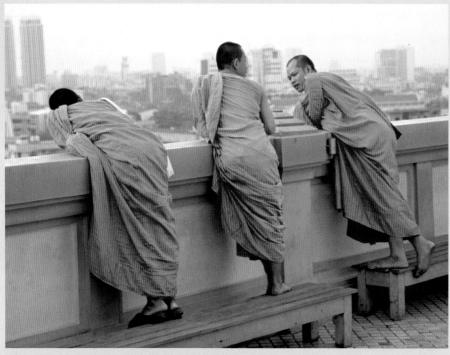

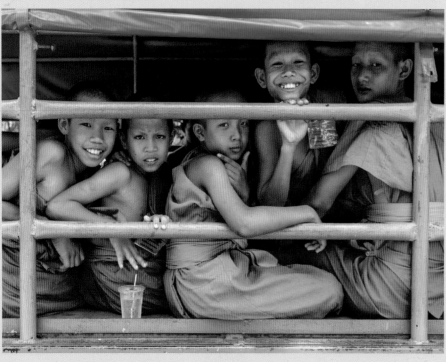

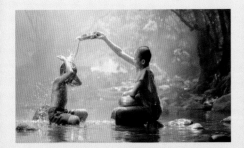

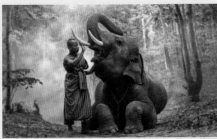

Thai monks also obey the rule "ora et labora" – "pray and work", engaging in hands-on manual labour and crafts but such worldly pleasures as taking snapshots with a mobile phone are not prohibited. "Temple boys" learn to pray but they also learn how to read and write: Compulsory for all: a round of alms.

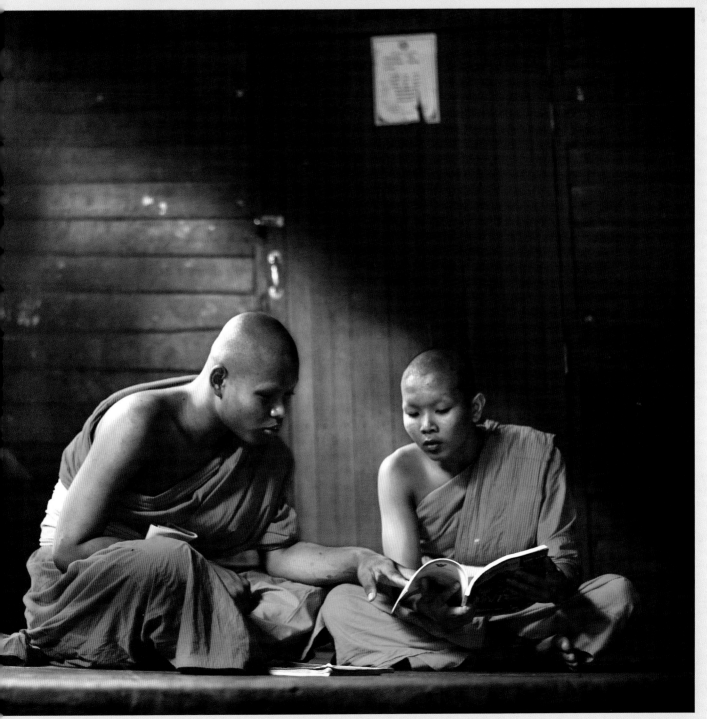

AYUTTHAYA

The second capital of the Kingdom of Siam was founded in 1350 by King U-Thong (Thibodi I) on the east bank of the Chao Phraya. Now it is a magnificent open-air museum of Buddhist civilisation. Monastic establishments, chedis, prangs (the Thai version of Khmer temple towers) and an array of monumental sculpture attest to its former glory. In its heyday, "The Invincible" – the translation of the place name Ayutthaya – was a cosmopolitan city with a population of at least a million, boasting 375 monasteries and temples, 94 city gates and 29 fortresses. The city was not as invulnerable as it thought, however: in 1767 it fell to an assault mounted by the Burmese. Up to then, for more than four centuries, Ayutthaya under 33 reigns had been the political and cultural center of a kingdom that had succeeded to the spectacular legacy of Angkor.

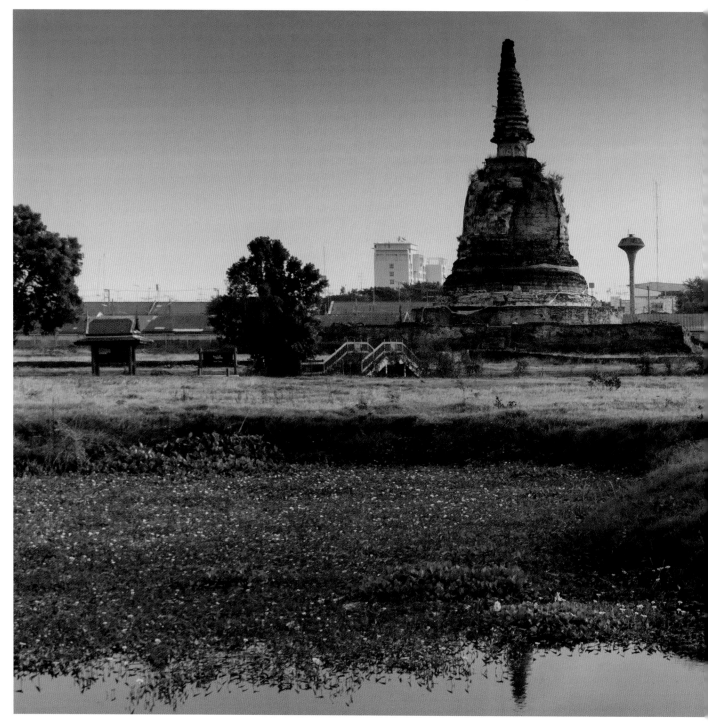

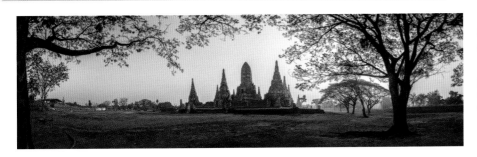

Opened in 1956, the old royal town has belonged to the UNESCO World Cultural Heritage since 1991, with whose help the restoration takes place. The most important monuments are now gathered in the historical center of the ruins. The Wat Yai Chai Mongkon temple (or: Mongkol, left) is one of the holiest places of ancient Thailand. From a distance you can see the great chedi.

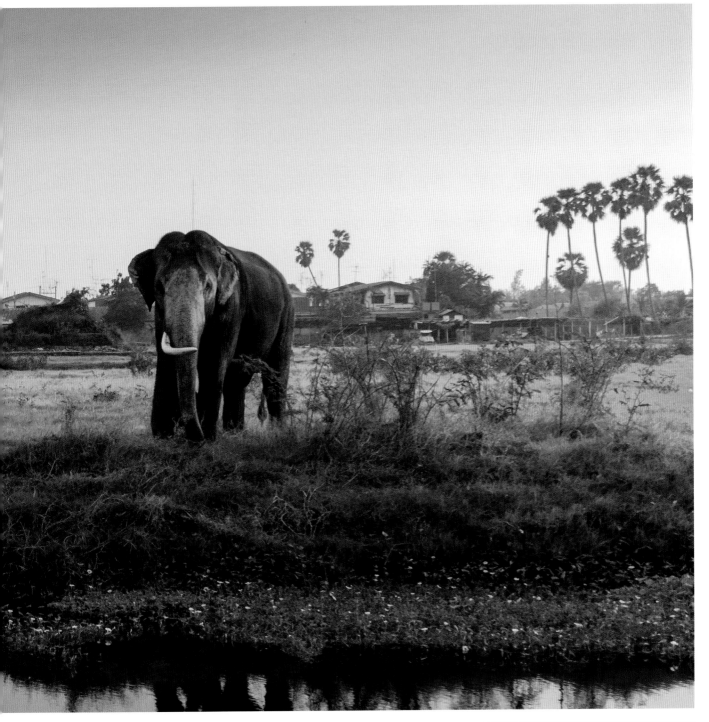

Like Asian copies of the Leaning Tower of Pisa, the ruins of the temples of the Wat Mahathat ("Temple of the Great and Holy Relic") also lean to one side. The soft foundation gives way under the weight of the heavy red stones. In any case, the floor of this almost 700-year-old temple is legendary.

Riches are buried in the temples and Buddhist statues, so many that a whole kingdom could be built from them. These stories were fueled by a find dating back to 1956, when a treasure chest with precious stones and golden images of God appeared. It can be seen today in the National Museum in Ayutthaya.

The towers of the temples were once gilded. They survived the wars with the Burmese, but not the challenges of the weather and old age, and so they collapsed in 1911.

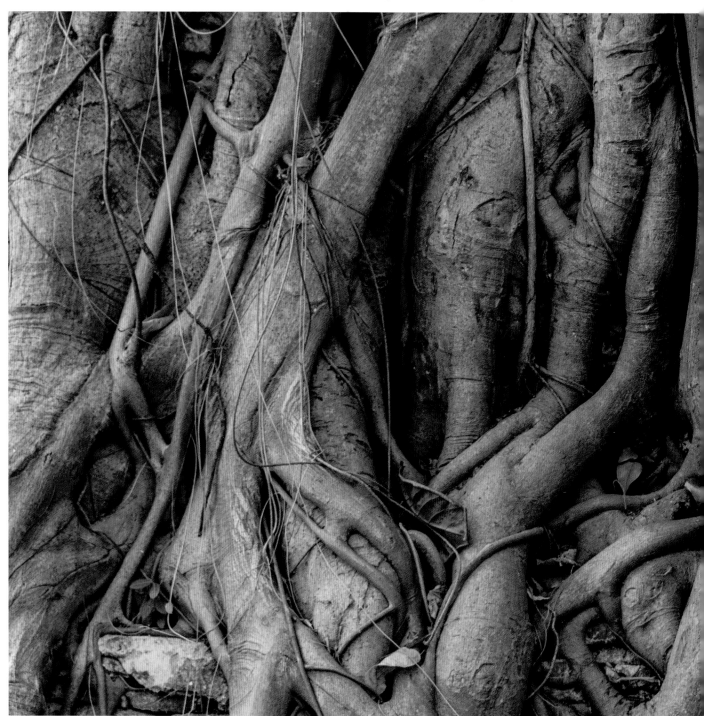

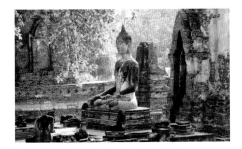

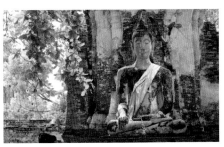

The most famous sight of the Wat Mahathat temple complex is the Banyan fig tree, which features the head of a Buddha tighly bound by the roots of the tree (below). Legend has it that the head was once buried, but nature brought it back to light with the roots. Many of the statues have lost their heads, but some are still preserved today (pictures on the left).

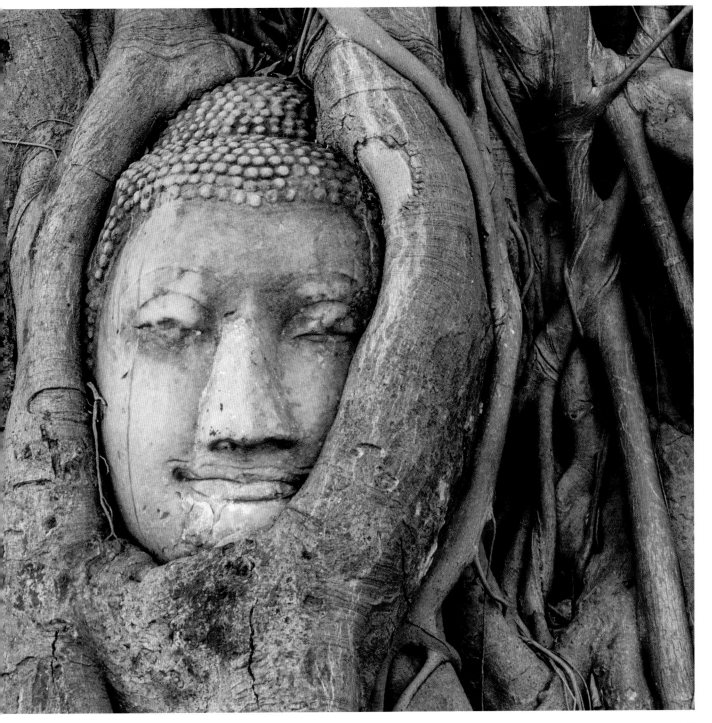

WEST THAILAND

The west of Thailand contains many stories, both tragic and mystical. The bridge over the river Kwai is famous for its gruesome origins.

In the temples one can find stories of saints and miraculous people, or astonishingly long Naga sculptures, which lead to the temples as a tunnel. Close by are unique natural experiences, whether in the caves of Wat Ban Tham or the Erawan National Park.

Most of the cities of west Thailand also feature fascinating exotic markets on the rivers or even on railroad tracks.

Water and marsh landscapes characterize large parts of west Thailand. Particularly beautiful colour variations can be seen at sunrise, just as they can be seen in Kanchanaburi, the city with the tragically famous "Bridge over the River Kwai".

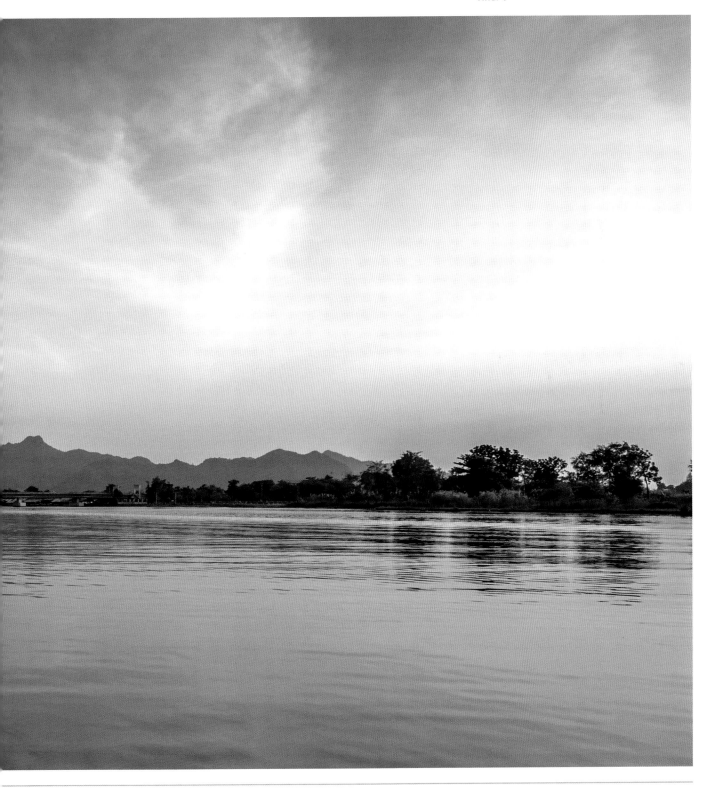

WAT THAM KHAO NOI AND WAT THAM SUA

Caves have always fascinated mankind with their rock formations, light shows and as that it can be used as a refuge. In the Kanchanaburi region, the caves gave people inspiration for special, religious buildings: The path to the monastery leads through a snake mouth, a Naga statue, a popular guardian of sacred sites.

The loud sound of mantra singing through big loudspeakers and the smell of incense hangs in the air. The Buddhist monastery has many Chinese influences, which are reflected in the expressive colour choices of the building and the architecture.

The Wat Tham Sua (Tiger Cave Temple) is adjacent. In the 1970s, a monk was meditating in a cave and, according to the legend, it was once inhabited by tigers. The temples were erected above the caves.

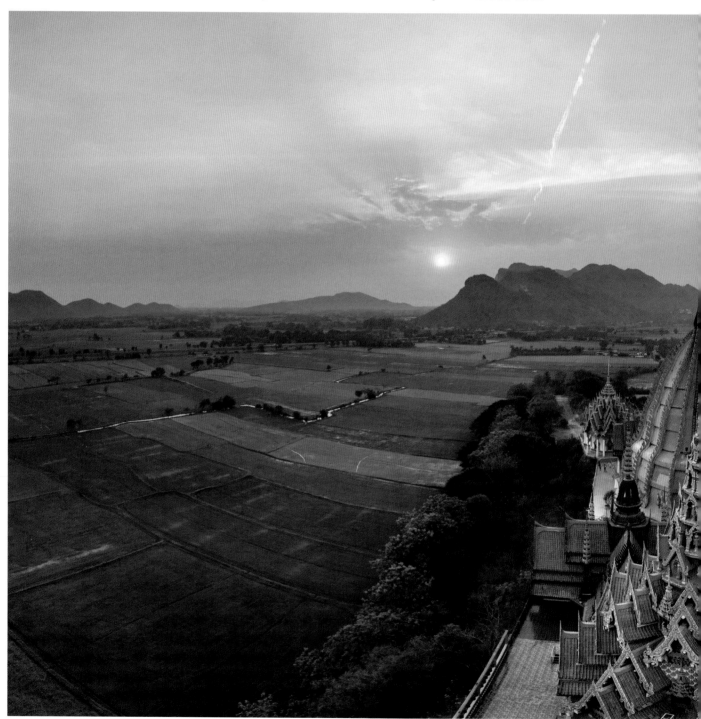

The Golden Buddha (left) is seated at Wat Tham Sua and looks over the landscape. Steps lead up to the top of the mountain from which you can experience a magnificent view of the landscape, especially at sunrise and sunset (Below, a view from the Chinese pagoda of Wat Tham Khao Noi). You can also reach the temple plateau via a small train.

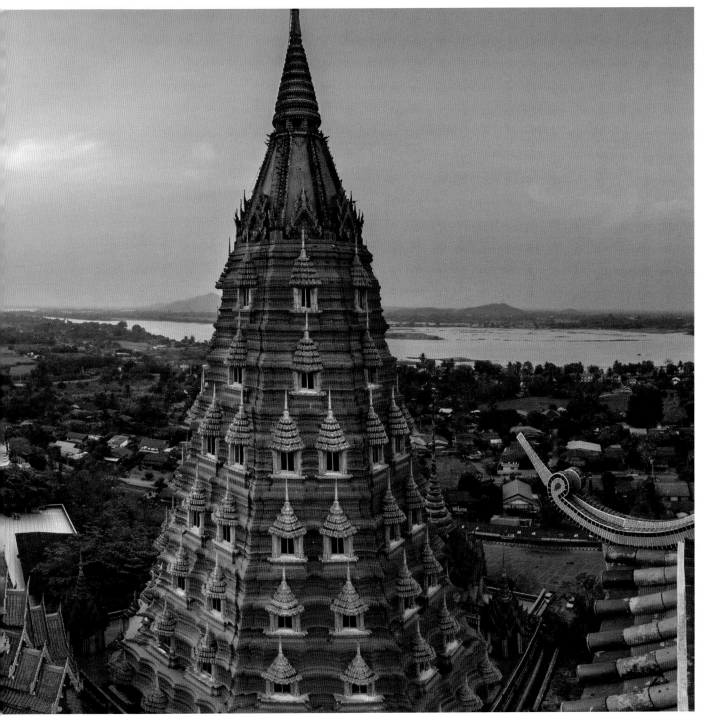

ERAWAN NATIONAL PARK

Elephants often stimulate the imagination, especially in Thailand, where they occur in many myths. According to legend, Erawan is a huge elephant with many heads, and each head is equipped with seven tusks. On it rides the Indian god of thunder and rain, Indra. The waterfall is named after the many-headed elephant, which is located in the Kanchanaburi province. The seven level waterfall is also the main attraction of the national park which features the same name.

It forms beautiful and small nature pools, in which tourists like to swim. Over time the rocks over which the water flows, have been slowly washed and offer the perfect place for a little natural wellness. Not only is the water an attraction of the park, but the park also features interesting caves.

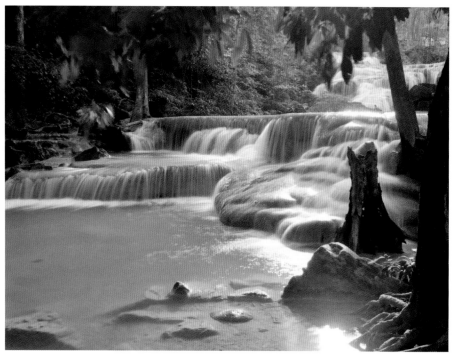

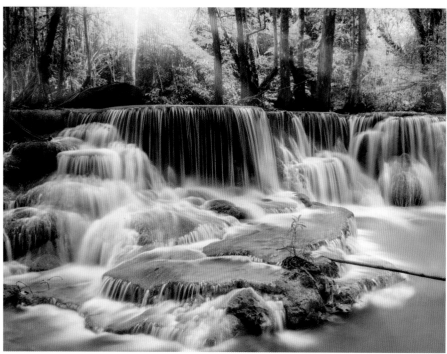

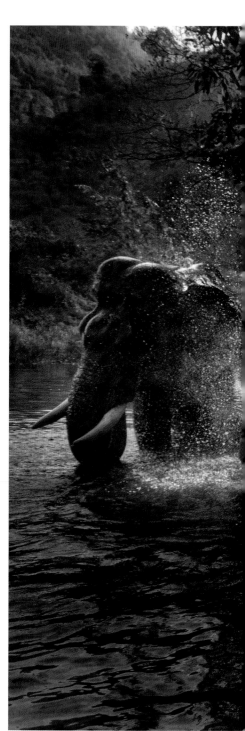

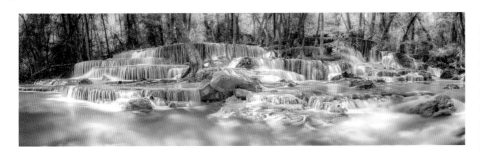

Not only the elephants from the Hindu mythology, but also incarnate grey giants are among the inhabitants of the national park.
It is an impressive sight when they are led to have a dip in the waterfalls and using their trunks treat themselves to a shower (below).
In many of the cascades you can be a human guest and enjoy an ice cold bath.

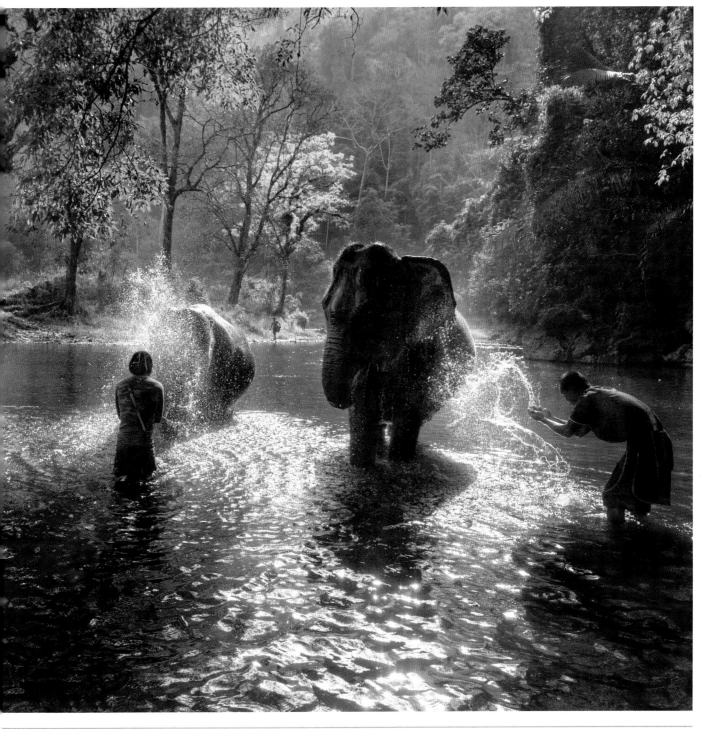

DAMNOEN SADUAK

At dawn the first long boats rush through the green-brown water of the canal, some of which are so fully loaded with pumpkins, melons or coconuts, which make you wonder how they manage to stay afloat.

Somewhere midway between the quantities of mangoes, corn on the cob or nuts, there are women sitting in a blue tunic and a wide straw hat. They spend the whole day under the bright sun and sell their goods. The Damnoen Saduak floating market is, however, no longer a secret. But those who come early in the morning can still observe the originality of these water markets. At that time of the day the spicy scent of the food stalls fills the air and the boats and their cargo offer a colourful sight. Tourists are welcome to go across the canal in small boats.

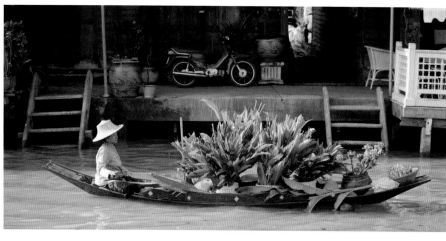

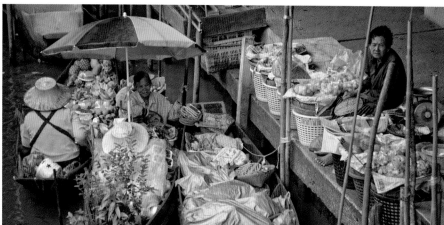

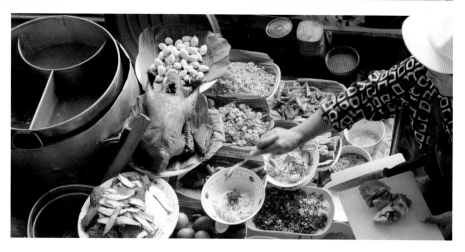

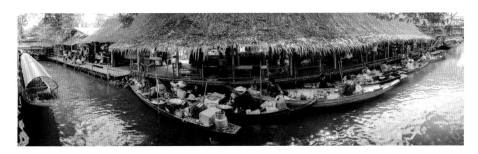

If you want to try exotic fruits or specialties from the food stalls, the floating market is the perfect place. It has existed for more than 100 years and allows farmers with fertile fields to sell their produce. The small tourist boats stop every now and then at stalls selling not only fruit, but also souvenirs.

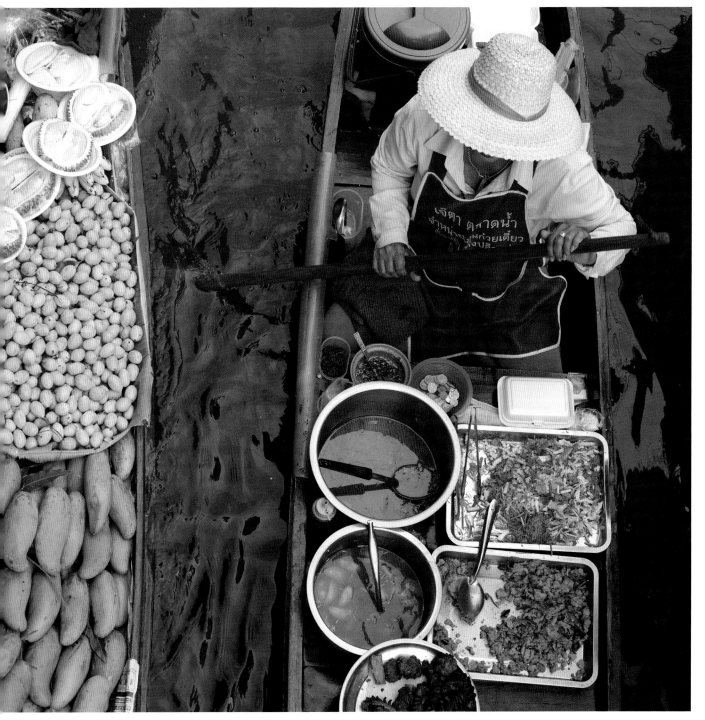

THAI CUISINE: (SPICY HOT) GOURMET DELIGHTS

The Thai cuisine, which uses such a vast variety of fresh ingredients and is rich in vegetables and herbs but virtually fat-free, is one of the world's healthiest. It is built around rice, the staple commodity which Thais believe possesses "sacred life-giving energy" (khwan). Thai dishes are usually seasoned to taste with traditional fish sauce or various kinds of chili. A meal consists of soup, a curry dish, salad and various sauces. Dessert is usually fruit, exquisitely carved into works of art for the table. The usual drinks are fruit juices and Thai Singha beer. Of course the styles of cookery vary from region to region. Northern Thai cuisine features fresh water fish, hot spiced salads of green papaya and all sorts of vegetables. Curries here are definitely milder than in the south, where the Laotian influence is unmistakable. The central regions have made the international reputation of the Thai cuisine. Here rice is served steamed. Fish and meat are seasoned with garlic, black pepper, coriander, ginger and lemon grass. In southern Thai cooking the coconut plays a major role: its mild milk makes soups and curries less hot. Seafood such as saltwater fish, prawns, lobster and shellfish are big here. The Indian and Indonesian influences are strong in the south. Many visitors not only enjoy Thai cuisine but take away tasty and healthy eating habits when they leave.

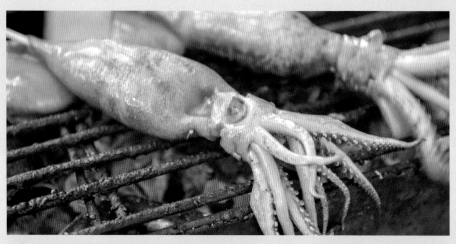

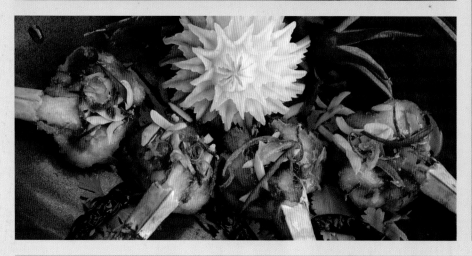

THAI CUISINE: (SPICY HOT) GOURMET DELIGHTS

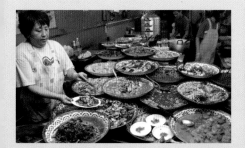

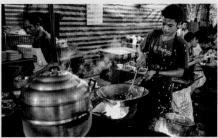

The freshness of the ingredients is important for the quality of the Thai cuisine. At the markets, the restaurant's chefs are looking for current offers and can also be inspired by the food stalls (pictures on the left). Seafood such as cuttlefish and prawns (picture strip above and below) are often on the menu, as is pork with noodles and bean sprouts (below).

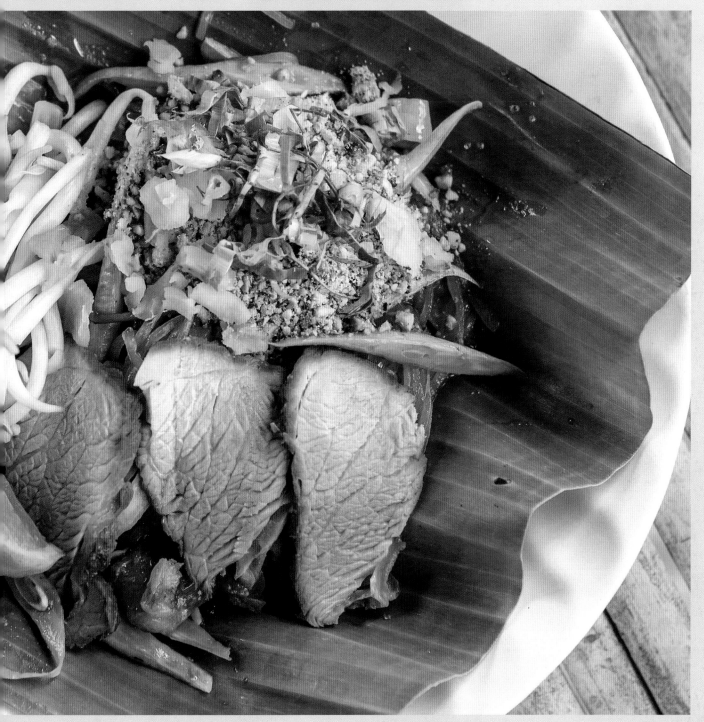

THAM KHAO LUANG

Sometimes the rays of sun playfully whirl through the room, dance on statues or form into bright corridors, in which the dust catches. Such a spectacle can be seen almost daily in the Tham Khao Luang Cave.

The many incense sticks that are ignited here make the bundle of light visible through a circular opening in the ceiling. The temple cave has been venerated for centuries, and high ranking monks were buried here. It is a perfect environment for silence and devotion, as several natural domes have formed in the dripstone cave.

Urns or Buddha statues stand in many niches of the Tham Khao Luang Cave. The statue of a "Ruesi", who as a healer most likely discovered herbal medicine and also acupuncture, is worth visiting.

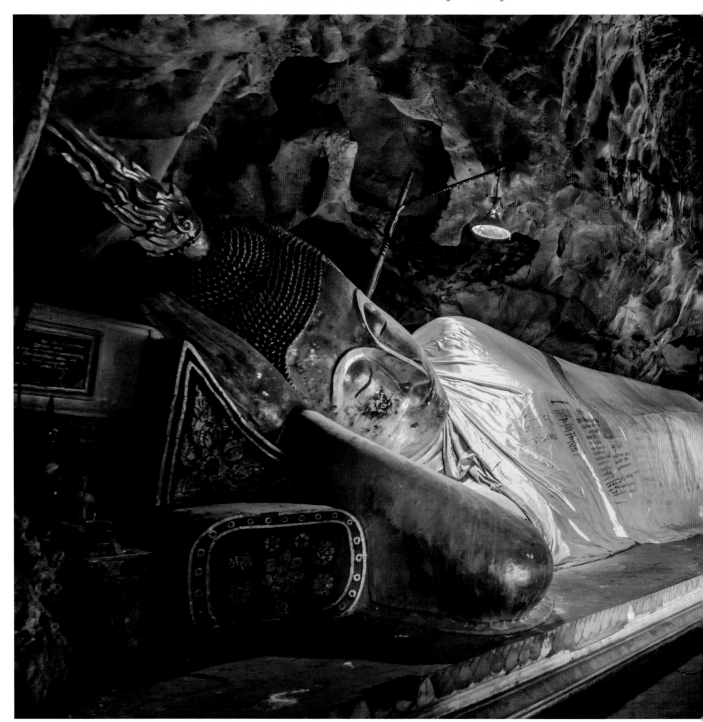

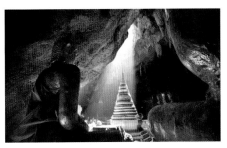

The lying golden Buddha is 15 metres high and is one of the main features of the cave (below). Although the statue of the Buddha is spectacular, the view into the small corners of the cave are also amazing. The seer, the "Ruesi," who is said to have lived here, is also said to have promoted Thai massage and the art of tattooing.

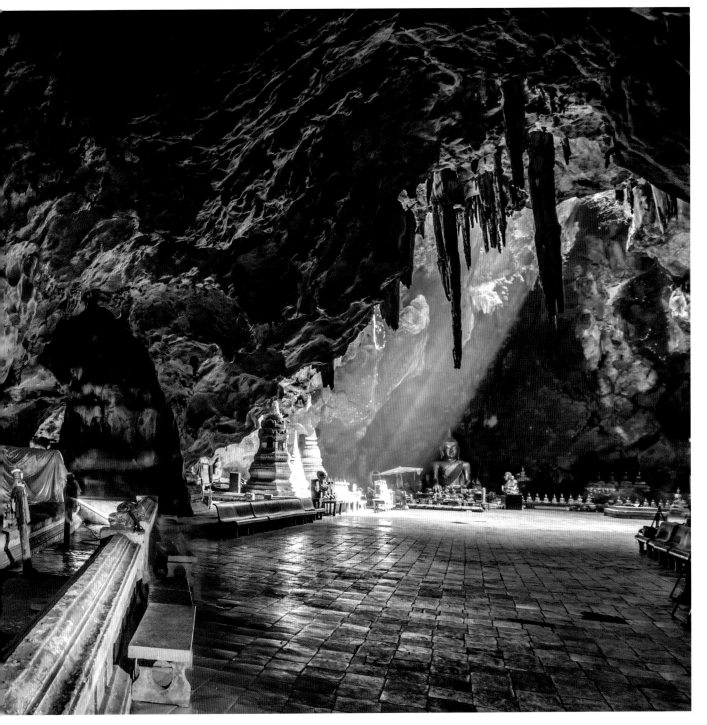

KHAO SAM ROI YOT NATIONAL PARK

"A mountain with 300 peaks" – this is the name of the area, which was declared as protected in 1966. Remarkable for the time was that it also protected coastal and marine areas.

The name makes a good impression on the landscape, which is a rugged Karst mountain range. Here you can find some extraordinary caves, such as the Phraya Nakhon Cave, which due to its vastness is rather like a canyon.

Their greatness and the play of the sunlight fascinated Thailand's kings in the 19th century. Outside the caves, the park offers spectacular excursions for ornithologists because not only the white-bellied sea eagle is located here, but also many storks and herons.

The marsh landscape, on the other hand, is still threatened today, as shrimp farmers in this region find an optimal terrain for breeding.

The light in the Phraya Nakhon Cave is truly divine, in which the Sala Kuha Karuhas, a pavilion open on all sides, was erected (right). It was built in 1890 to honour King Chulalongkorn.

KHAO SAM ROI YOT NATIONAL PARK: BUENG BUA

Long wooden bridges lead along and through the center: the Bueng Bua swamp landscape of the Khao Sam Roi Yot National Park is gigantic, about 37 square kilometres. Due to the large number of water lilies growing here, the marsh landscape is also known as a "Lotus Swamp". You can reach the middle of the swamp landscape on the wooden bridges, but a more idyllic trip can be taken on a wooden canal along the water covered by reeds and seaweed.

Particularly in the months of August and September, birds make their home in the park but all year round there are also cormorants and other seabirds, which are located in the fishing area of Bueng Bua.

The Lotus Swamp landscape is the largest of its kind in Thailand and offers especially at the blue hour, lighting effects that resemble painted watercolours. The hinterland of the national park is home to primates such as dusky leaf monkeys or loris, as well as turtles and small predator species.

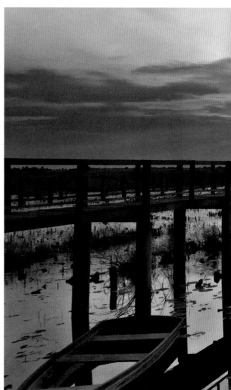

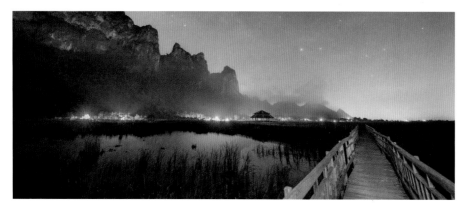

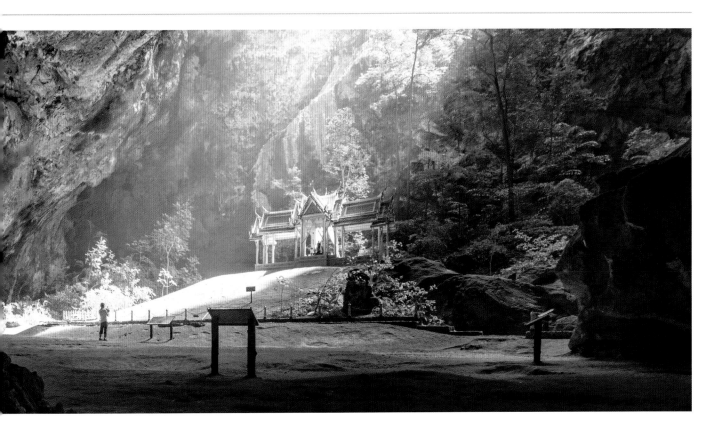

KHAO SAM ROI YOT NATIONAL PARK: BUENG BUA

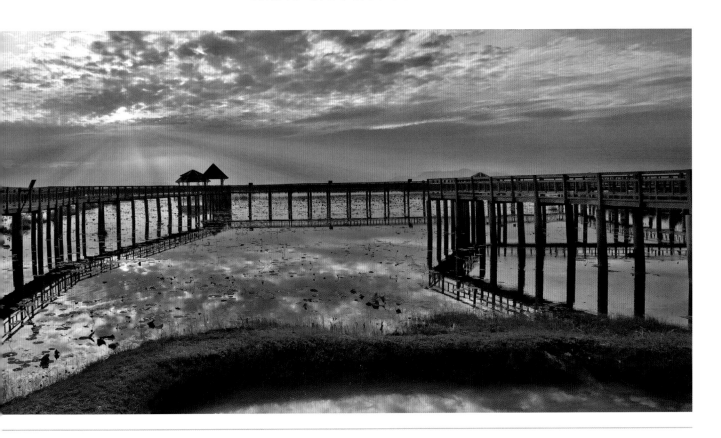

WAT THAMMIKARAM

The Wat is located at the summit of Khao Chong Krachok. You need to climb round 400 steps to reach it, but whoever climbs it will not be alone because the mounain is home to a hoard of monkeys. They sometimes even steal things directly from visitors pockets.

The mountain that the visitors climb is right on the Gulf of Thailand and offers a magnificent view of the countries coves and beaches. The small, out-lying islands look as if they were thrown out from here and the long bridges lead directly into the sea in most places. It is an optimal location to seek out the most beautiful beach for later!

The Wat appears very modern with many of its details, but it was originally built in 1922. The pavilions with the column-supported rooms look very light and open and allows everyday life to pause for a short moment.

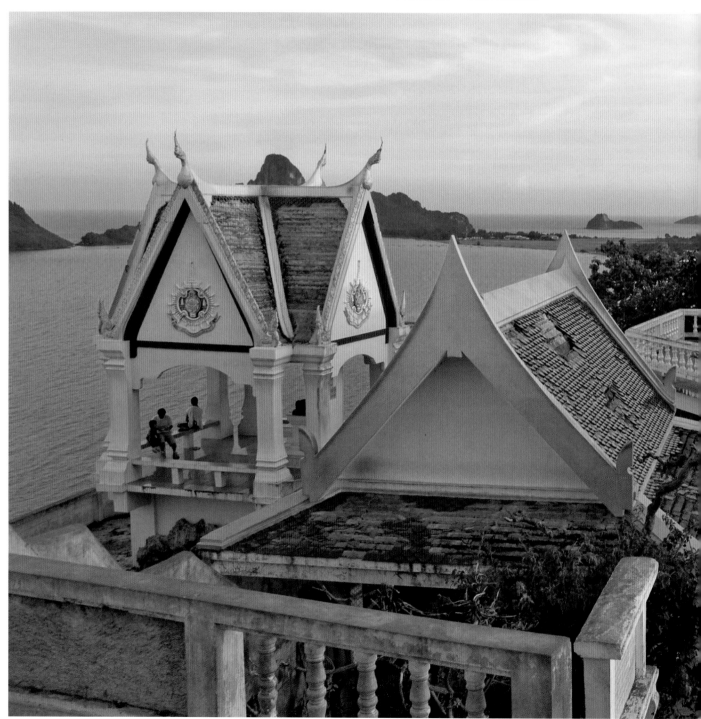

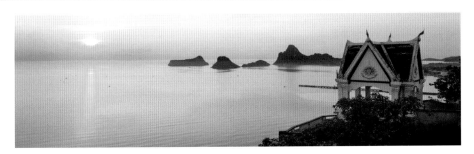

With its flowering trees in the surrounding temple grounds, the Wat is particularly worth visiting in the spring, when the air is filled with scent of blooming flowers (below).
From up here, the sunrise and view are especially lovely (left). Whoever has climbed the 396 steps to the top can make a souvenir and take a memorial photo in front of a large sign that confirms the number of stairs that have been climbed.

SOUTH THAILAND

The south of Thailand is something of a dream for sunbathers and those who are fans of the beach. Almost white sand, clear water and a breathtaking landscape, have lured visitors to the region around Phuket, Krabi or to the national parks along the Malaysian border for decades. The lime-green limestone rocks, which protrude vertically from the water, are amazing especially early in the morning or during sunset. For those who want to, you can enjoy a lovely stretch of beach all to yourself. To get there you sometimes have to take a bit of a hike, but the effort is worth it in the end.

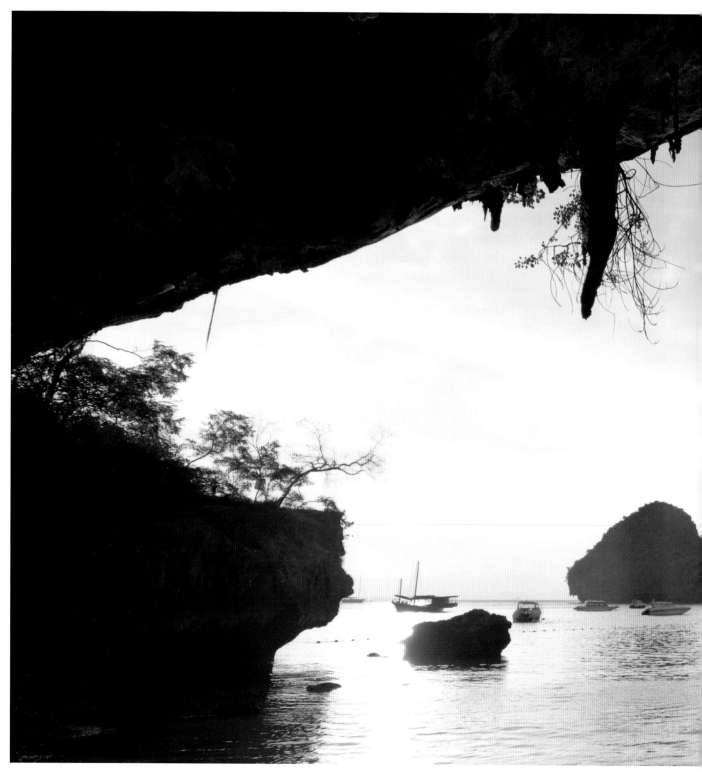

One of the most beautiful beaches in the whole country is located on the Railay peninsula. The view from the small cave temple over the bay is especially at sunset one of the most romantic places of southern Thailand.

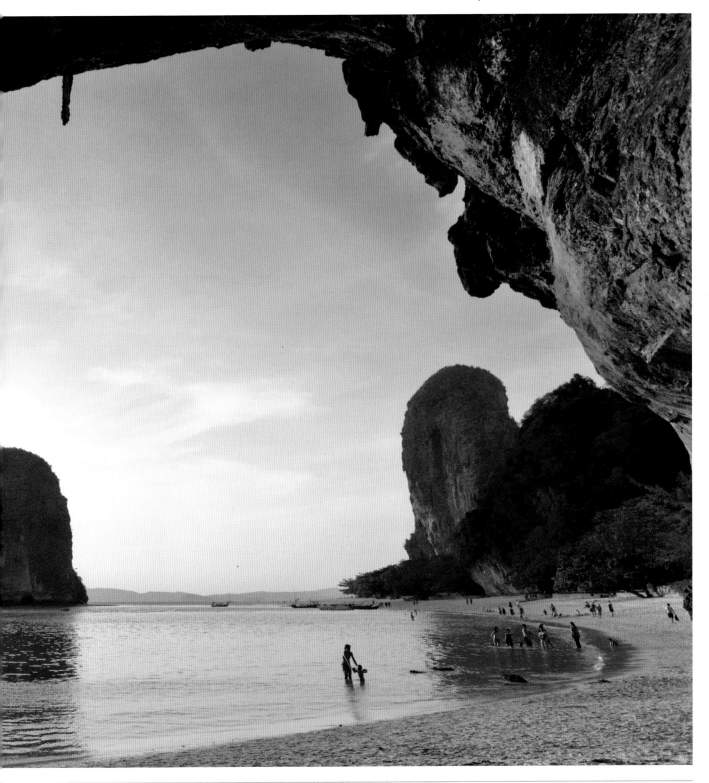

MU KO ANG THONG NATIONAL PARK

Its largely untouched beauty is due to the fact that the National Marine Park, which is approximately 40 square kilometres in total, covers around 40 square kilometres of land, and was a military restricted area until 1980. From Ko Samui there is a ferry connection to the main island of Ko Wua Talab. Panthers, monkeys, sea otters and snakes live in the island's forests. From a 400 metre high vantage point you can enjoy a breathtaking view of the neighbouring island of Ko Mae Ko, on which a crystal clear salt water lake (Thale Noi) is fed by an underground inflow from the sea.

Ko Sam Sao, a smaller island east of Ko Mae Ko, is famous for the richness in fish of its coral reefs. There is also a well-known anchorage for diveboats.

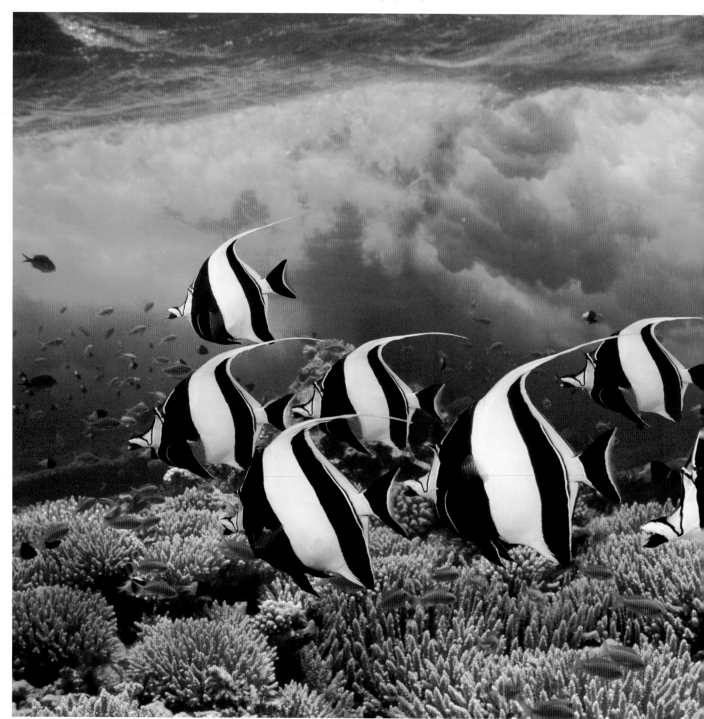

Nature's Adventure – in the Mu Ko Ang Thong National Park there is a fascinating underwater world. Here you can find banner fish (below), which are noticeable by their black, white and yellow striped colour. From the mountain on the main island of Ko Wua Talap you can experience breathtaking views of the surrounding islands (far left).

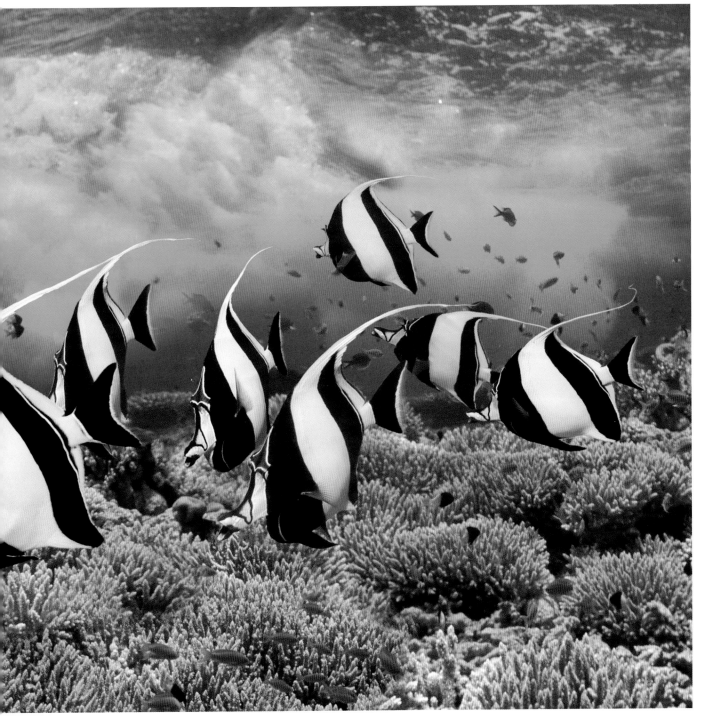

Diving fans have known of Ko Tao for a long time. The island offers perhaps the most spectacular dive sites in all of Thailand, which is why their infrastructure is tailoured especially to their guests.

The over 60 kilometre journey by boat to Ko Samui is neither short nor very comfortable. Ko Tao is very popular with backpackers. They appreciate the relaxed atmosphere on the island.

Ko Tao means "Turtle Island", even though the animals had to be relocated only a few years ago. But today the sea turtles are one of the main attractions.

It is almost paradoxical that holidaymakers now appreciate the seclusion of the great tourism on Ko Tao. Between 1933 and 1945, the island was used as a prison due to its great distance from the mainland.

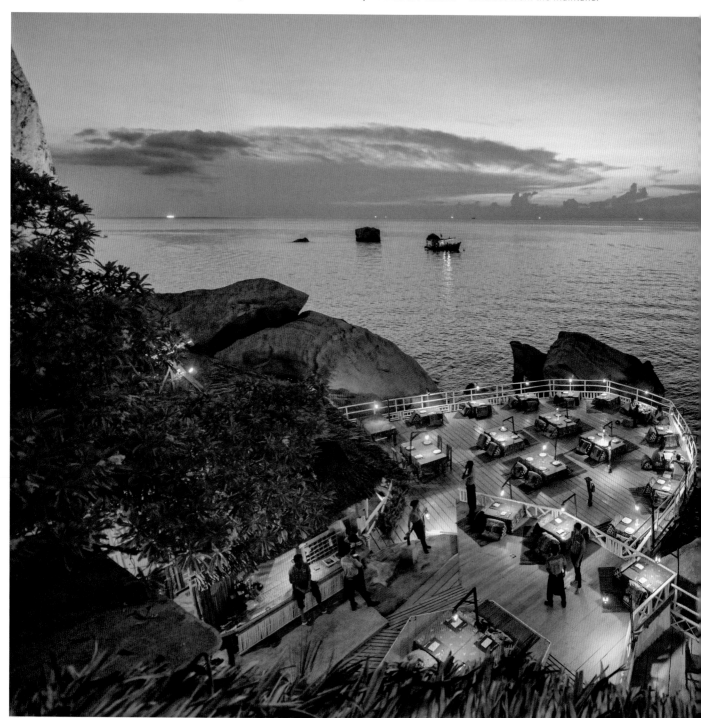

Longtail boats with their characteristic roaring engines connect the beaches and bays on the island of Ko Tao. Over the years, the facilities and restaurants have become more fashionable and offer spectacular views over the sea (large picture). The Thai people have always had a flair for attention to detail and promoting the wonderful nature of their country.

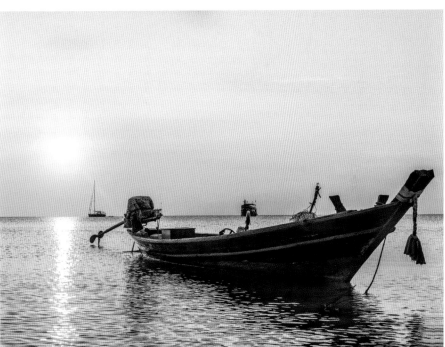

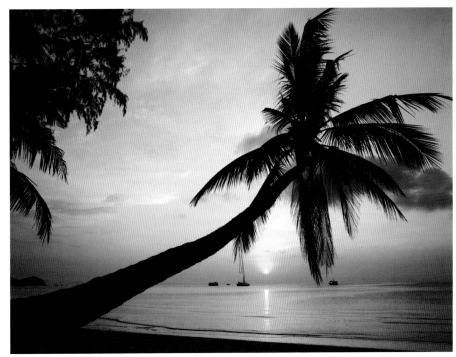

KO SAMUI

A holiday dream come true: kilometres of immaculate white sandy beaches and idyllic coves, crystalline turquoise waters, palms swaying in the warm breezes, rainforest and waterfalls, bizarre cliffs and unspoilt fishing villages make Ko Samui, which, with a surface area of about 247 square kilometres, is Thailand's biggest island after Phuket and Ko Chang, one of the country's top travel destinations.

Sunbathing, swimming, snorkelling and scuba diving are what most of the visitors are looking for who land at the regional airport virtually at the feet of "Big Buddha", who was built in 1972. The ancestors of many of the 31,000 people living on Ko Samui emigrated to Thailand from China almost two centuries ago. They were the ones who planted all the coconut palms but the crops are still harvested by specially trained monkeys.

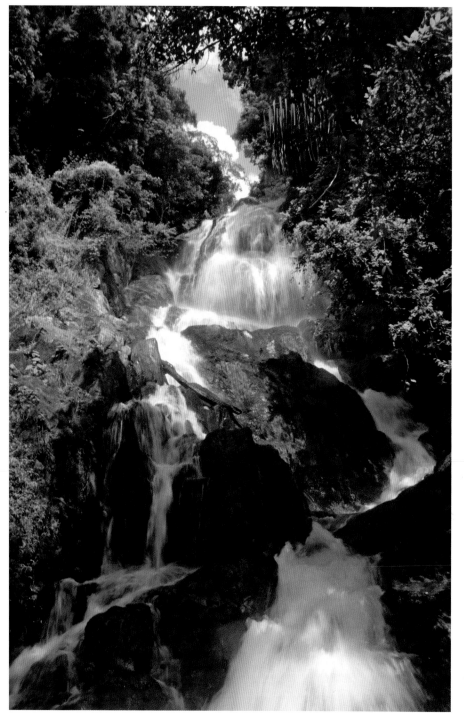

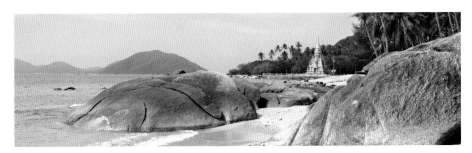

A lovely excursion leads to the Na Muang Waterfalls (below). These cascades are not exceptionally high, but they are very idyllic in the middle of the rainforest and can be reached on foot from the ring road on a two-kilometre walk through the jungle. Left: Laem Sor Chedi is located on a mostly deserted beach in the south of Ko Samui.

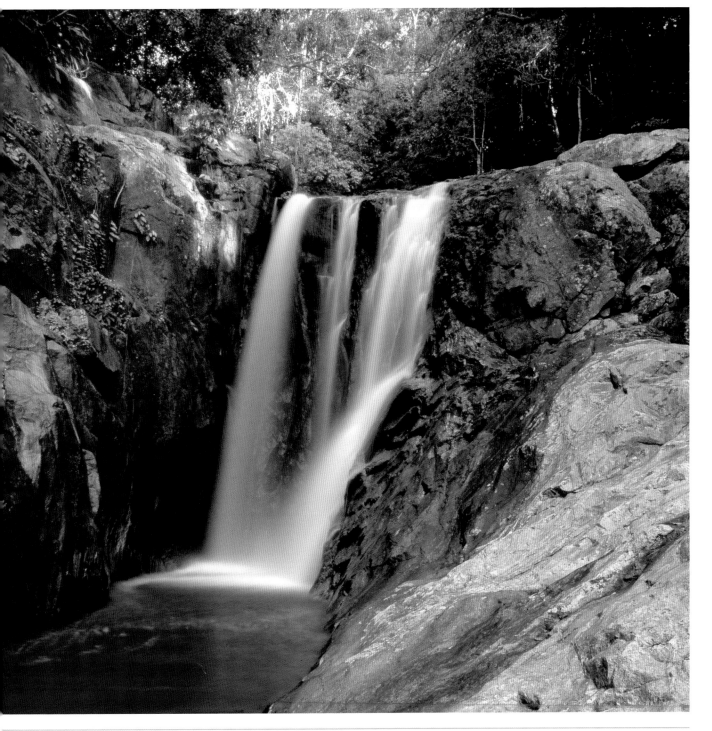

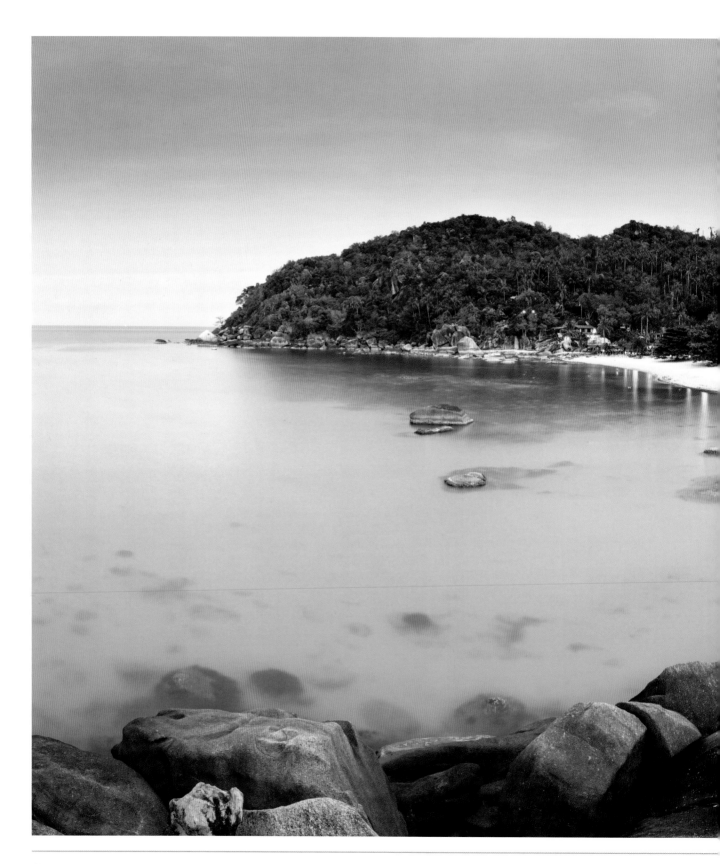

The white sandy beach of Crystal Bay is almost entirely reserved for the inhabitants of the beach resort.

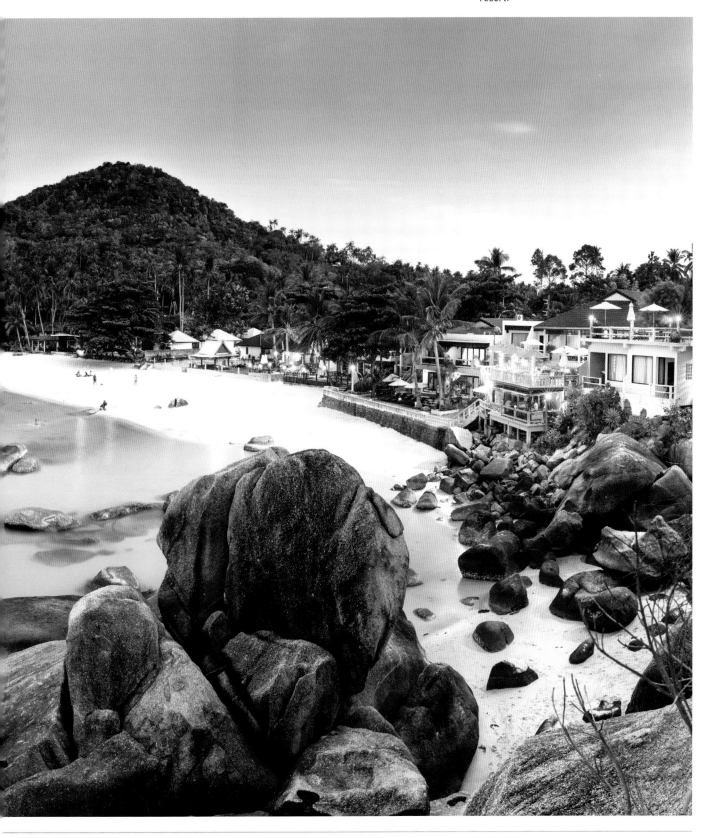

KHAO SOK NATIONAL PARK

You have to be very lucky to see the elephants in this national park or you could experience a great surprise as they cross paths with you.

The national park is one of the most spectacular in southern Thailand. Parts of the park are artificially designed. The Chiao Lan Lake, for example, is twice the size of Lake Chiemsee. What was negative for nature on one hand, but was a blessing for visitors on the other hand is that they can explore the partically inaccessible park via the water.

The nature reserve is located some 70 kilometres northeast of Khao Lak and is also caprivating with its limestone rocks, which rose out from the seabed 60 to 140 million years ago. But those who are lovers of colourful butterflies and metallic iridescent dragonflies originally come to the area and really get their money's worth.

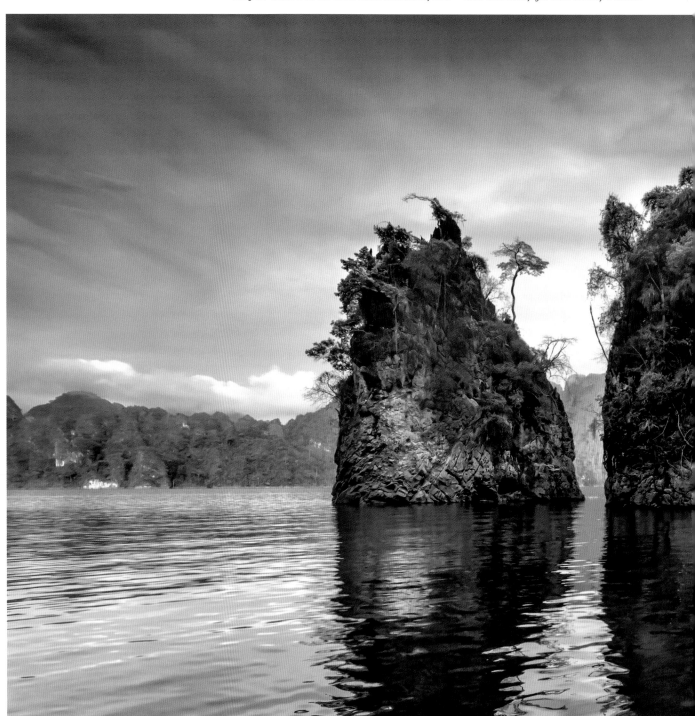

A fairytale atmosphere prevails early in the morning or after heavy rainfall in the Khao Sok National Park. When the mist slowly lifts and the fine structures of the seemingly impenetrable jungle become visible, one of the most beautiful moments of the whole day is created. It is a moment to dream – except that this green magical world is almost tangible.

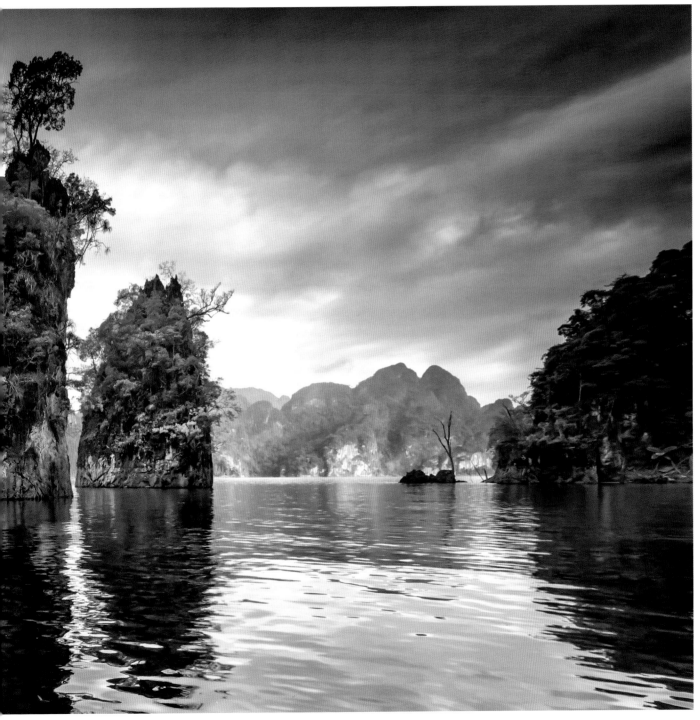

MU KO SIMILAN NATIONAL PARK

Like a pearl necklace with nine beads, the Similan Islands are strung out in the Andaman 70 kilometres off the west coast of Thailand. For the sake of convenience, they have been numbered here from north to south. Together with two other islands they comprise Mu Ko Similan National Park, part of Phang Nga Province. Scuba divers and snorkellers marvel at the spectacular underwater vistas: the water is so clear that you can see down at least 18 to 25 metres and in places even more than 40 metres. The diving grounds to the west of the islands are in the open sea whereas those in the east are fringed with coral reefs. The larger fauna around the Similan Islands includes whale sharks, wobbegongs, grey reef sharks and manta rays. The beaches are fine white sand. Rock formations up to 200 metres high look as they were casually stacked up by a giant's hand.

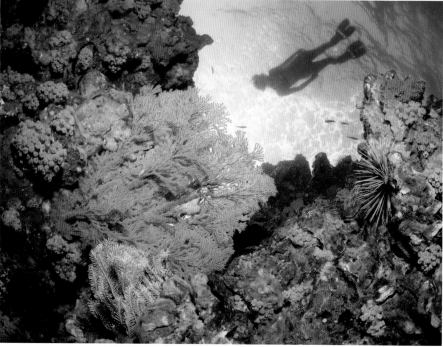

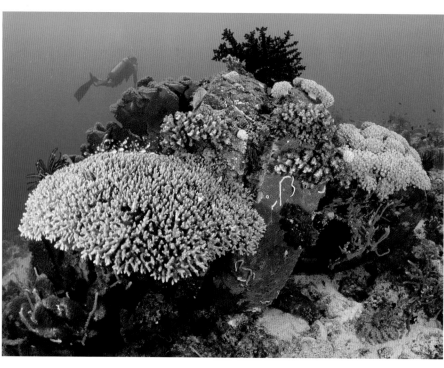

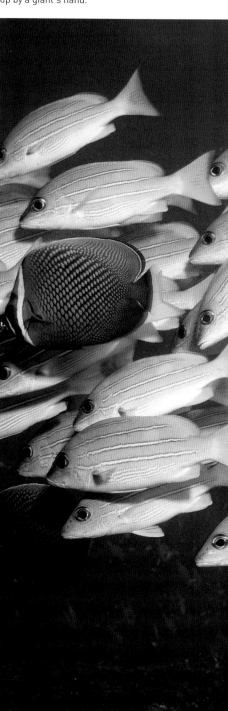

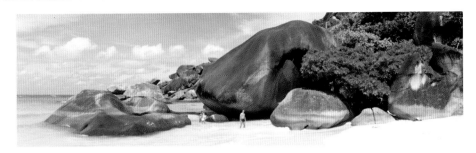

The Similan Islands are the ideal place for a stopover in the underwater world: the dive sites of the Mu Ko Similan National Park are among the best in the world. Snorkellers also are presented with a fascinating underwater panorama (below: blue stripe snapper and redtail butterflyfish). Left: Gigantic granite rocks lie in the bay of Ao Kueak on Ko Similan (Island 8).

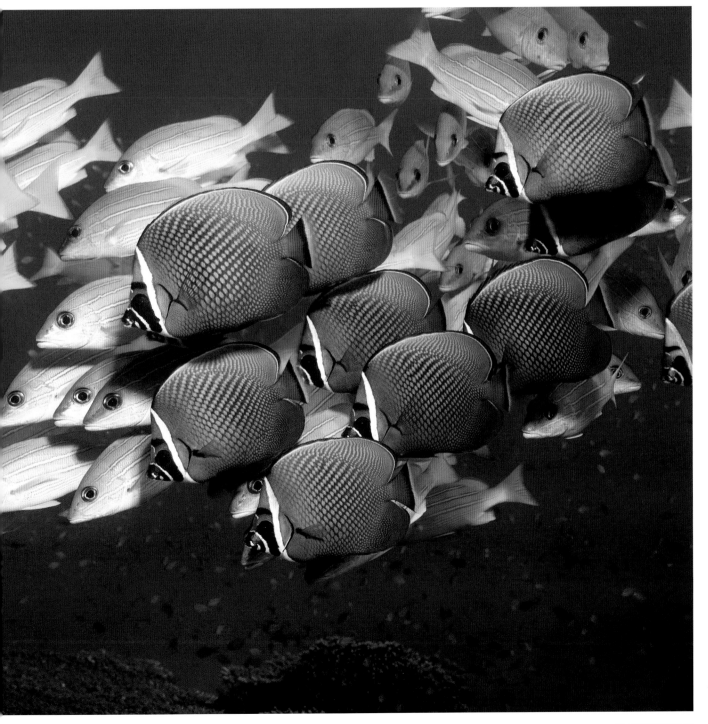

LOCAL SEA NOMADS: LIVING ON, FROM AND IN THE WATER

In Thailand, there are three indigenous peoples, variously known as people of the sea, people of the water or even Sea Gypsies, who spend much of their time roaming the sea: the Moken, the Moklen and the Urak Lawoi, who used to spend most of the year at sea in the boats. They only went ashore for a few months during the rainy season. A UNESCO pilot project has been devoted to the largest of these three peoples, the Moken, to preserve their traditional way of life in a protected area (Surin Islands National Park, Phang Nga Province). Their origins, like the meaning of their name, are obscure. Their nomadic way of life is of course based on boats, which they call "kabang".

The French anthropologist Jacques Ivanoff contends that the boat symbolizes a human body with mouth, anus and various organs. The Moken originally lived mainly from fishing with spears, nets and traps as well as diving for shellfish, sea cucumbers, prawns, sandworms and other forms of seafood. The Moken speak their own language which is reminiscent of Malay and Polynesian dialects. They are also animists who believe in spirits and the spirits of their ancestors.

A three-day festival, Ne-en Lobong, is dedicated to the ancestors' souls: a boat is pushed out into the sea to ward off misfortune, illness and demons.

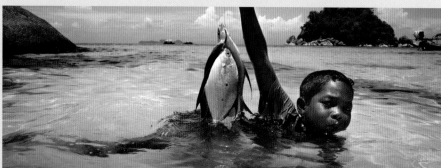

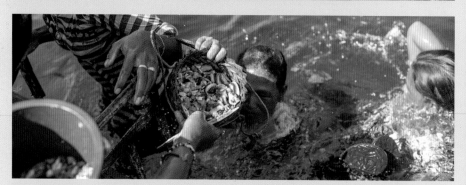

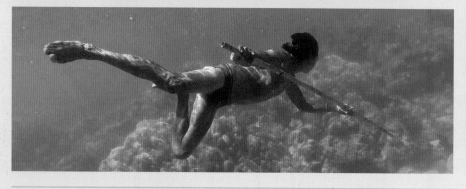

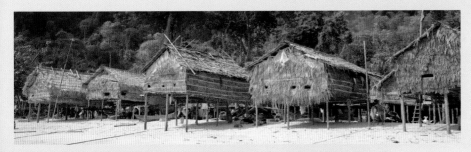

The residential area of the Moken ranges from today's Myanmar in the north over Thailand and Malaysia up to the Indonesian islands in the south. As semi-nomads, they originally lived on land for a few months a year to repair their boats or build new ones. Their swimming and diving skills, which they learn and perfect from childhood, are amazing.

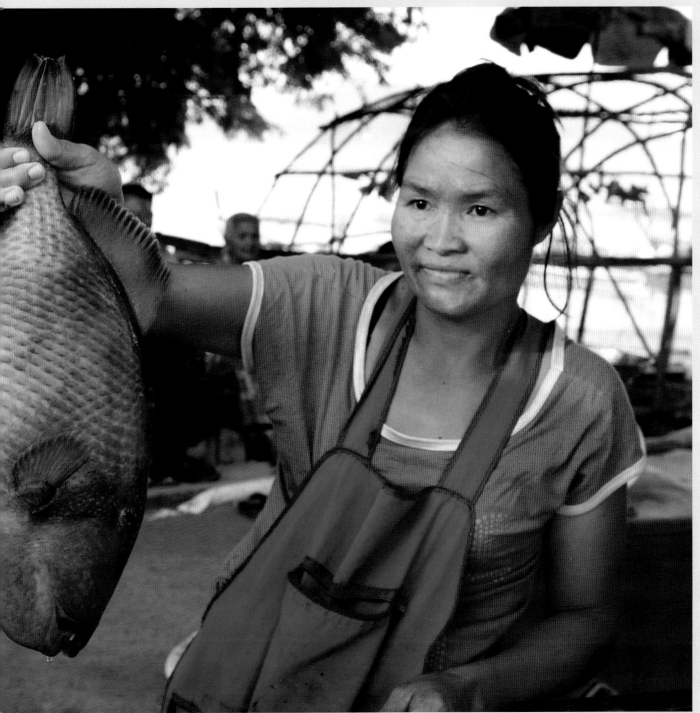

The perfect time for beach runners is at low tide, when the water retreats into the sea. They can look down at the sand and will be fascinated by all that the sea has left behind. But for whose who live here, their thoughts wander back into the recent past.

In 2004, a huge tidal wave swept over the entire beach area near Phuket, partly in the bay of Krabi, but especially in Khao Lak two days after Christmas. Thousands of dead tourists and locals were lost to the sea and the tourist infrastructure was almost completely destroyed.

Even then, the water had retreated far out into the sea, so far that the tourists were fatally fascinated, before the great wave carried them away. Today only the warning signs – and the signposts to the escape routes in the case of a tsunami – bear witness to the catastrophe.

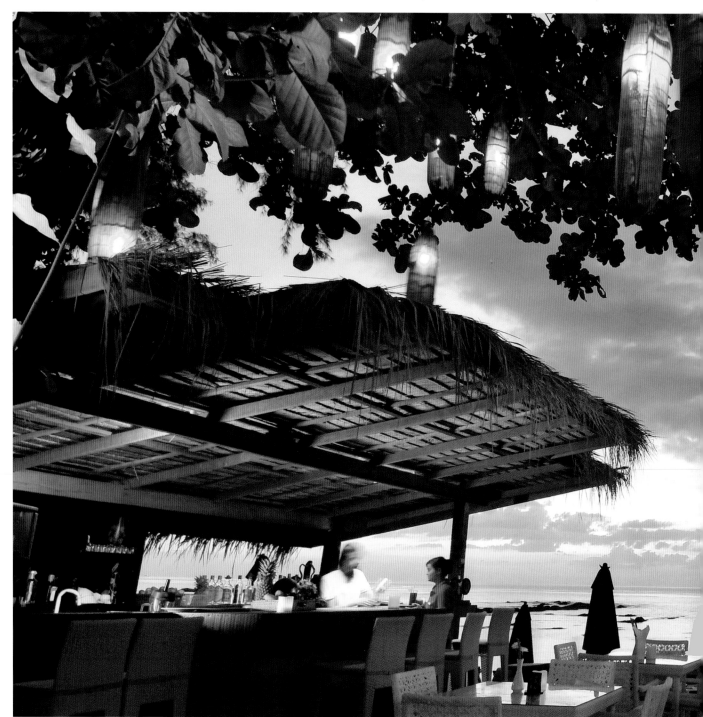

The resort has already been rebuilt, is more luxurious than before and is almost all made of brick. Simple bamboo huts with thatched roofs are something that is now difficult to find in the vicinity of the beach. The sunsets in Khao Lak are still the most beautiful in Thailand – just because the beaches with their many bays are the ideal setting for a dream holiday.

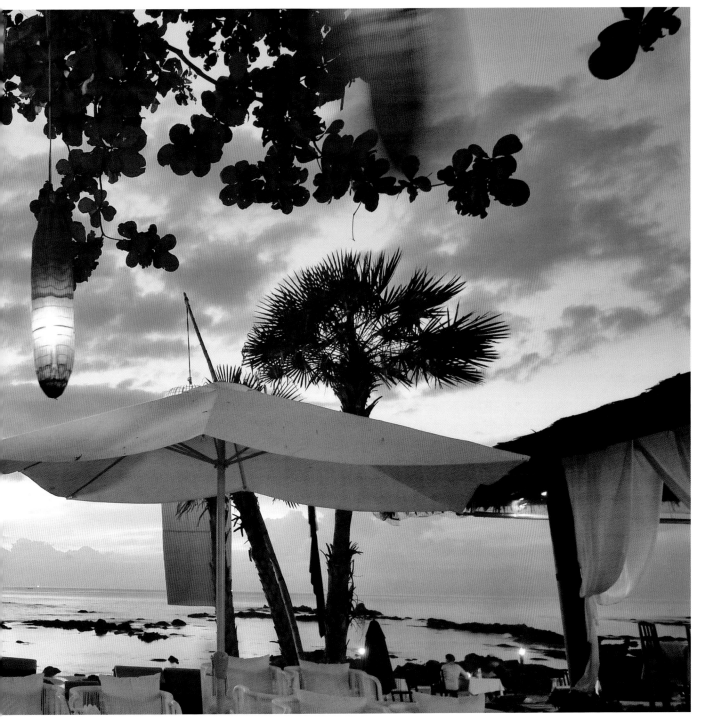

Slowly and carefully, the fishermen take their nets out of the water with the handmade lifting structures. Usually only a few fish are caught in it, but this is part of everyday reality. Whether or not the catch was good on this day will be decided in the evening, as the nets are lifted several times a day from the sea.

The scene is symptomatic of life in the Phang Nga Bay. Life moves a little slower than any- where else. Whether with the sea nomads or on the luxurious sailing yachts that sail through the spectacular bay with its limestone cliffs rising vertically from the water.

More than 100 of the bizarre shaped islets sit in the water, overgrown with lush green bushes and large climbing plants, and inhabited only by monkeys and magnificently colourful tropical birds.

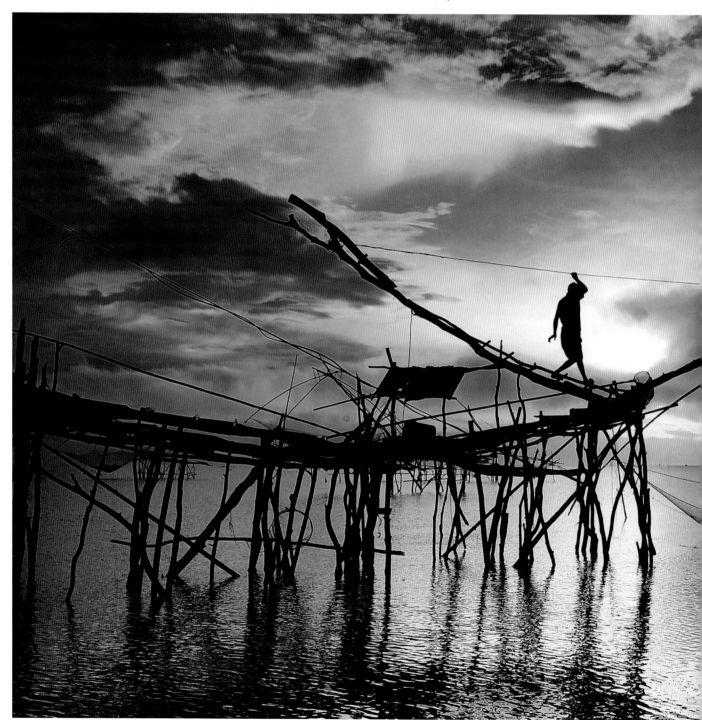

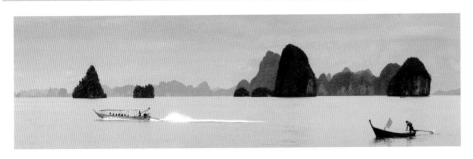

During the day, the rattle of the longtail boats is omnipresent, especially near the most famous islands and the mainland. Day tourists will be taken to the legendary James Bond island, larger ships provide their regular services between Phuket, Krabi and Ko Lanta.
The whole magic of this island world, on the other hand, is only experienced by those who stay until the sun sets.

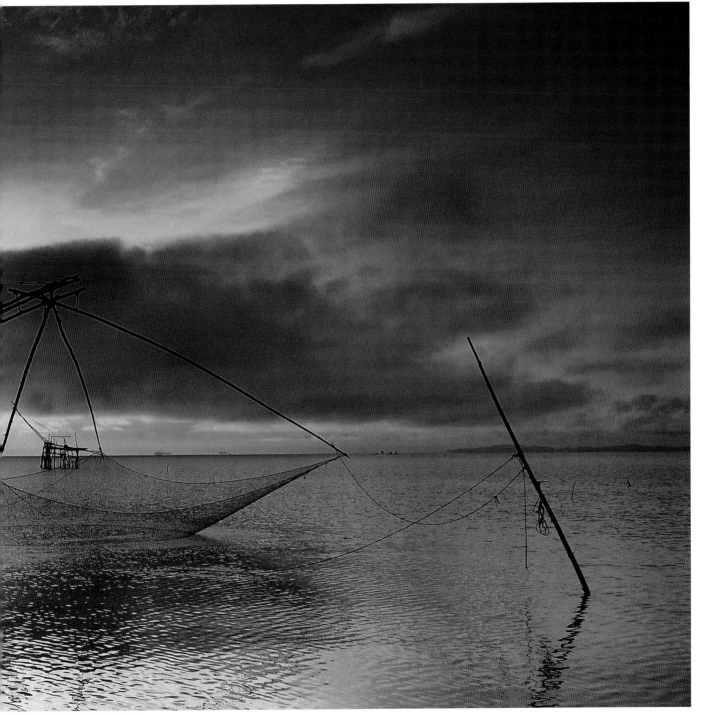

AO PHANG NGA NATIONAL PARK

Like the backs of prehistoric reptiles or dragons, cones and pyramids rear up in Phang Nga Bay. These "monoliths" are the visible tops of limestone reefs that have built up in the Andaman Sea over more than 100 million years and once stretched from northern Malaysia to central China. In 1981 an area covering some 400 square kilometres was designated Ao Phang Nga National Park. One purpose of the park was to protect the mangrove swamps in the northern part of the bay. They are the largest of their kind in Thailand. One of the most famous rock formations is "Nail Island" – as legend has it, it is half of a nail that an irate fisherman kept casting back into the sea when it persisted in reappearing in his net instead of the desired catch. Many of the islands are karst honeycombed with caves, which were probably used as shelter by human beings in prehistoric times.

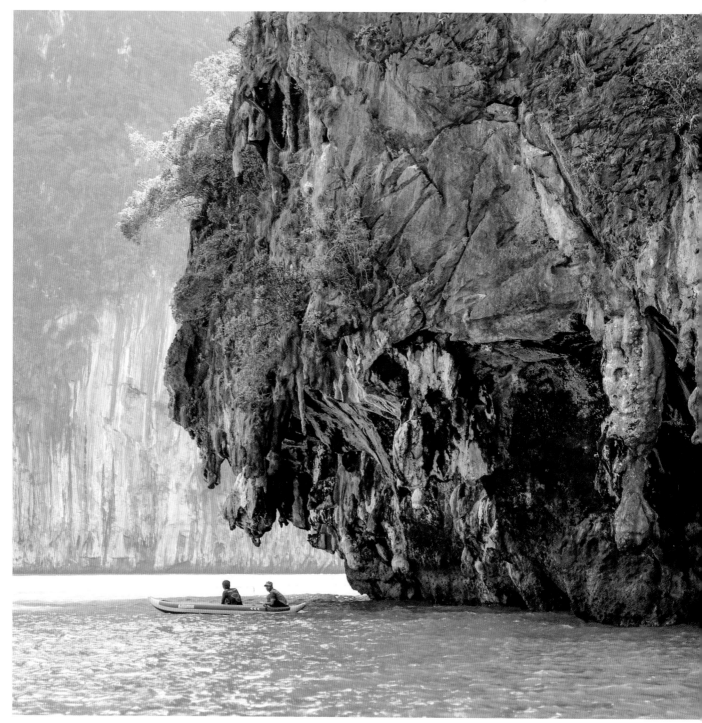

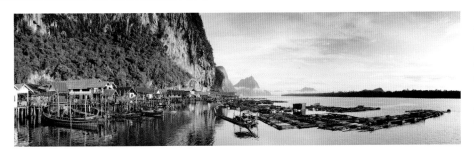

The bay is about 50 kilometres long and 50 kilometres wide and has no dangerous currents, and the river feeds south into the open sea. A magic world of stone can be found in the many limestone caves of Phang Nga Bay, which can be discovered under rock overhangs. The excursions to the inner lagoons of some islands are particularly attractive.

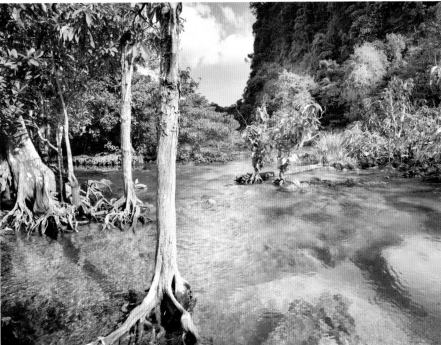

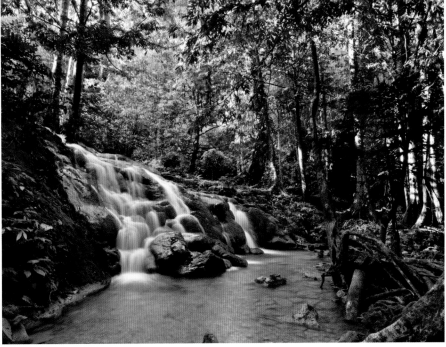

KO PHUKET: PHUKET

After the damage caused by the tsunami in 2004 could be remedied, the island of Phuket, which lies on the west coast of Thailand, is once again the epitome of a vacation paradise. The legendary white sand beaches and picturesque bays attract millions of visitors every year. The island capital is nothing more than a thriving trading center with a population of more than 80,000. The entire tourist infrastructure of the island is managed from it. But also most of the nationwide bus lines lead directly into the city, which is about 700 kilometres from Bangkok. The architecture of the spacious residential and commercial buildings is very interesting as it was modelled on the Portuguese colonial style. They are characterized by thick walls and high ceilings to prevent heat. It is a building style that is rarely found in Thailand.

The food at the night markets is particularly appealing. The food is authentic, but above all varied, the ingredients are often different and the spiciness is sometimes a real challenge for Western palates.

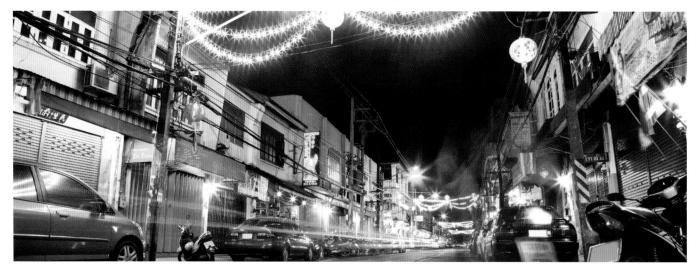

NINE EMPEROR GODS FESTIVAL

The "Nine Emperor Gods Festival" is not for the sophisticated. When people run over glowing coals, stick the tips of paper umbrellas through their cheeks or they injure their faces with knives, these are exceptions in the town of Phuket. The tortures are meant to cleanse the body, bring luck, or at least evade evil – that is what they hope anyway.

For the first time, the religious festival was celebrated in China in 1825 and is still celebrated today, where a great many Chinese people live. Not only pain, but also renunciation are connected to this. For nine days, the participants have to renounce sex, tobacco, alcohol, meat, fish and dairy products. In the meantime, however, a new name has been given to the festivities, which usually take place in September or October: the Vegetarian Festival.

This does not frighten even the most feinthearted tourists, who can also participate in the celebrations in some restaurants – at least a little. All restaurants that cook purely vegetarian food hang a yellow flag on the building wall. However, the nine burning lanterns, which are attached to homemade poles, have a different meaning: they symbolize the presence of the nine Chinese gods during the festivities.

The highlight of the festival is the sixth day. During the processions the participants pierce their faces with knives or metal bars and climb on ladders with sharp rungs to call the gods.

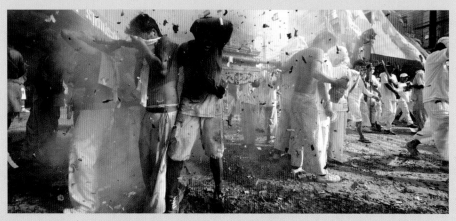

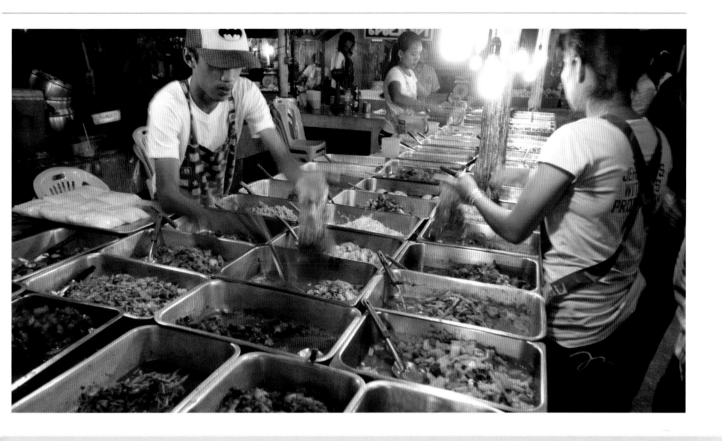

NINE EMPEROR GODS FESTIVAL

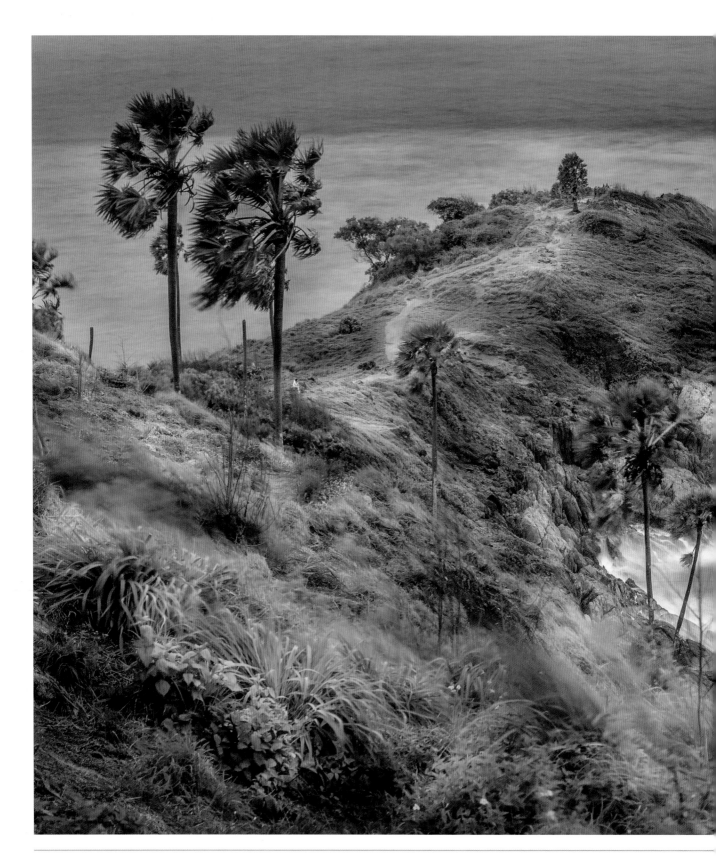

The southernmost point of Phuket is a popular
hot spot for sunsets and a trip to the rocky cape
during the day is something worth taking.

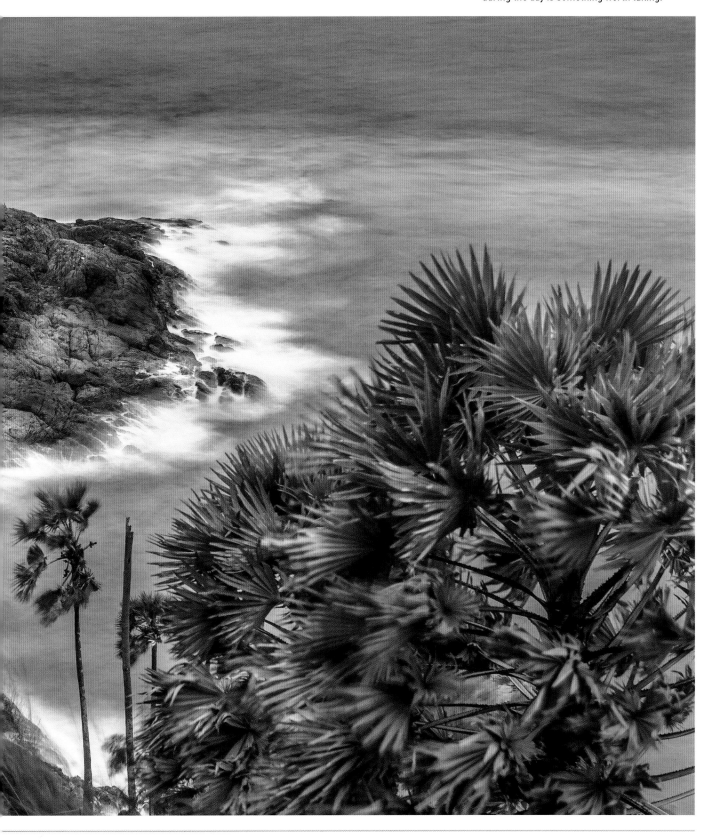

PHUKET'S MOST BEAUTIFUL BEACHES

In the evening, the landscape is bathed in soft light and golden colours. In the west of Phukets the sunsets are particularly picturesque. The beaches are now almost empty, only one or other single holidaymakers are still sitting on the beach waiting for a sundowner or using the last light of the day for a dip in the warm sea. The most famous beaches are the long, but rather interchangeable Patong Beach, Kata or Nai Harn. The best beaches on the island can be discovered with a little effort.

The Freedom Beach, for example, can be reached after a good kilometre walk through the jungle and also has a small reef. Laem Singh Beach, a small and dream-like bay can only be reached by car and then along a trail path or by longtail boat. The long Mai Khao Beach, is where the international airport run-way begins. There is also the Layan Beach with its gentle waves, which is mainly used by emigrants and locals, who particularly appreciate the small restaurant with cheap Thai food.

Or, if you want watch a romantic sunset, you can rent a kayak and enjoy the last rays of the sun on the water.

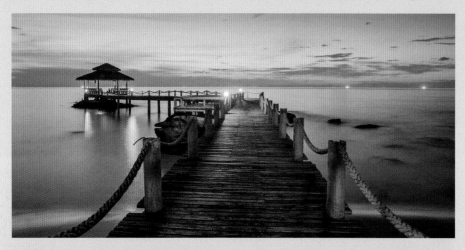

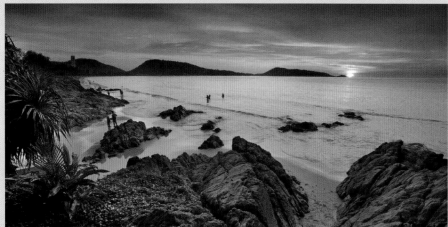

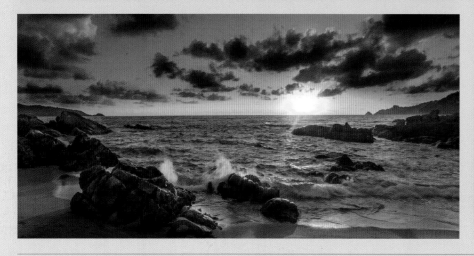

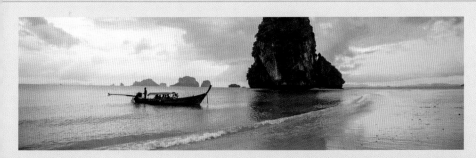

The most beautiful beaches are almost all in the west of the island. In the east, gnarled mangrove forests, shrimp farms, small fishing villages or rubber plantations dominate the waterfront. There are only a few beaches, which can satisfy all tourist requirements. For the mobile guests, however, the east offers authentic Thai life, which is definitely worth a day trip.

KRABI

The coves fringing the port town of Krabi with the finest sandy beaches and crystal-clear water are extremely enticing. Once a sleepy fishing village, Krabi, on the delta of the River Krabi where it flows into the Andaman Sea, is now the adminis-trative center of the province of the same name. Bizarre limestone formations and sheer cliffs provide mountain climbers with routes up to the highest level of difficulty. Several diving schools have become established in and around Krabi. They offer a full range of scuba diving excursions for anyone from beginners to advanced divers to the diverse underwater world of such off-shore islands as Chicken Island and Ko Lanta Island. Boat trips to explore the wild unspoilt scenery around Krabi – thought to have been the site of Thailand's earliest settlement area – are a memorable experience.

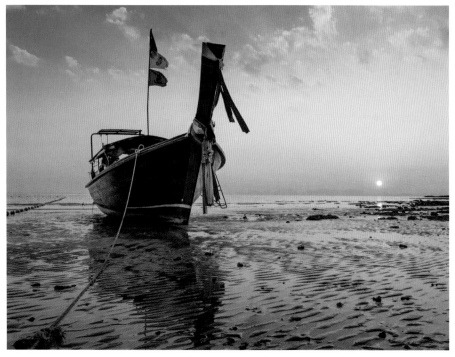

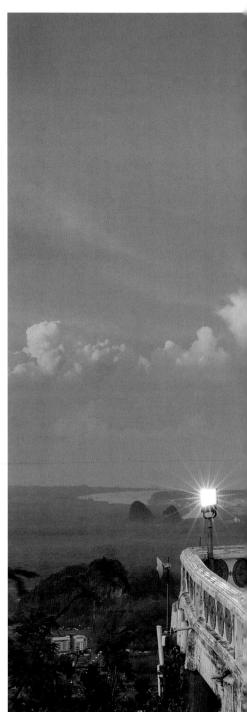

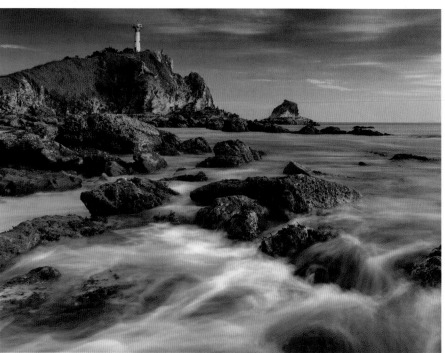

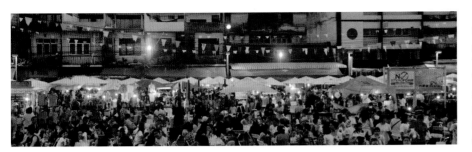

One of the main attractions of the city of Krabi is about eight kilometres from the city center: Wat Tham Sua, the Tiger Cave Temple (large picture). The temple complex sits high above Krabi, and can be reached via a strenuous 1237 step climb. Golden chedis, tiger statues as well as a gigantic Buddha and a magnificent view are what await visitors.

KO PHI PHI

"The Beach," in the truest sense, because these beaches are a dream come true. This is also what Leonardo DiCaprio's filmcrew thought, when in the year 2000 they made a film bearing the same name on the Ko Phi Phi islands. Young people looking for freedom, adventure and the most perfect spot on Earth. The finest sandy beaches, palm trees and coconuts, which cater to your every need. Welcome to paradise, in the Maya Bay. But the movie also showed the importance of conservation.

Interfering with the landscape had consequences: Above all, garbage disposal was and still is a problem in the archipelago. It is also because thousands of holidaymakers visit the island on day trips. Colourful boats are brought to Ko Phi Phi Don, the larger island, or Ko Phi Phi Leh, the smaller sister island.

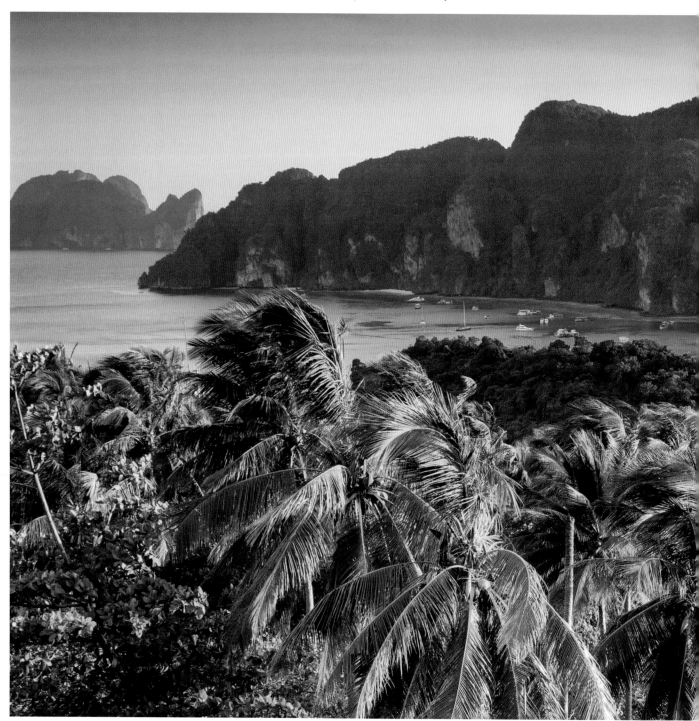

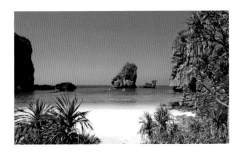
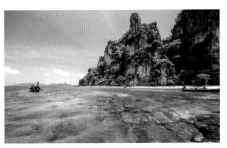

Ko Phi Phi Don (all pictures) is now a major tourist hotspot. It is no surprise, because you can experience the south seascape for yourself: crystal clear, turquoise water, dense jungle covering almost the entire island, and bizarre rock formations characterize the picture. The smaller island of Ko Phi Phi Leh offers spectacular rock formations, such as the "Viking Cave".

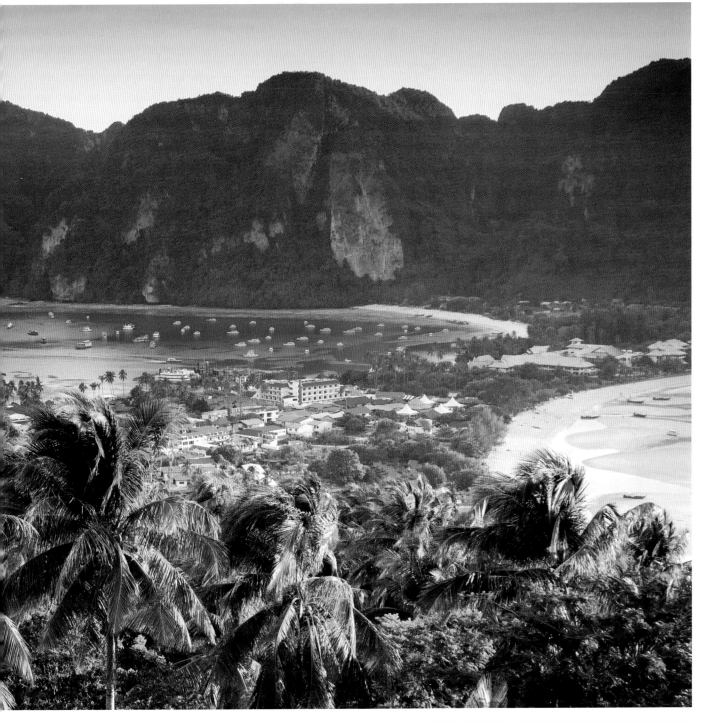

KO LANTA

Ko Lanta consists of two island parts: Lanta Yai in the south and Lanta Noi in the north. An approximately one kilometre wide waterway separates them from each other.

While the smaller sleepy Lanta Noi is still touristy, the larger sister island is well developed. With a length of 24 kilometres, the west coast features bungalows and fine resorts – beach holidays as if they were taken directly from a picture book – while the mainland is largly untouched. Very few visitors come to hike here, but they don't know what they are missing: dense, species-rich rainforest. This jungle at the southern tip has been declared a Mu Ko Lanta National Park together with 15 offshore islands in 1990. Here a hiking trail leads to a beautiful picnic area at the waterfall and a lighthouse

Ko Lanta does not feature the most beautiful beaches in the Andaman Sea, but here they know exactly what tourists want: there are exclusive hotels on the west coast of Lanta Yai with all the comforts that guests need.

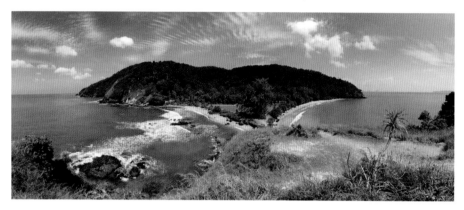

KO NGAI

A tourist gem hidden in the shadow of Ko Lanta, towards Malaysia: Ko Ngai. Especially snorkellers, divers and sunbathers are tourists who frequent the island. Apart from the lush nature there is not much to see. However, if you are hoping for a romantic bamboo hut on Ko Ngai, then you will have to look hard. The east side, which is more attractive with its beaches, is already equipped with several resorts.

Still, the atmosphere is casual and relaxed, but most of the hotels already have swimming pools, a expansive restaurant and a prestigious reception. For backpackers, it is a sure sign that the times of relaxed reggae evenings sat around the camp fire are over.

The comfort of living is much higher. The progress has given Ko Ngai some good and less attractive sides.

Those who visit the west coast of Ko Ngai are completely alone with nature. Except for two small and also quite narrow sandy beaches, the shore is rocky and rough. The snorkel areas are all the more appealing.

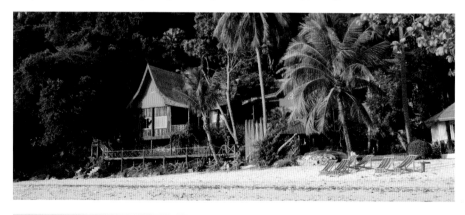
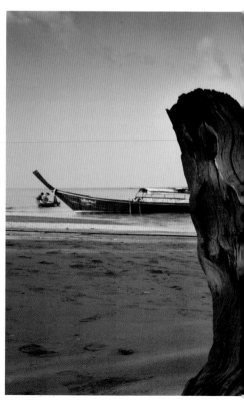

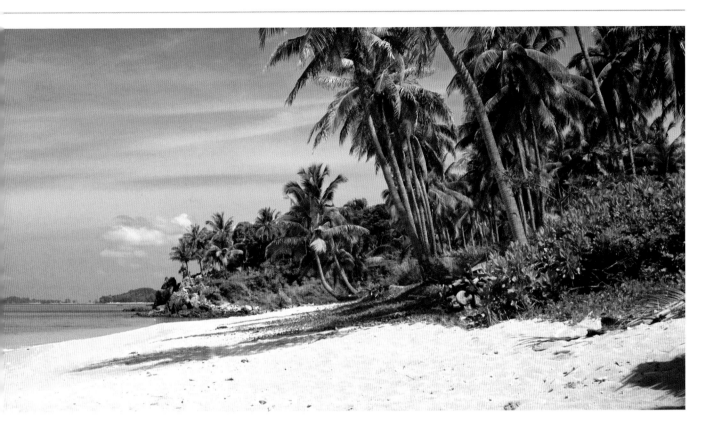

KO NGAI

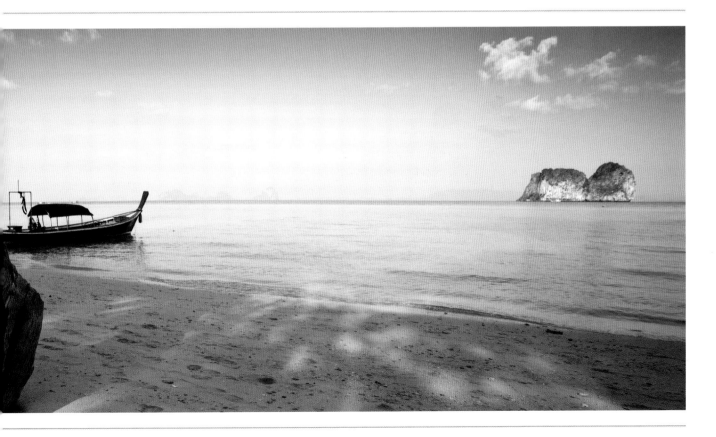

A PLAY OF SHADOWS: NANG YAI AND NANG TALUNG

Nang Yai, the classic Thai shadow puppet theatre, is rarely seen today. Leather figures, up to two metres high, are alternately held in front of a light source in a dramatic sequence in order to tell a story.

Nang Talung, the slightly smaller, more filigree and more mobile version of the Thai shadow puppet theatre, has been preserved mainly in the south of the country. Here there are also traditional workshops for the shadow puppet theatre. In a performance, in contrast to the "still images" of Nang Yai, the figures are only about 50 centimetres high, have moving arms and do not move as a single piece.

They feature a relief in leather embossed figures illuminated from behind in order to throw their silhouettes on a canvas. They frequently show episodes from the Ramakian, the Thai version of the Indian Ramayana. The first epic poem with 24,000 four lined stanzas, was recorded as early as the 3rd century BC.

The poem is about heroes and demons as well as love. In the Indian version this love is first fulfilled in heaven and in the Thai version it happens on Earth. Traditional music and sometimes chanting accompany the imaginative play of shadows.

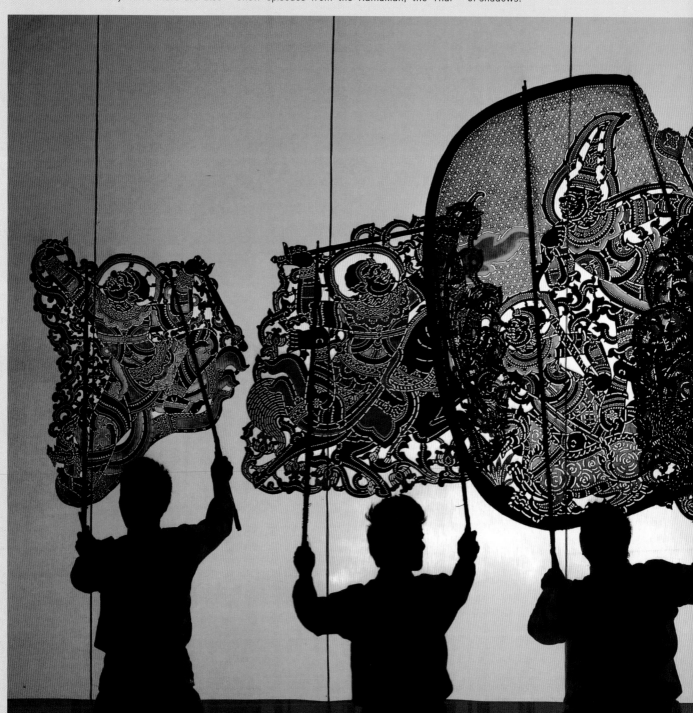

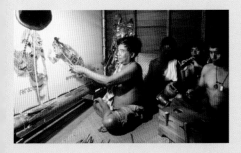

In addition to the classic puppet show, there are two forms of shadow puppet theatre in Thailand: Nang Talung (far left and picture top) and Nang Yai (picture bottom and large picture). The Suchart Subsin Shadow Puppetry Museum in the southeastern province of Nakhon Si Thammarat is equipped with a shadow puppet theatre (left). Traditional plays are also shown here.

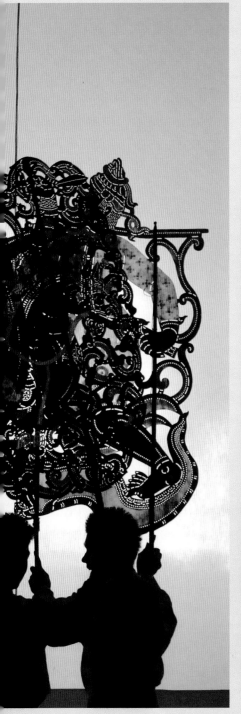

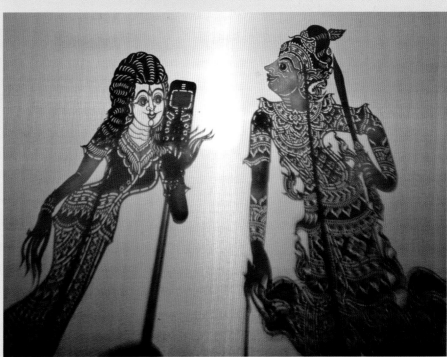

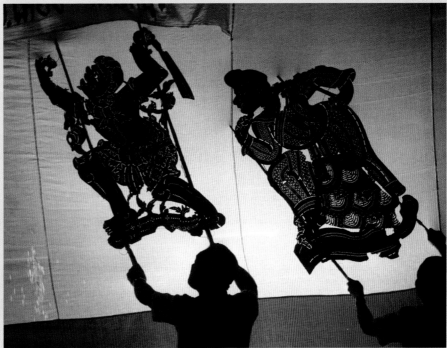

It is very likely that visitors will come across some Thai people at a particular place in the park, who hold 1000 Baht in the air and smile ecstatically. But it is neither the fascination of Mammon, nor a religious or even high-donated background, which makes the locals radiate with happiness.

It is rather the fact that the Thai are thrilled to see the multi-level waterfall, which is depicted on the 1000 Baht note, as they can now see the waterfall for themselves. In spite of this, it is advised that you look closely at your feet whilst in the park. There are at least 31 reptiles, among them are poisonous vine snakes and Asian rat snakes which live in the undergrowth. Asian elephants also stroll freely around the 570 square kilometre national park, where 90 mammal species live.

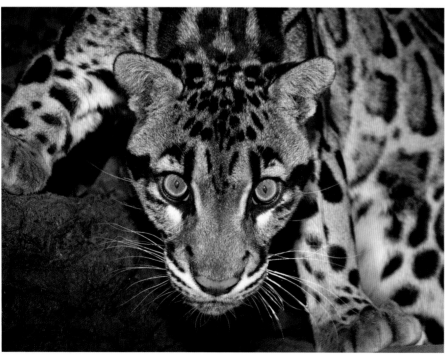

The park is famous, because it features the highest mountain of Thailand, the Khao Luang (1835 metres). However, visitors are much more enthusiastic about the enormous variety of flowers and blossoms. More than 300 species of orchids can be discovered, some of them are found exclusively here. In addition to elephants there are also green vine snakes and clouded leopards (picture strip from above) that live here.

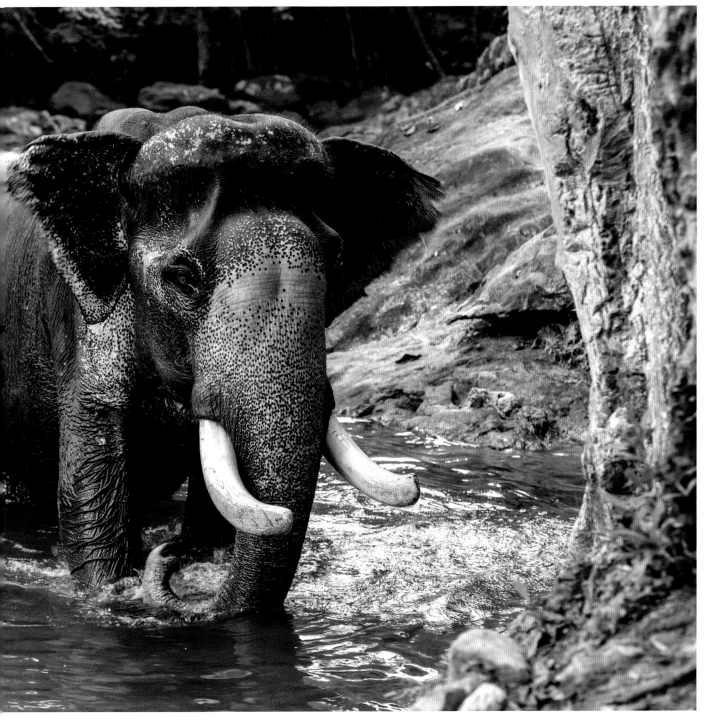

SONGKHLA

As a commercial center, Songkhla, like its neighbouring Nakhon Si Thammarat, is the capital (approximately 68,000 inhabitants) of the province of the same name. It is located in the far south of Thailand, near the Malaysian border, at the tip of a peninsula between Lake Songkhla, the largest inland sea in Southeastern Asia, and the Gulf of Thailand. Previously, the city was called Songkhla, "City of the Lions", because there is a nearby rock resembling a lion's head.

The city has a turbulent history. Once an important port for Muslim traders, it was almost completely destroyed in the 17th century and rebuilt a few kilometres away. The most important place is the National Museum in the former Governor's Palace as well as the Wat Matchimawat from the 16th century.

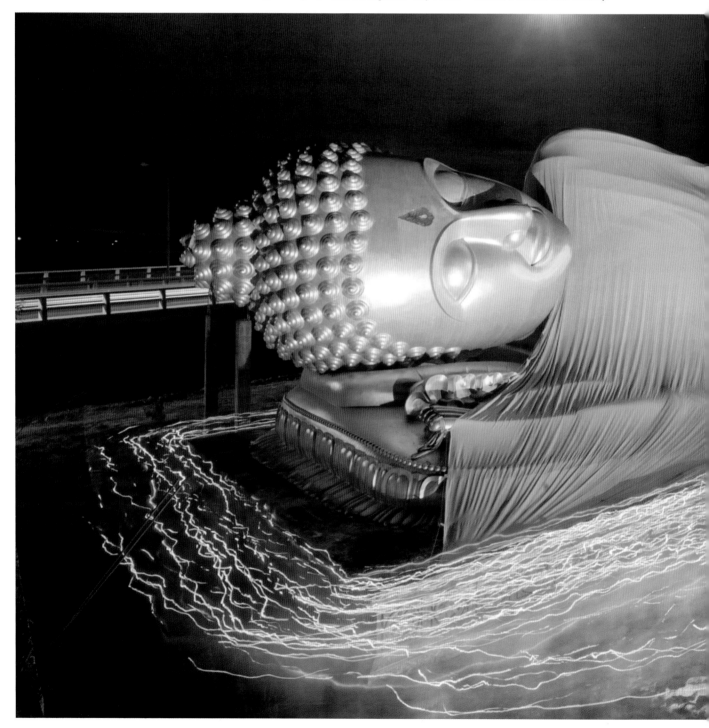

Close to Songkhla lies the temple complex of Wat Phranon Laem Pho with its about 20 metre long lying Buddha (below). Off the coast of the city stretches the beautiful Samila beach. On it there is a mermaid sculpture (far left), which is taken from the epic poem "Phra Aphai Mani" by Thailand's most famous poet Sunthorn Phu (1786 to 1855).

EAST THAILAND

Those who travel from Bangkok to Cambodia, will discover a region of Thailand, in which the contrasts could hardly be any greater – and almost all clichés are fulfilled. The neon signs of the bars shine brightly in Pattaya. The Gulf of Thailand is also a popular destination for the citizens of Bangkok, but here you will find quiet spots between the popular beaches. And if you venture further into the east, you are plunged into the world of precious stones and jungles.

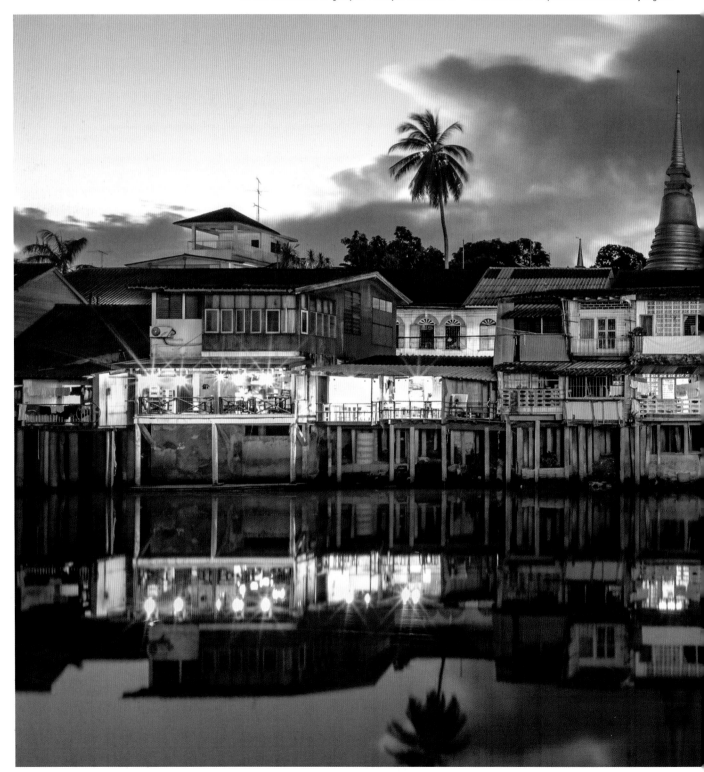

Chanthaboon is the district of Chanthaburi, located on the river of the same name. The houses are partly built on stilts and small inns and restaurants wait for customers in an idyllic atmosphere.

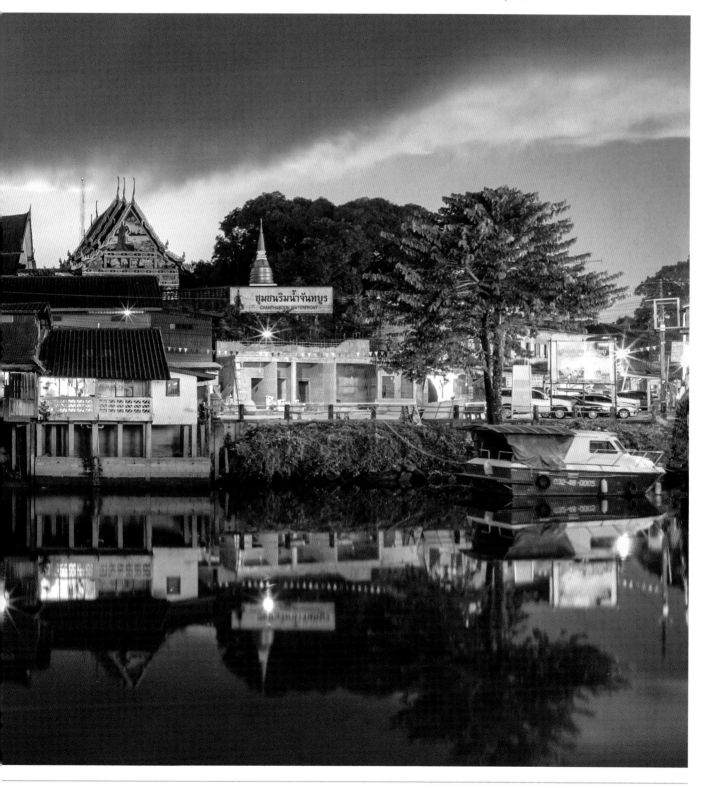

PATTAYA

Back in the 1960s Pattaya was a sleepy little fishing village with palm-fringed beaches and one attractive little hotel. That was when the rich in Bangkok were discovering its potential as a weekend resort. An explosive upturn, however, came with the Vietnam War: the little village soon became the Pattaya we know today – with all its bars, nightclubs and discos. Those were the days when the town became notorious as a center for sex tourism. Nowadays Pattaya is doing everything it can to attract holidaying families with a variety of options: spending time on the lovely beach or taking boating excursions out to sea, visiting a crocodile farm or admiring the Buddha statue on the southern fringe of town. Moreover, some small fishing villages nearby – such as Naklua Bay – have succeeded in remaining unspoilt and are indeed rewarding to visit.

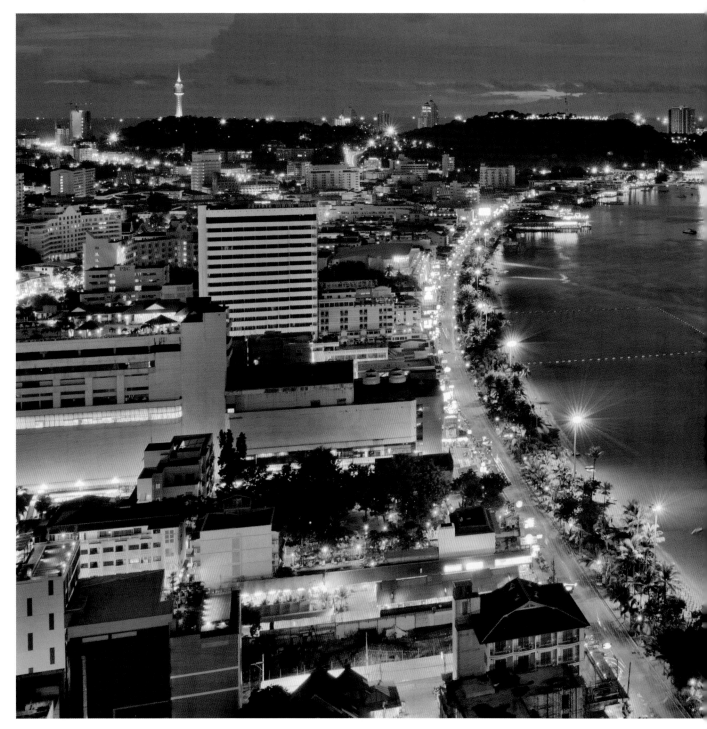

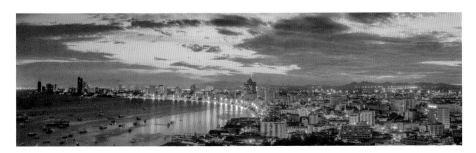

Some visitors who spend their days bathing in the sunshine on the beach at Pattaya think nothing of plunging into lurid nightlife when darkness beckons: the notorious side-streets off Pattaya Beach Road all look alike – bars, and clubs "a go-go" under a neon sky.

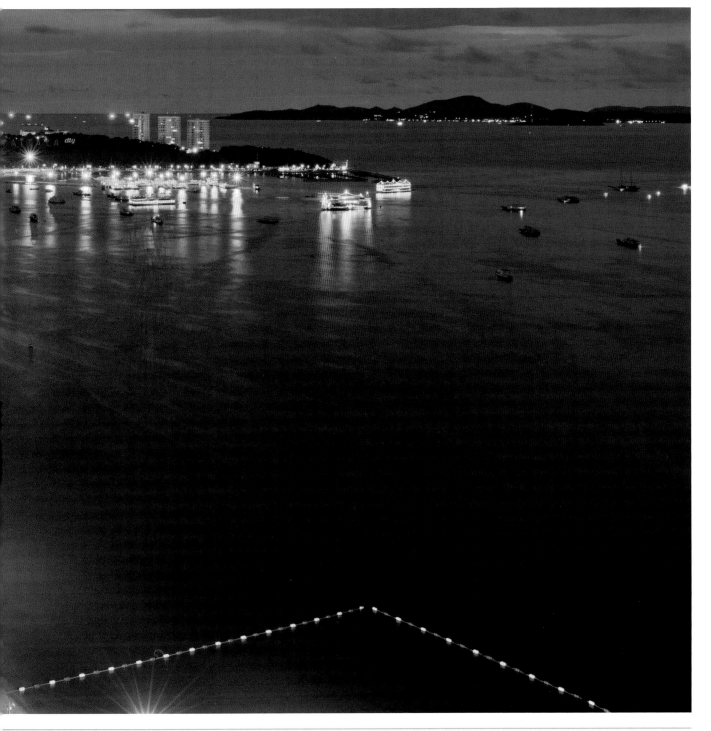

PATTAYA: PRASAT SATCHATHAM

"Sanctuary of Truth" – a huge building was constructed in 1981 under this promising name. In Naklua Bay, in the north of Pattaya, the largest teak house in Asia is being built on a plot of 120,000 square metres.

The Thai people have already been constructing it for the past 30 years and another 15 years are estimated for the completion of the mammoth project. The building is covered with mythologi-cal figures from the world of gods and animals. The Buddha heads especially create a harmonious atmosphere. The work is the testimony of the wood carvers of Thailand, and the artists work in their own workshops daily. They not only produce new pieces, but also rebuild old ones, as salt water, the sun and the wind quickly corrode the building, which is supposed to symbolize transience.

The "Sanctuary of Truth" in Pattaya is built on sand and is close to the sea. What looks like a great temple from the outside is officially not a religious place of worship but the local people already revere this building. This is no surprise as it features handmade statues of gods and Buddha faces. Everything here is hand-carved whether it be doors, stairs or towers.

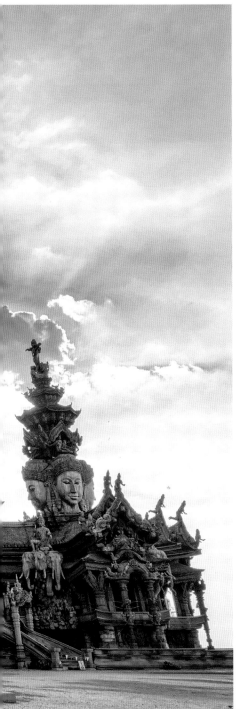

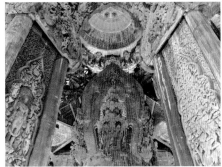

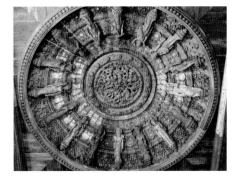

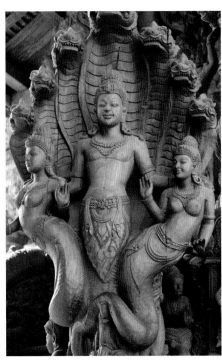

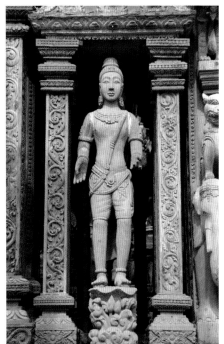

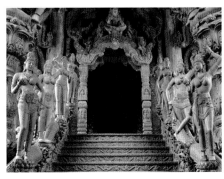

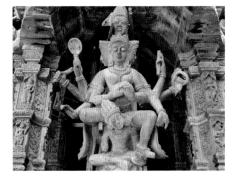

RAYONG

This quiet village lies only a stone's throw away from the bustling Pattaya. With its offshore islands on the Gulf of Thailand and the green mainland it is a very attractive location for visitors. You will find picturesque beaches; the light coloured sand and turquoise sea have been responsible for the growing tourism in recent years.

Meanwhile, the new resorts are linked to the beaches like pearls on a necklace. The town is surrounded by 100 kilometres of coastline, and the most beautiful beaches with their fish restaurants are in Laem Charoen and Ban Phe. From here you can catch a ferry to Ko Samet. Not only tourism but also the industry has been booming in recent years. Rayong is the center of the production of the typical Thai fish sauce Nam Pla.

A holiday close to nature is often possible on the beaches of Rayong and even on the golden beach of Hat Sai Thong. The locals come to relax in this area. It is a destination for nature-bound tourists who do not need a vibrant nightlife. The beaches are thus all the more beautiful.

KO SAMET

Rocks, bays, the finest beaches – Ko Samet is just 13 square kilometres in size but promises to fulfill many holiday dreams. Because of its proximity to Bangkok, the island is a popular destination for domestic short breaks. Especially on weekends and holidays it is pouring with people, which makes the hotel prices rise. During the rainy season the island gets less rain and remains relatively dry compared to other areas.

Swimming, diving and snorkelling around the corals as well as extensive beach hikes – there is no lack of outdoor activities. In addition, you can quickly go back to the mainland and walk through the national parks or go on a safari: to waterfalls with idyllic bathing areas and impressive caves, or to see the last remaining elephants in the jungles that are threatened by deforestation.

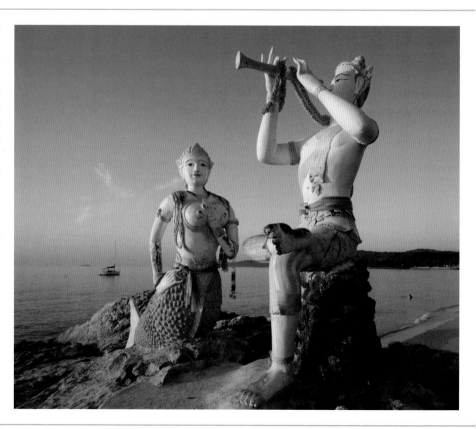

The statues, erected between Ao Phai and Hat Sai Kaew, illustrate the dramatic story of the literary Sunthorn Phu, in which a mermaid rescues Prince Aphai Mani from the ocean and takes him to Ko Samet.

KHAO LAEM YA NATIONAL PARK

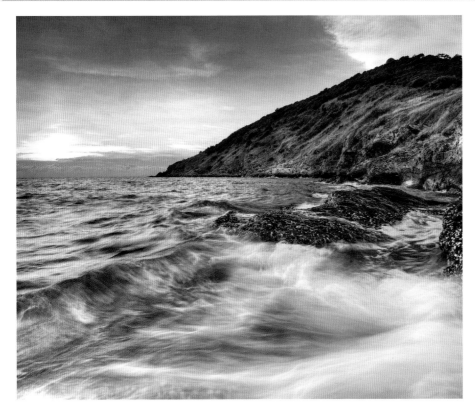

The national poet Sunthorn Phu has placed a very special monument in this protected area: the epic "Phra Aphai Mani" is probably one of the most famous stories in the country. It is about two princes, one of which is caught by cannibals and later saved by mermaids.

The national park, which extends around the Samet archipelago, is indeed mystical. The islands are called the Moon and Shark Scale Island and you can really enjoy your dream holiday on its white beaches and in the turquoise blue sea. Ko Samet is one of the most famous islands. In the south, the nature reserve is covered with dense forests and if you like hiking, you can go on a tour of the waterfalls. Not only on land, but also in the water, divers and snorkelers can enjoy themselves as the area is bursting with a great diversity of species.

The views of the sunset are particularly beautiful on the coasts of the nature reserve. Mae Ramphueng is home to the longest beach but also to the small bays are worth the trip. Beauty arouses interest, and thus hotels without building permission were erected here.

KO SAMET

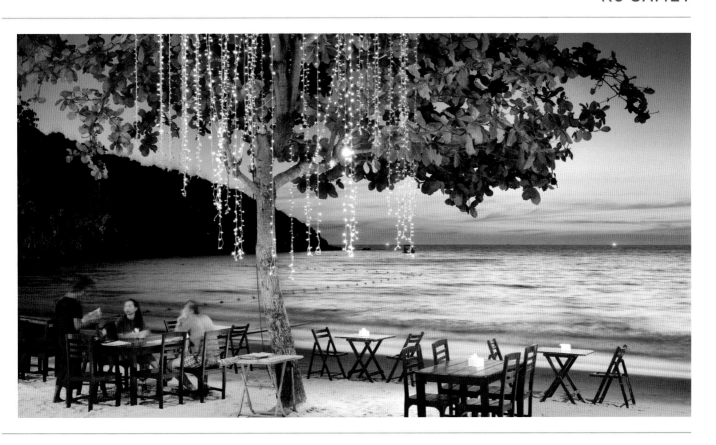

KO CHANG

In the 1980's it was once a typical paradise for backpackers. Peaceful, natural, without electricity and roads. Hiking trails led across the 30 kilometre long and 14 kilometre wide island. Generators produced electricity in a handful of accommodation for several hours a day; only in 1996 did electricity come to Ko Chang via a sea cable. Beaches and bays were only accessible by boat.

Before the tourists arrived and the construction boom began in the late 1990s, the inhabitants lived on fishing and rubber production. Today the White Sand Beach is the hotspot for hotels and bunga-lows, the most beautiful lagoons can be found on the six kilometre long sandy Klong Prao Beach. In the mountains, which are up to 750 metres high, and are located in the mainland of the small part of the country, there are forests with wild boars, monkeys, snakes and birds that await explorers who are not afraid of a sweaty hike.

Sai Khao is called White Sand Beach in Thai, and it definitely stands by its name (below). Right: Cape Chai Chet.

KO CHANG: MU KO CHANG NATIONAL PARK

At the easternmost tip of Thailand there is a very special gift from nature. Ko Chang, the "Elephant Island," is covered with a dense carpet of tropical forests. It is the only park of its kind and is home to a wide variety of different species. Ko Chang is, after all, the second largest island in Thailand after Phuket and has white sandy beaches and mangrove forests.

A variety of bird species can also be found here, including parakeets, red-headed trogons or brown throated sunbirds. In the mountains, many very clear rivers appear and overcome the diffe-rences in altitude partly with dramatic water-falls.

The nature reserve also extends into the sea, where large coral reefs are found, especially around Ko Wai, which is one of the dozens of islands that are located in Ko Chang. Sea turtles can also be seen in the water.

Even if the name suggests, elephants are not native to the island, but they are used for trekking where they take visitors to the waterfalls.

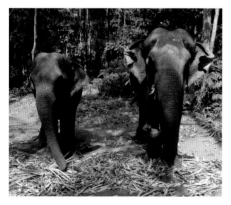

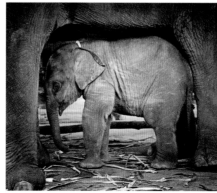

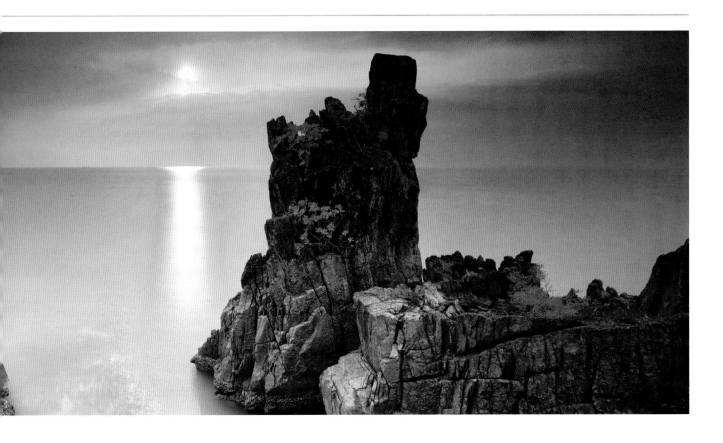

KO CHANG: MU KO CHANG NATIONAL PARK

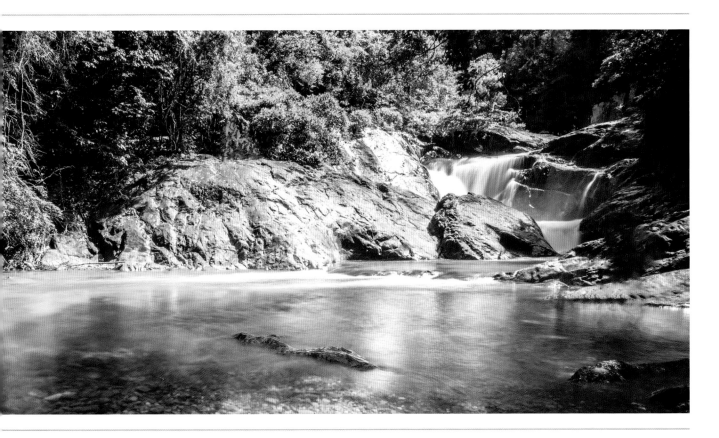

NORTH THAILAND

The Thai kingdom of Lan Na, the "Land of a Milli-on Rice Paddies" grew up around Chiang Mai in the 13th century in the mountainous, jungle-covered north country of modern Thailand.

In the far north, three countries – Thailand, Myanmar and Laos – converge to form the Golden Triangle. Rainforest and teak interspersed with rice paddies, roaring waterfalls and bizarre limestone caves are notable features of this diverse region. In the mountains, ethnic minorities have succeeded in retaining their own cultures.

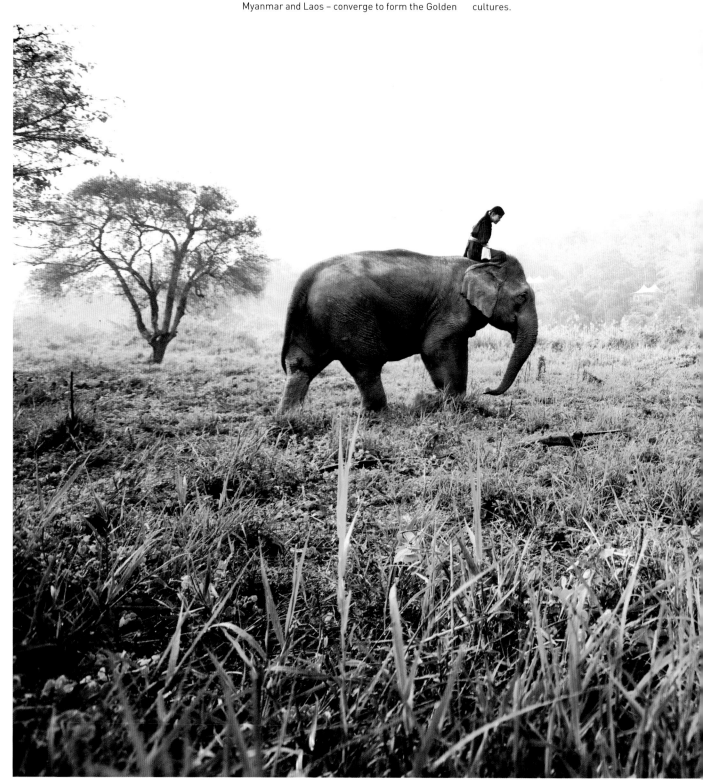

Elephant rides have also become rare in northern Thailand, but there are regions around Chiang Rai (below) where this ancient culture is still preserved.

WAT THAM KHAO WONG

The Wat Tham Khao Wong temple is located a few kilometres outside the city of Ban Rai. It is a fairytale nestling in a landscape of mountains and forests. The path to the place of worship leads uphill up many steps and is held in place with tree trunks. Trunks also played a major role in the construction. When the plans for the temple were created, the locals began to collect wood. Thanks to this assistance, in 1987 the place of worship was built entirely from natural materials. This makes it a symbol for natural construction and preserving, regional resource consumption. The two-storey building in a pagoda style fits well into the landscape with its warm wooden shades. Meditation classes are regularly given here and the caves behind the temple are suitable for those who wish to retreat and remember the simple life as a monk.

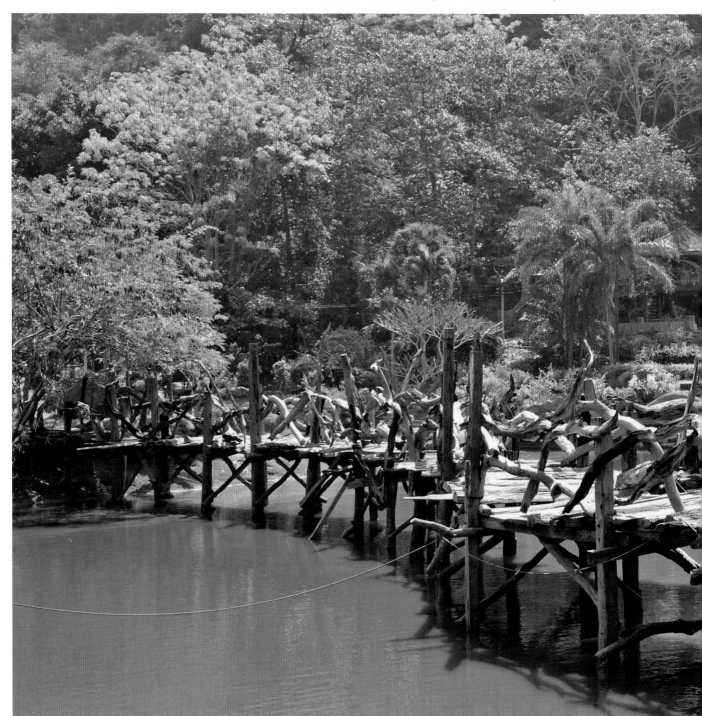

As the name suggests in Thai, a temple was built here on a mountain. It is made entirely of wood and dates back to 1987. At the foot of the building is an artificial fish pond which is designed to promote inner peace. Palm trees line the shore, the shade allows you to relax after the quite strenuous ascent to the temple up many stairs.

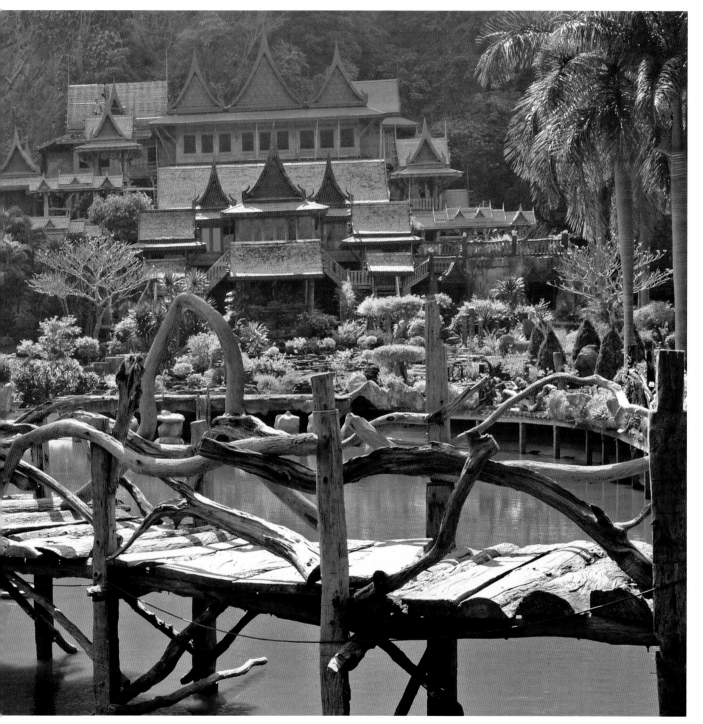

KHLONG LAN NATIONAL PARK

The Umphang is without a doubt something of a touristic highlight in Thailand. It is still almost completely undeveloped, and when tourists come to visit, they are usually experienced hikers. They experience a whole different world in this reserve, which covers an area of 300 square kilometres. The highest peak is the 1,440 metre high Kun Khlong Lan. Some rivers emerge from the mountains, which form picturesque waterfalls that make their way into the valley. The small pools welcome hikers to soak their feet in the water. In the past, indigenous tribes of the Hmong settled in the area, but they were resettled upon the opening of the park, so that the ecosystem was not brought out of balance by human intervention. After all, sambar deer, black bears and tigers live in the reserve, whose numbers have steadily increased since the designation of the protected area.

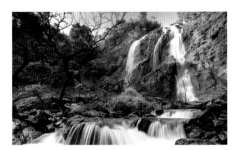

The Khlong Lan waterfall falls impressively over 55 metres into the depths (both pictures). The landscape is particularly colourful in the autumn when the leaves of the trees turn to bright reds. Since 1982 the area has been protected as a national park in the Dawna mountains. For a time, it had been used as a retreat from communist guerrilla.

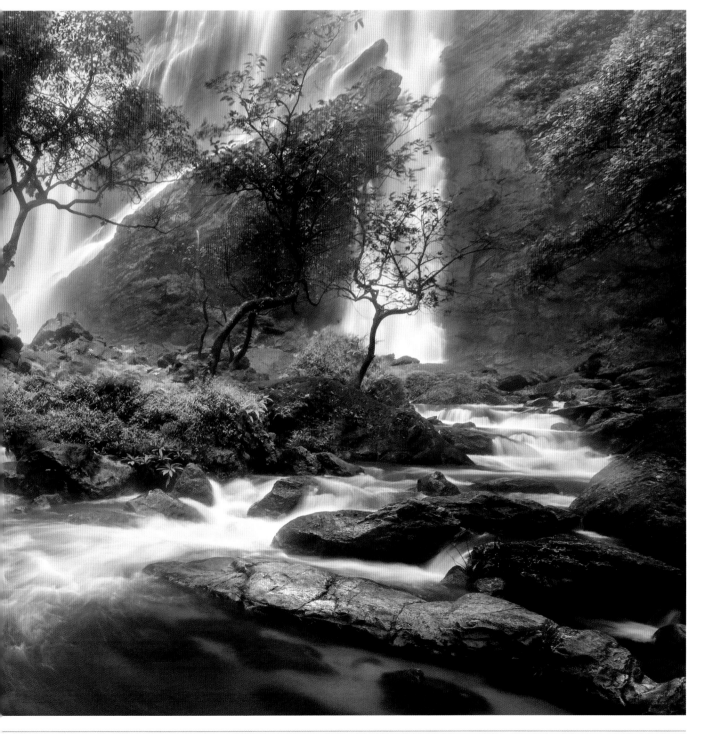

KAMPHAENG PHET

The historic center of Kamphaeng Phet is, with Si Satchanalai and Sukhothai, a UNESCO Cultural World Heritage Site. Founded on the River Ping in 1347 in the reign of Liu Thai as an outpost of the Kingdom of Sukhothai, it remained an important garrison city for the kings of Ayutthaya even after the eclipse of Sukhothai (in 1376). Important temples were built within the center (and outside it). Towards the close of the 16th century, the city was invaded by the Burmese. Within the remains of the city walls (Wat Phra Kaeo, Wat Phra That), which were once surrounded by high earthworks, an impressive clutch of ruined temples has survived as well as outside the center (Wat Phra Si Iriyaboth) in Kamphaeng Phet Historical Park to the north. The Kamphaeng Phet National Museum is also well worth a visit for its superb bronzes and ceramics.

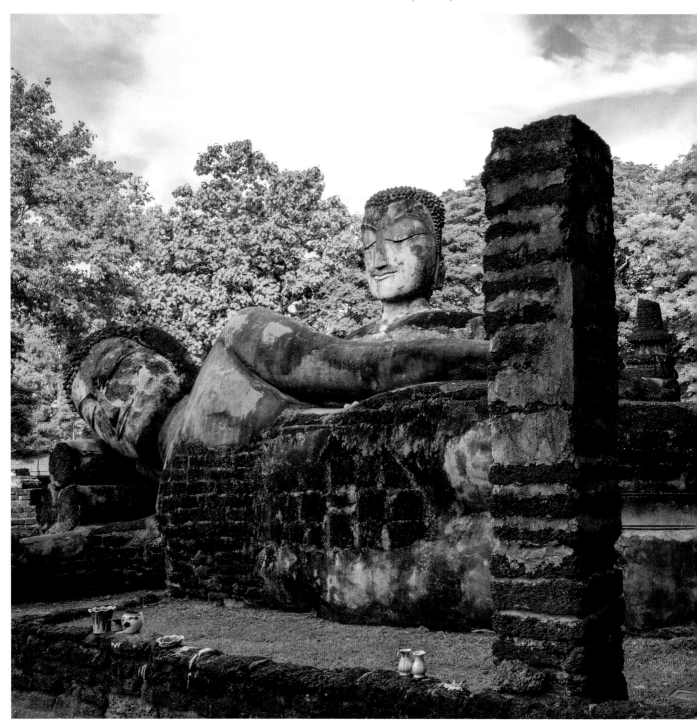

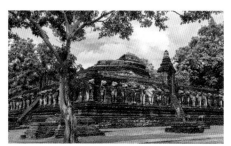

Of waxing and waning: In the Kamphaeng Phet Historical Park, weathered statues seem reminiscent of Henry Moore. Below: In the same park, four statues at Wat Phra Si Iriyaboth embody the four asanas of the Buddha. The name speaks for itself (Si = four; iriyaboth = posture). The elephant wall belongs to the Wat Phra Kaeo (pictured above); Left: Wat Chang Rop.

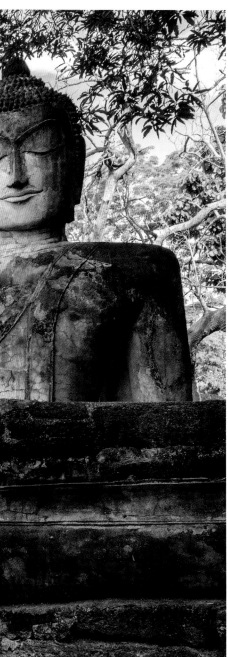

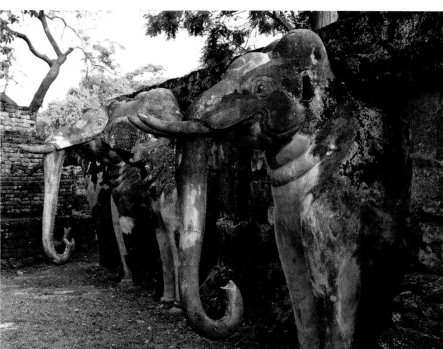

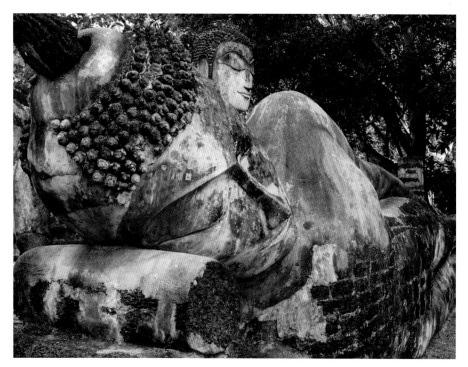

SUKHOTHAI

"May the land of Sukhothai bloom and flourish," is inscribed into a stone dating back to the reign of King Ramkhamhaeng the Great (reign 1279–1298), now displayed in the National Museum in Bangkok. The first capital of the Kingdom of Siam really did attain its zenith under Ramkhamhaeng the Great. Only a few decades after the departure of the Khmer (1238), the first independent Kingdom of Siam extended into what is now Laos and on down into the Malay Peninsula. The "Golden Age" lasted until the close of the 14th century.

That period of prosperity produced the finest Siamese works of art and the development of the Thai script. After declining in the following century, however, Sukhothai was almost forgotten until restoration of the ruins began in 1977, culminating at long last in the opening of Sukhothai National Historical Park.

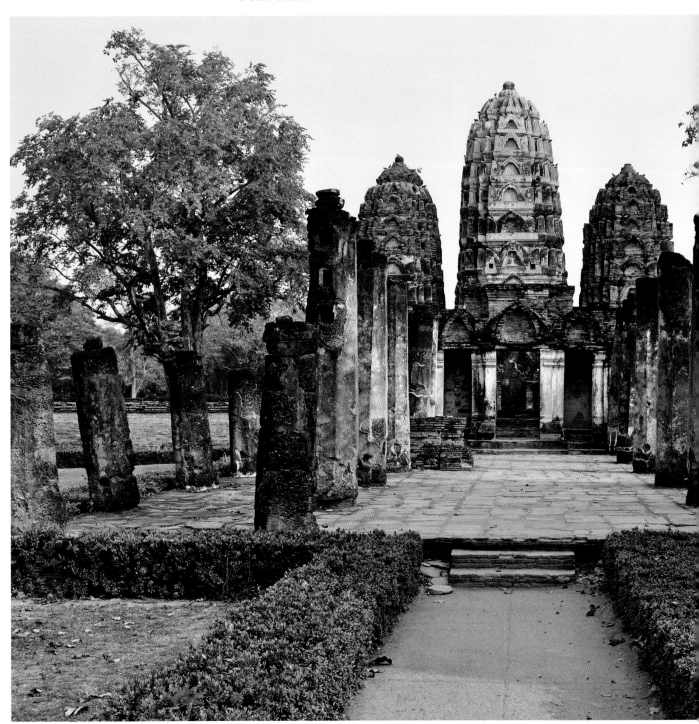

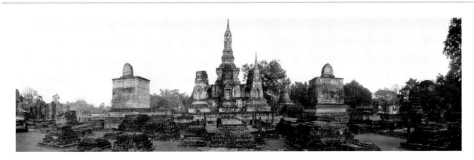

The entire city and temple complex of historic Sukhothai were once encircled by walls and moats – a veritable fortress. In fact, Sukothai was the first capital of the Thai kingdom until the end of the 13th century. Since 1991 it is a UNESCO Cultural World Heritage Site. Large picture: Wat Sri Sawai.

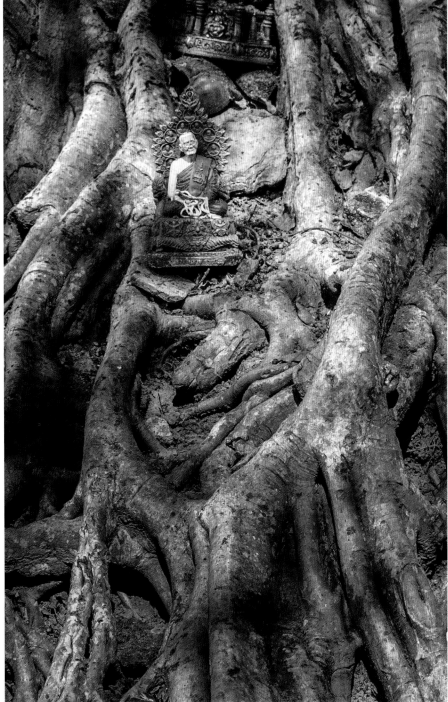

Large stone eyes look out through a gap in the thick wall. They seem to know everything. It is no wonder that many a visitor is awed when they enter the giant temple.

The square layout of the Mondop, the cube-shaped pavilion of Wat Si Chum measures a total of 32 metres. The filigree, an approximately 15-metre-high Buddha statue has an interior that is a reminder of overcoming suffering, in any case, religious scholars point out the mudra, the handiwork and the masonry work from the 14th century. In the southern part of the building, a small staircase leads to the roof of the complex. It is said that King Naresuan had positioned a speaker in the 16th century to strengthen his troops spirits for the battle.

The soldiers believed that the Buddha himself spoke the words.

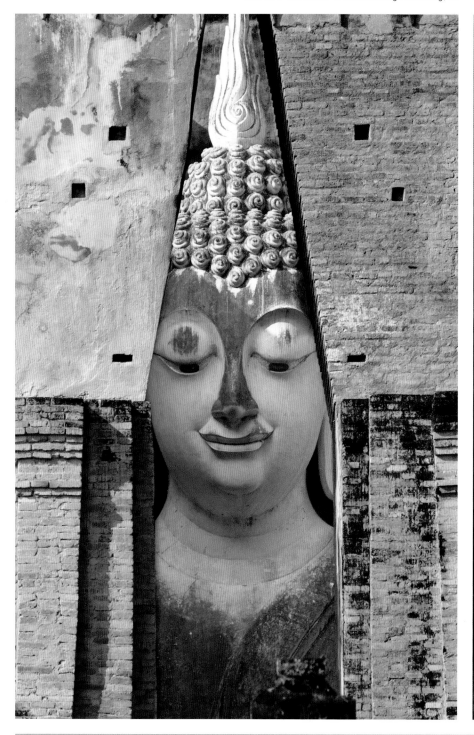

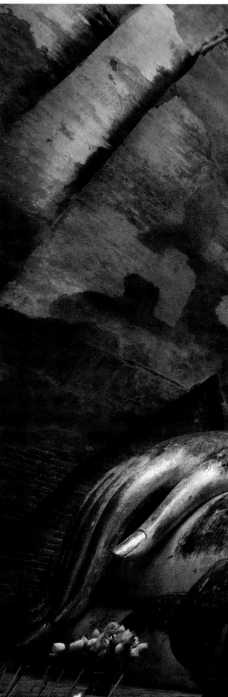

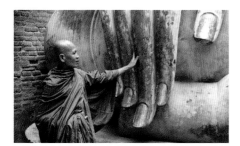

The soft and elegant Sukhothai style with the slender Buddha statues is represented in a special way by the huge sitting Buddha in Wat Si Chum. Signs of worship are the gold plates that pilgrims placed on the hand of Buddha (left). A flame-like pinnacle (a pointed tower) high-tied up hair is typical of the Sukhothai Buddhas.

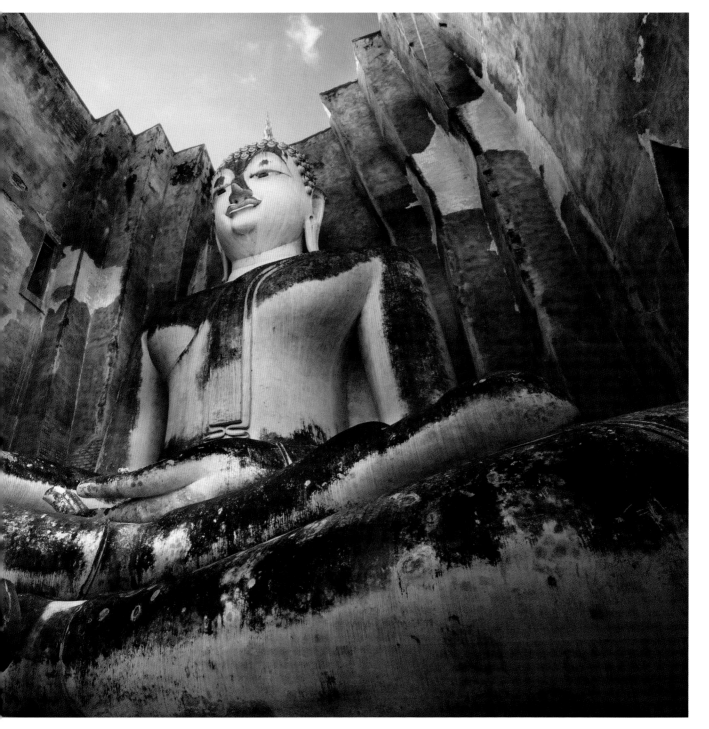

WAT PHA SORN KAEW

Mosaics are always fascinating. Small, bright coloured stones, which act like jetsam are what children like to carry in their pockets and is something that they can arrange into their own shapes and colour effects.

Perhaps they also remind us of our childhood, as the mosaics seems to be so full of the joys of life and are all together colourful. It is a creative combination of forms and patterns, but also al-ways symbolizes separation, because the joints interrupt the large colour panels.

Thoughts like this may go through many people's minds as they enter the contemplative silence of the Wat Pha Sorn Kaew temple. This is where one of the most beautiful mosaics in the country is featured. More than five million pieces of mosaic are processed here and adorn the foot of the large quintuple, white Buddhas.

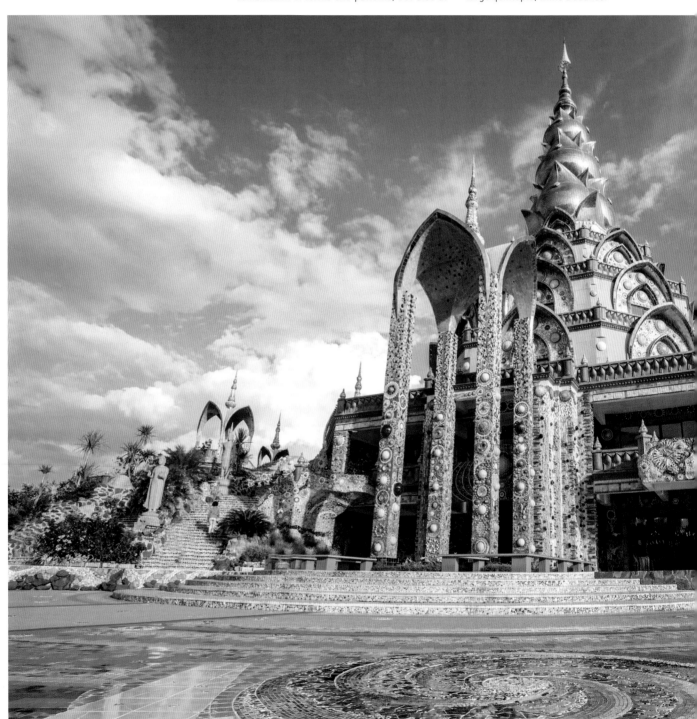

Another insider's tip is to visit the Wat Pha Sorn Kaew temple near Khao Kor, because the area is completely untouched by tourism. Although the building is not even 20 years old, it is one of the most extraordinary in the country due to its mosaic art. The temple is located on a 830-metre high hill, which gave the temple its name: "Temple on the Glass Cliff".

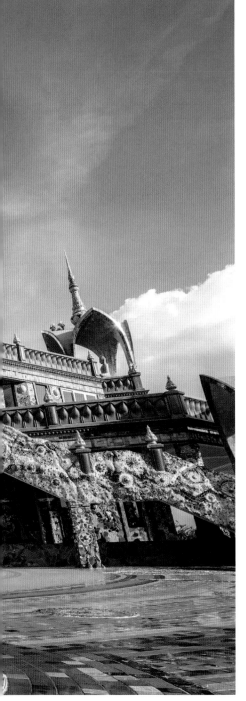

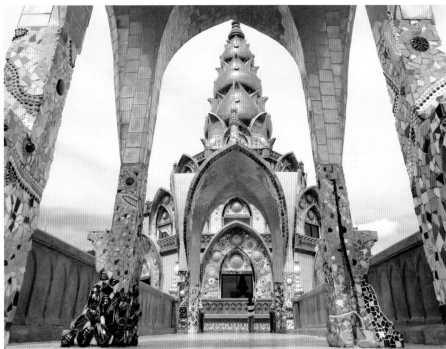

WAT PHRA SI RATTANA MAHATHAT MAHA WORAWIHAN

The eyes almost closed and the gaze raptured into meditation, a completely relaxed facial expression – the Wat Yai Buddha, as this shrine is also nicknamed, is one of the most beautiful in the country.

Those who are familiar with the Buddhist symbolism will immediately be able to interpret the hand gesture: Right hand on the knee, the left in the lap and the palm up – this mudra stands for the subjugation of demons and clarifies the immovability of Siddhartha Gautama. The huge portrait probably dates from the 1420's.

At that time, King Mahathammaracha IV ordered to commission this statue. But the best sculptors in the country could not satisfy the king with their work. The statue was cast three times until it finally satisfied the demands of the ancient ruler.

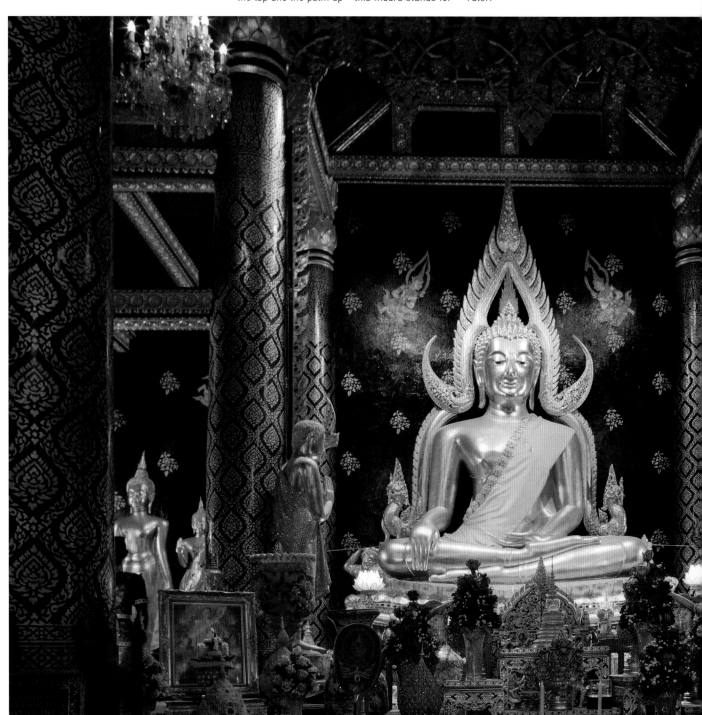

The golden columns and the dark ceiling underline the beauty of this Buddha statue, which is highly revered throughout Thailand. Some say the statue seems to shine. In any case, visiting this temple guarantees one thing: that you will forget the hustle and bustle of the modern world for a a brief moment. The Wat is located in the 70,000 inhabitant city of Phitsanulok in the province of the same name.

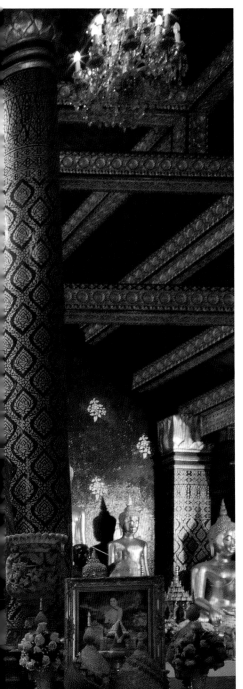

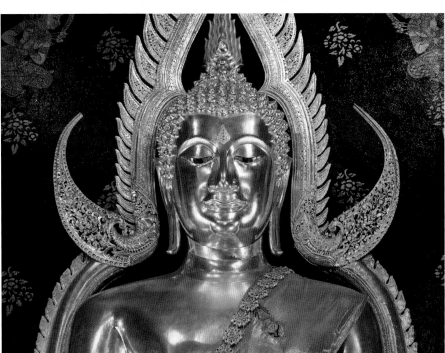

NAN

Nan (population approximately 22,000), a provincial capital, lies in north-western Thailand on the border of Laos – in the valley of the Nan, a major tributary of the Chao Phraya. The inaccessibility of this border region enclosed by lofty mountain ranges ensured a degree of autonomy and remoteness from the outside world for centuries. It still gives visitors today a good idea of ancient rural Thailand. The annual boat race, in which up to fifty oarsmen compete in colourfully painted dugouts, is the festival for which Nan is best known. The historical high point of the region is undisputedly 16th-century Wat Phumin with its four handsome Buddha statues and murals (of later date). The province is famous for its cottage industry, which produces beautiful textiles. Some families earn a modest living by refining salt. The Doi Phu Kha National Park offers a beautiful view of the surroundings.

The Statue of the Wandering Buddha overlooks the city of Nan (above) from Wat Phra That Khao Noi; The Wat Bun Yuen temple is located outside Nan in the district of Wiang Sa (below).

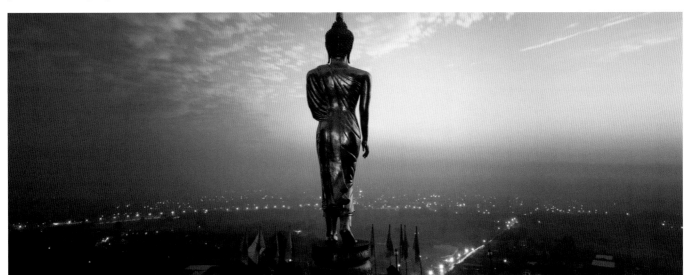

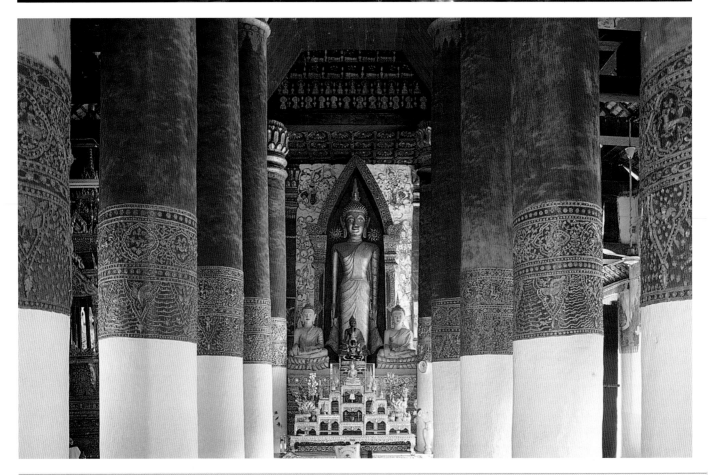

One of the most important temples of the city is Wat Phra That Chang Kham on Pha Khong Street right in the heart of Nan.

The main building, the Wihan, was built in 1458. In the center there is a sitting Buddha statue, and the walls are adorned with – quite faded – paintings. Precious scrolls are kept in Wihan, which not only contain Buddhist teachings, but also provide insights into the law and astrology in the 15th century.

Even more ancient than the main hall is the golden Chedi behind it, which probably dates from the 14th century, from the time of the construction of the temple complex. Twenty-four elephant figures surround the tower.

The sitting Buddha is the center of the Wat Phra That Chang Kham temple (at the bottom), opposite the National Museum in Nan. On the Chedi you can see a stylistic connection with Sukhothai. Here, too, elephants form the base of the golden spire (below).

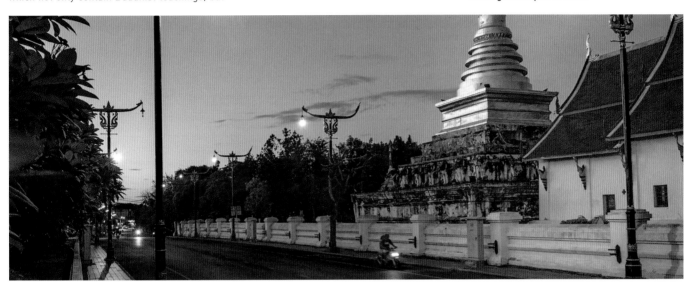

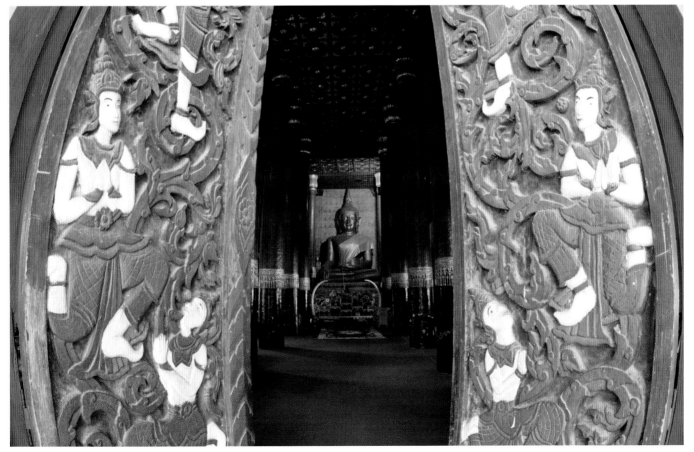

THAI ELEPHANT CONSERVATION CENTER

In the past they dragged the heavy teak logs out of the woods and worked day after day together with the Thai people. Today it is forbidden to chop wood in the jungle, and the elephants are not allowed to work – if it not where for the Conservation Center. The ancient tradition of the elephant school is maintained and the mahouts teach their animals as they used to: they have to stack tree trunks, roll or pull out the wood from the forest. The riders climb on the back of the animals and present their skills in shows. Some visitors may ride on the animals or clean and bath them as a volunteer. The mahouts work according to old tradition and still educate the elephants as if they were work animals in the forest. Today, the center in Lampang also looks after sick animals and has a hospital.

Elephants are very intellegent animals and demonstrate their skills not only in the dressage pieces with the mahouts, but are even able to paint pictures on a canvas with a paintbrush in their trunk.

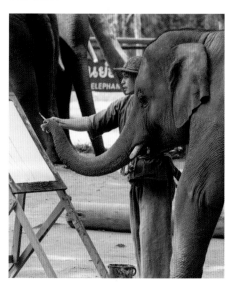

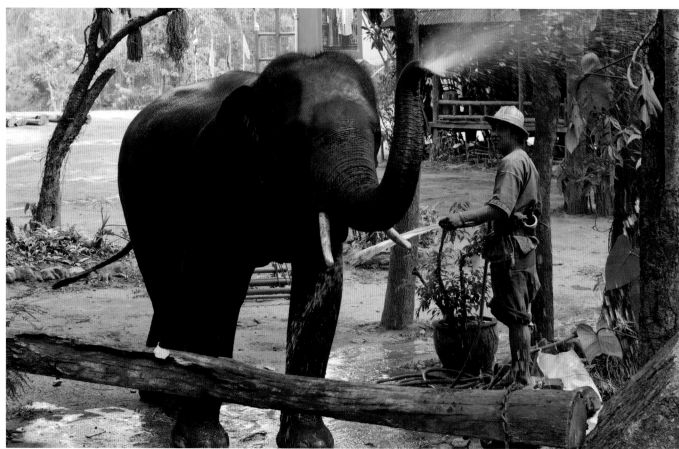

"An illustrious king possesses seven things: a per-fect wife, a capable treasurer, a sagacious minis-ter, a horse as fast as an arrow, a wheel of law and a valuable precious stone as well as the most noble white elephant:" According to the 14th-century Thai Buddhist cosmology. Elephants, and espe-cially white elephants – which are not a separate species but rather albino grey Asian elephants

– are venerated in Thailand. The reverence with which elephants are regarded in Thailand is proba-bly rooted in Buddhist mythology. As one version of the birth legend of the Buddha has it, when Maya-devi was pregnant with the Buddha, a white ele-phant appeared to her in a dream and then disap-peared into her womb. The white elephant was none other than the Buddha himself.

Until the early 20th century, a white elephant adorned Thailand's national flag and is still flaunted on the Royal Thai Navy ensign. More-over, a Thai king's reputation is still defined by the number of white elephants he owns.

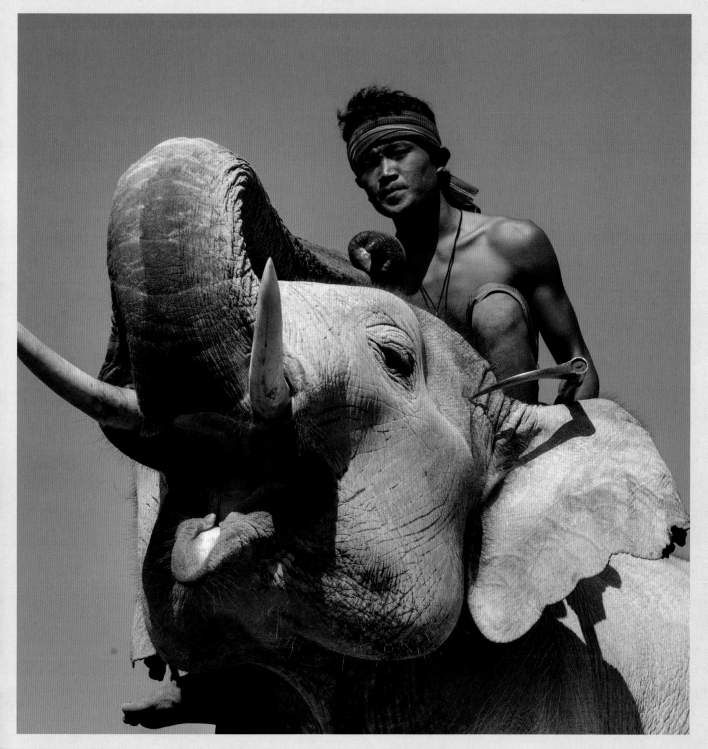

CHIANG MAI RICE TERRACES

The rice terraces of Chiang Mai are as if the gods had created a huge mandala on Earth. For centuries the farmers laboriously defied the mountains centimetre by centimetre and prepared the fields for the cultivation of probably the most important Asian food.

No other food has such importance in Thailand as rice does. Approximately 30 million tonnes are harvested per year. In doing so, the farmers have to be very patient and have to work hard in order to get a harvistable plant from the seed.

The rice must first swell for a few days and then germinates best in warm soil. The terrace shaped fields are perfectly suited for this purpose.

The plant needs three to five months in the warm, rainy climate to produce a rich harvest.

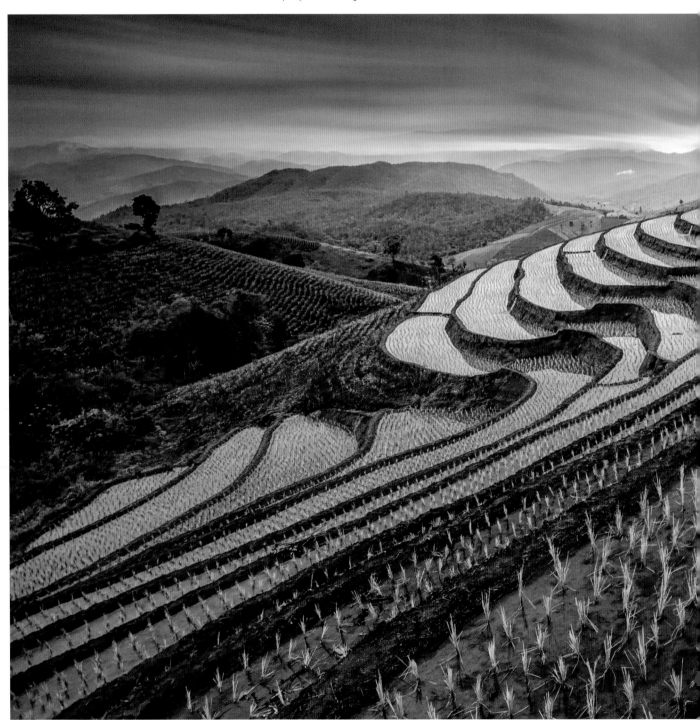

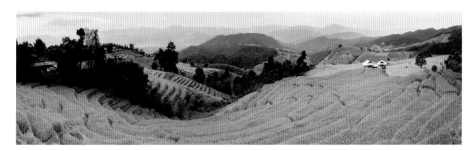

The small rice plant saplings prefer to grown in the water. Previously, the area around the King River Chao Phraya was the main cultivation area for rice, but the north of Thailand today has vigorously caught up. Machines have now replaced water buffalo and oxen from the fields. Whether long grain, round trip or jasmine rice – the varieties are almost unlimited.

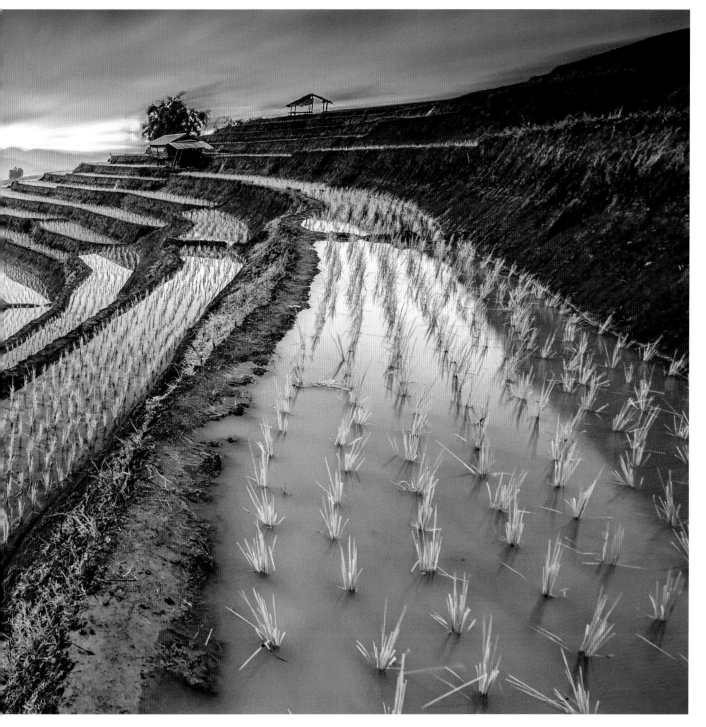

RICE: ASIA'S BREAD

Rice cultivation looks back on thousands of years of history in Thailand. Archaeologists have found some of the earliest evidence of rice as a food staple at Ban Chiang in north-eastern Thailand. Flat central Thailand is so fertile that farmers can harvest three crops a year, thus meeting most of the country's needs. Rice even plays a major role in Thai mythology and temple rites. Rice cultivation depends on a plentiful water supply. The flood waters of the Chao Phraya and its tributaries as well as the monsoon rainfall ensure that there is enough water: the rainy season from June to October sets the pace for the rice farmers. Wet-rice cultivation is the rule in Thailand and it requires meticulous care of the paddies. Rice (oryza) was not originally an aquatic plant at all – over millennia, breeding and natural selection adapted it to submersion in the paddies. The advantage of wet-cultivation: the fields being flooded prevents the growth of many weeds and pests living in the soil. After the monsoon, the fields are cultivated and the seedlings are planted. Then the vivid green of the rice paddies makes Thailand's scenery even more beautiful. The rice plants mature during the dry season. After a few weeks, the golden yellow ears are harvested and threshed without the aid of machinery, traditional agricultural methods being preferred.

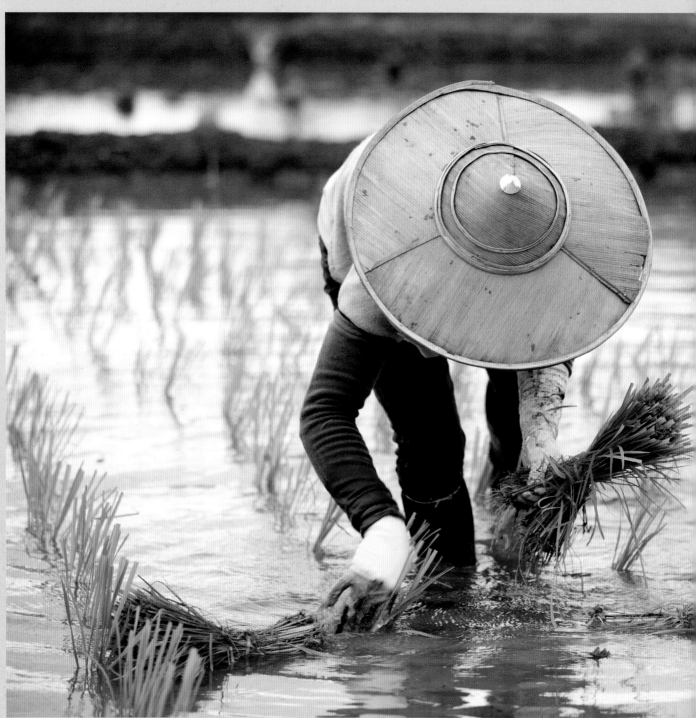

Thailand is now the world's largest exporter of rice: more than 7 million tons annually. Top, from the left: a rice plant ready for harvesting, rice packaged in banana leaves, rice cooked in bamboo and the famous Thai rice noodles. Bottom: wet-rice cultivation is labour intensive since it still mainly entails manual labour.

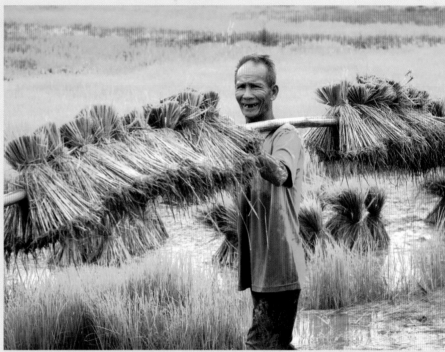

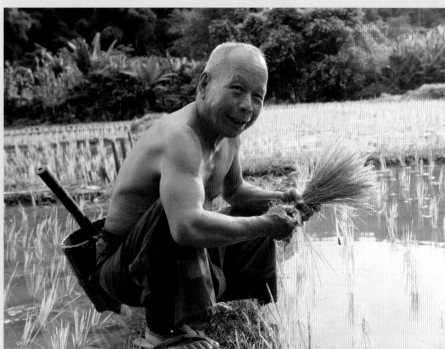

DOI INTHANON NATIONAL PARK

Welcome to the "roof of Thailand": at 2590 metres, Doi Inthanon dwarfs all other mountains in the country. The most important watershed in South-East Asia runs through the national park of the same name about 100 kilometres south-west of Chiang Mai: the headwaters of the rivers that are Thailand's vital main arteries flow south from here to Chao Phraya. The national park astonishes visitors with impenetrable jungles, wild gorges, water-falls and caves, and rare flora and fauna. It is home to the Karen and Hmong, hill tribes who cultivate flowers and vegetables here under the auspices of a development project. Great importance is attached to preserving the evergreen rainforests – for years threatened by logging – and the almost Alpine vege-tation at higher altitudes.

A Buddhist stupa (Thai: chedi) holds the ashes of King Inthawichayanon, who died in 1897.

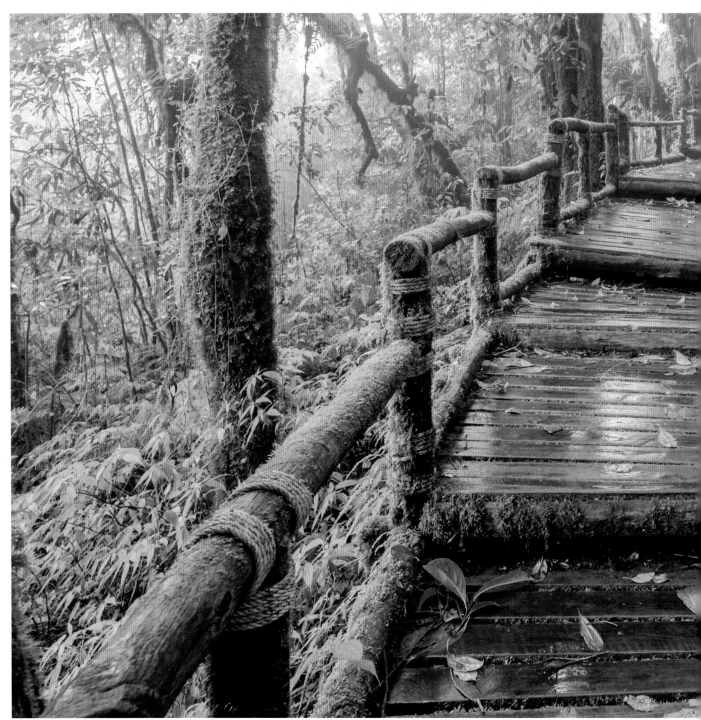

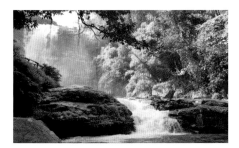

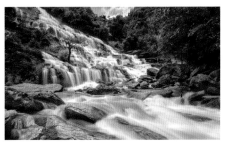

The diverse landscape of the national park named after the highest mountain of Thailand includes waterfalls like the Mae Ya (left). Through the park, the Ang Ka Trail leads through the dense rainforest (large picture). On the way through the park you can hear the songs of green-tailed sunbirds, the bar-throated minla, the pin-tailed parrotfinch or black-tailed crakes (picture strip from the top).

CHIANG MAI

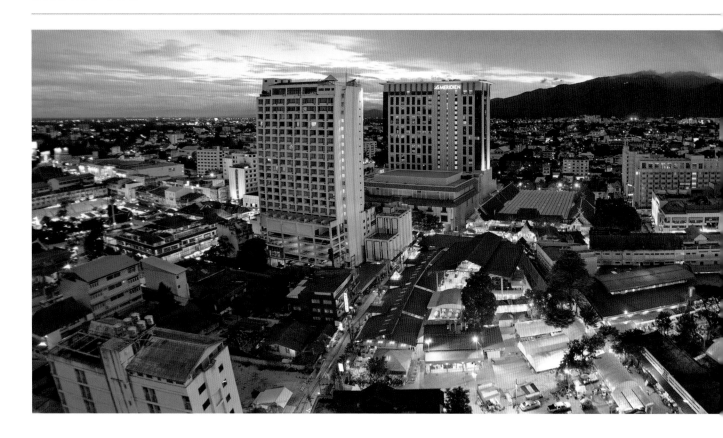

CHIANG MAI: THE OLD TOWN

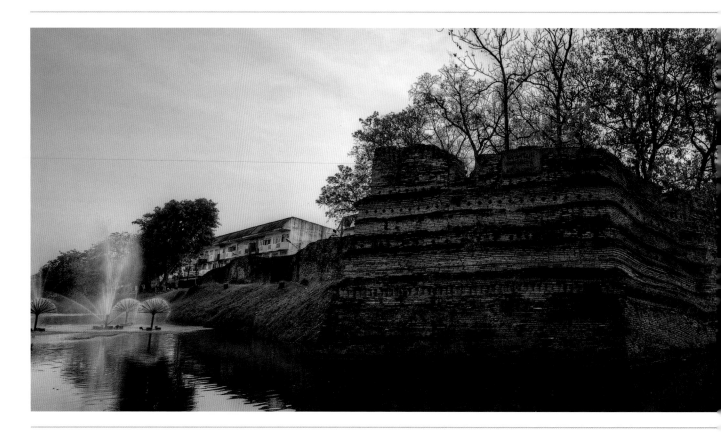

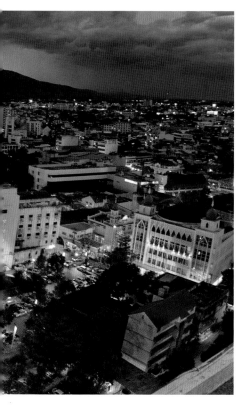

Chiang Mai, capital of the province of the same name (population: approx 290,000), is called the "Rose of the North" because of its lovely setting on the river Ping below Doi Poi, which is 1685 metres high. The Old Town is protected by walls and moats. For generations the inhabitants have come through a maze of narrow alleys to the temples and markets, often hidden from view, in which the heart of the city throbs.

Visiting the daily night market along Chan Klang Road is an experience in itself. Tranquillity and contemplation are more likely to be found in the 200 temples dotted about the city. The oldest is Wat Chiang Man on Ratchaphakinai Road, built by King Mangrai as a residence in 1296. About a kilometre west of the city is Wat Suan Dok on the Suthep Road. The white royal chedis (stupas) contain the ashes of members of the royal family.

Beyond its cultural attractions, Chiang Mai shows the face of a fast-growing Asian city, characterized by construction sites and the everyday hustle and bustle, including adventurous guides (bottom right).

CHIANG MAI: THE OLD TOWN

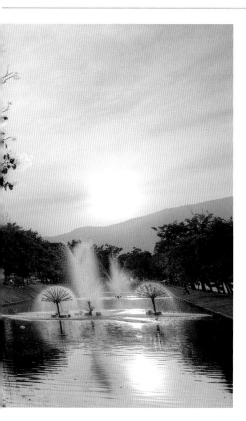

Chiang Mai was founded in the 13th century as a center of the rice cultivation. The white grains still provide the city with wealth.

A witness to this is the old town, which is surrounded by a square moat. The moat is also one of the few historical remains, civic buildings have mostly been demolished and replaced by concrete houses. The city gates and walls are replicas of the old buildings.

Today, beyond the temples, crafts, markets and jade workshops are popular attractions. The old splendour of the city is witnessed by the ornate teak buildings that provide a contrast to the modern buildings.

The remains of the old city wall as well as various Wats with their magnificent carvings and portals are still preserved today. The carvings are still a large part of in the city.

The old moat created a special mood around the city (left). The city walls as well as the gates, such as the main gate (below), are almost always replicas of the former fortifications.

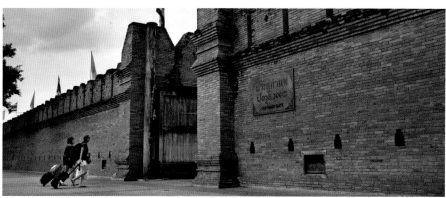

CHIANG MAI: WAT PHAN TAO

When Thailand celebrates its festival of lights, this temple is probably at its most beautiful. Thousands of lanterns, candles and tealights surround the garden in a soft, warm light.

The Yi Peng festival is a real highlight in the region, as the worshippers release lanterns into the air and the Wat Phan Tao becomes one of the most beautiful places in Chiang Mai. The temple is uneventful for rest of the year. You can hardly even tell that the building dates back to the early 15th century. No wonder, because it has been renovated and restored over time, and the main view today, with steep pointed roofs dating from 1870, when the wooden structure was given its present appearance.

A golden Buddha forms the center of the complex, and smaller sculptures of the god sit in front of it.

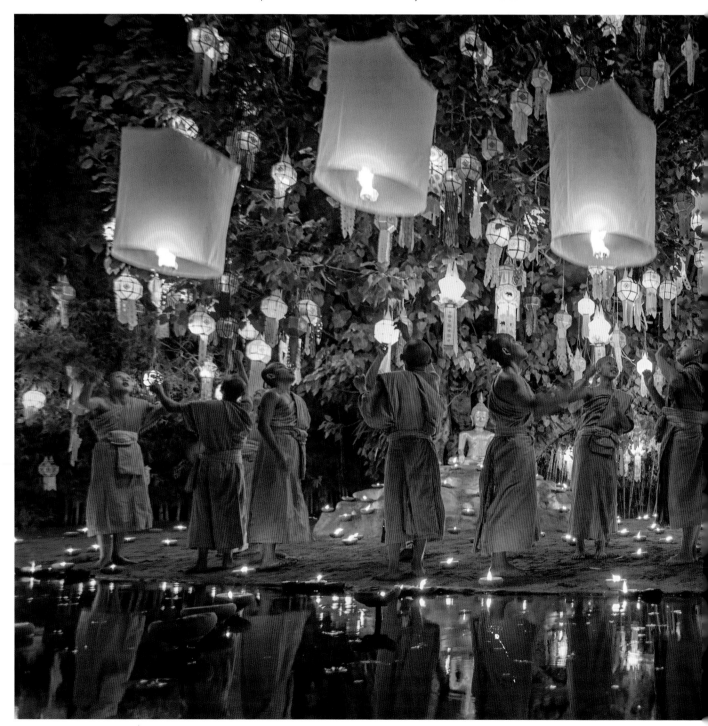

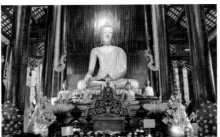

All pictures: The lantern festival Loi Krathong – mostly in November – Chiang Mai is spectacularly beautiful: The worshippers light candles or lanterns throughout the city, let them float along the water or ascend into the sky. The whole city shines with magical lights, at the festival, which is known in Chiang Mai under the Lan Na name Yi Peng.

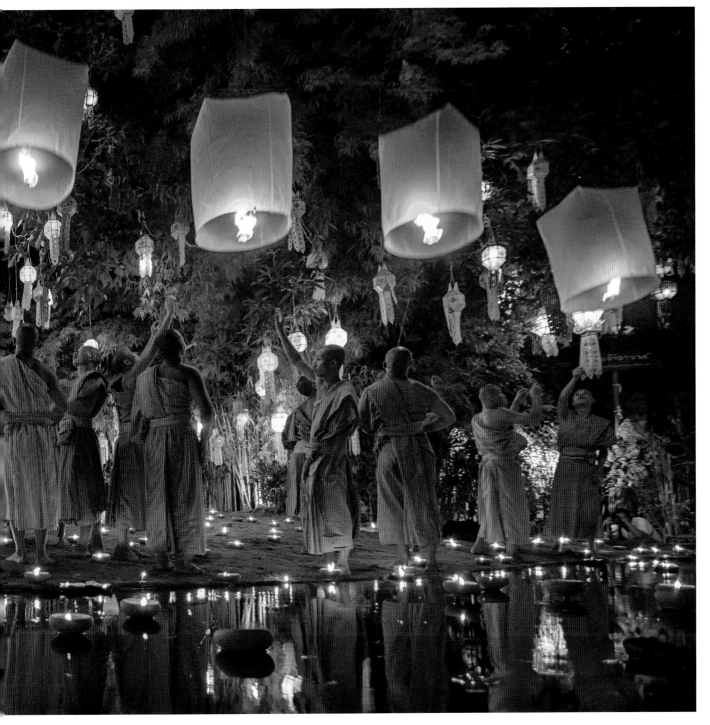

CHIANG MAI: WAT UMONG

When nature reclaims human structures, the overall picture can sometimes take on picturesque features – as in Wat Umong. The temple was erected by King Mangrai (around 1238–1137) for the Sinhala monks.

In contrast to the typical temples of the environment dominated by gold and white, sandstone is the predominant element of this temple. Buddhas, chedis and other structures fit perfectly with nature due to the material. Overall, the site measures more than 60,000 square metres in size.

Not only above ground, but also below there are hidden mysteries, because a historical tunnel system connects the buildings. The corridors are often decorated with Buddhist art. Today the monks of the forest monastery still live in harmony with nature.

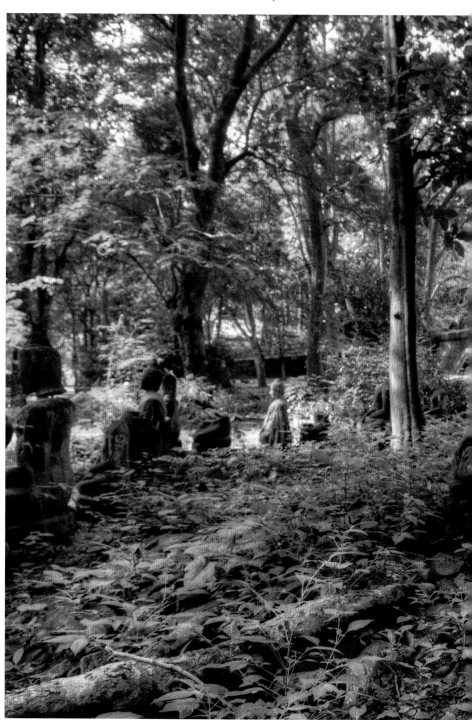

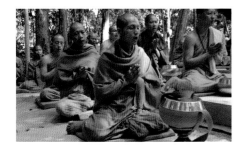

Large image: It seems as if the moss makes the Buddha laugh – nature has reclaimed large parts of the proud complex. Moss and lichens couldn't be more picturesque as they grow over statues creating what looks like fluffly green hair. Visitors like to come here to enjoy the seclusion and learn the meditation skills of the monks (far left).

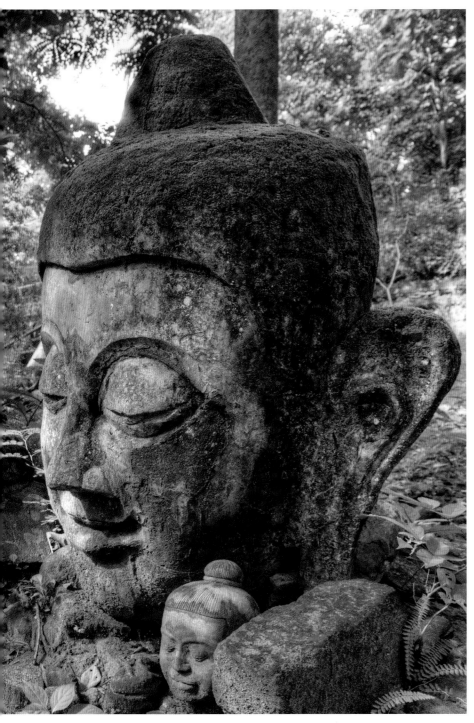

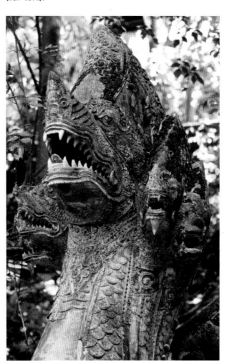

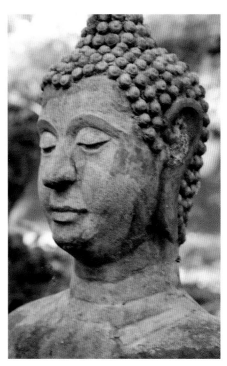

THE MOUNTAIN PEOPLES: MANY DIFFERENT FACES

Many ethnic minorities live in northern Thailand. They have retained a lifestyle that in some respects seems archaic. They have also kept their own languages and cultures, their ancient customs and their religions, which are in many cases animistic in nature and are based on a belief in spirits and the cult of ancestors. More than 600,000 members of these ethnic groups are believed to live in the region. The largest group is the Karen on the border with Myanmar. Not much is known about their origins – they presumably came from south-western China or from Tibet. The cultural affinities the Akha, Lisu and Lahu feel with Myanmar are reflected in their ethnic dress. These peoples once cultivated opium in the Golden Triangle. The Hmong (Mien) and Miao (Yao), speakers of languages in the Sino-Tibetan language family, settled in Chiang Rai and Nan provinces. The Padaung are a subgroup of the Karen, whose women wear jewellery in the form of metal spirals around their necks and legs. From puberty onwards, they endure having increasingly longer spirals twisted around their necks to lengthen them unnaturally. As one legend has it, this jewellery was intended to deter slavers and ward off tigers. According to another, the Padaung thus express their lineage as the descendants of serpent spirits. Religion or cult? Even today it is difficult to tell.

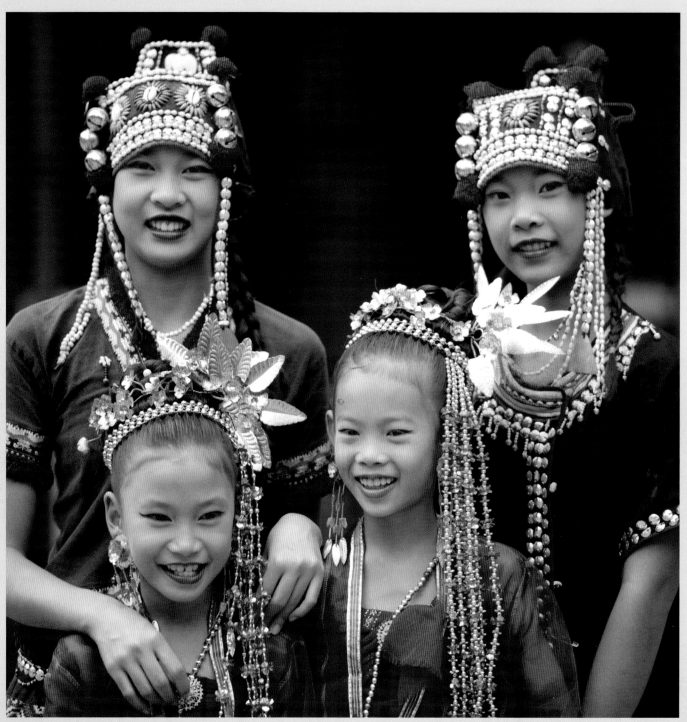

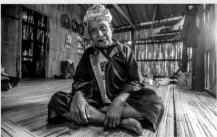

Pictures left: The Yao women wear their long hair under a turban; Man from the Lahu tribe.
Pictures below: Akha girls and women present their costumes with colourful necklaces and earrings.
Particularly striking is the headdress, which reveals a lot about the status of the wearer. Lovingly, coins, monkey pelts, shells, chicken feathers or bamboo are worked into it.

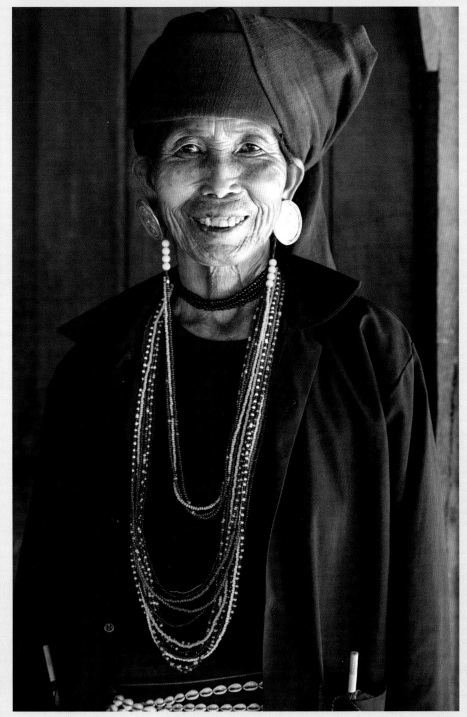

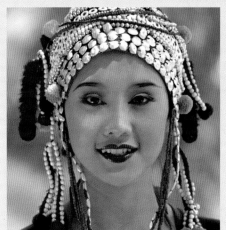

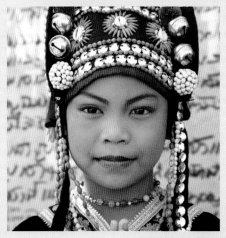

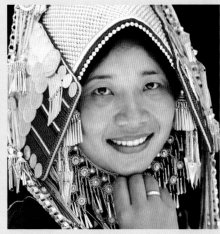

THE JEWEL SONS OF MAE HONG SON

The Poi Sang Long Festival in Mae Hong Son is believed to derive from a Buddhist legend, according to which Prince Rahul, the Buddha's own son, forsook the things of this world to live by his father's spiritual teachings. This makes Prince Rahul the first Buddhist to have entered on a novitiate. When a tradition is as splendid as the Buddhist one is, it goes without saying, at least for participants in this particular festival – mainly Shan mountain people who live here – that it must be celebrated with as much pomp and ceremony and as colourfully as possible. Every year, usually early in April, boys aged seven to fourteen assemble in Mae Hong Son to be selected for consecration as novices – so to speak, as "monks on probation" – at a three-day festival. On the first day, their heads are shaved, then they are bathed in perfumed water, dressed for the festive occasion and made up with cosmetics to look surprisingly feminine. At this stage, the dressed-up boys are called "Sang Long" or "Look Kaew" – Jewel Sons. The second day of the festival begins with a colourful procession bringing generous offerings to the monks at the monastery. On the third day, another procession takes the boys selected as novices to the ordination ceremony in a temple at Mae Hong Son. An ancient tradition lives on.

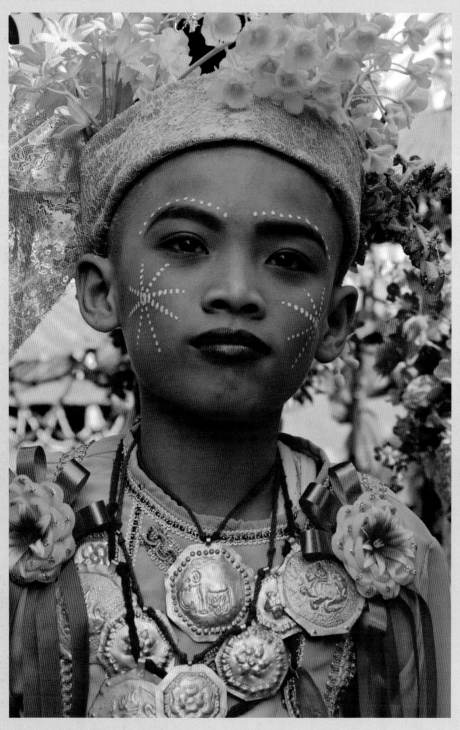

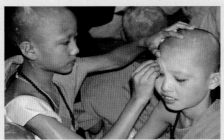

Aspiring novice monks at the Poi Sang Long Festival in Mae Hong Son are treated like little princes. Relatives carry them on their shoulders, protect them from the sun's rays with parasols and never take their eyes off them. What for some is a cheerful spectacle will end for others with the donning of a monk's habit.

THAM LOT CAVE

From the northeast, the water flows into this cave. The Nam Lang has paved its way straight through the rock. It is not a hidden cave, quite the opposite.

With its 25 metre wide entrance, which is also ten metres high, it resembles a dome of rock rather than an insignificant hole in the rock and gives Nam Lang its amazing appearance. It looks as if the flowing water also brings fresh air into this huge cave system. The river is not the only attraction that the rocks offer. Stalactites and stalagmites have formed to look like a waterfall. In addition, one of the earliest human testimonies of Thailand was found here, traces of hunters and gatherers from 9,000 BC. Granular frogs (*Hylarana glandulosa*), whose croak sound like a dog barking also live in the caves.

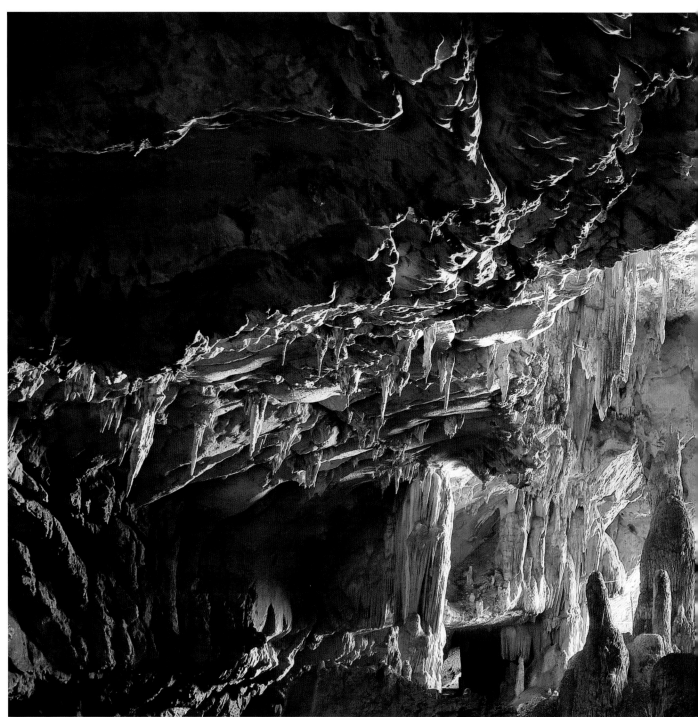

Sunlight and dark caves create unique shadows: Tham Lot is a cave system with large dimensions – and is therefore also suitable for claustrophobics. The calcareous deposits are especially beautiful when the moisture makes them sparkle.

The tools and bones of early human beings were found in the surrounding Phima cave.

CHIANG RAI: WAT RONG KHUN

Pure white buildings are rare in Thailand, especially when they are temples.

Either they are embellished with gold, brightly coloured or made of wood. But a completely white temple? With this structure, the artist Chalermchai Kositpipat broke away from the traditional ways. He consciously chose this colour, although white in Thailand is also the colour of grief.

However, it also stands for the purity of the Buddha, and therefore the artist perceived white as a suitable colour for his building, which was constructed in 1997. Finely crafted structures provide a special design, which may be somewhat compared to a gingerbread style house.

At the moment, not even a quarter of the building is finished, and the construction is expected end in 2070.

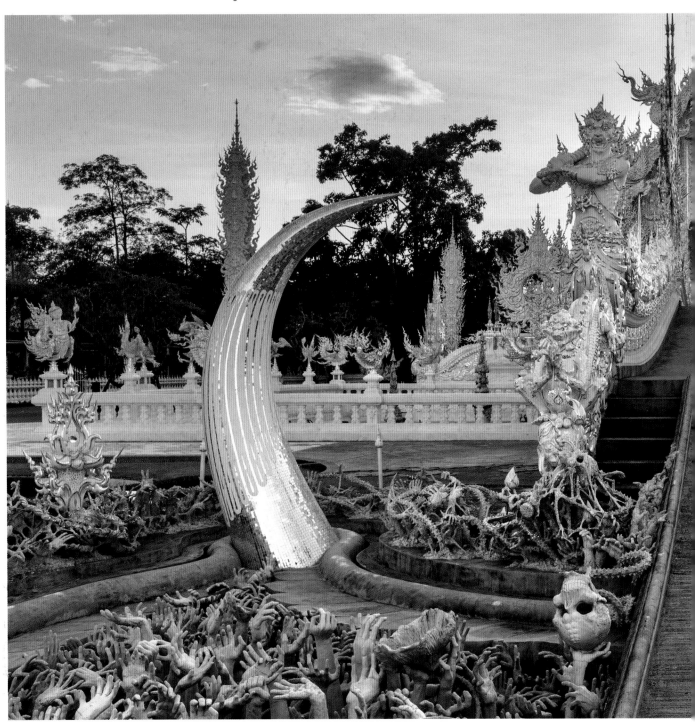

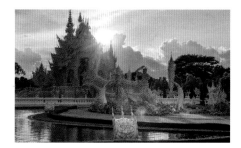

The four elements play a major role in the language of the temple, often symbolized by animals. Everywhere there are scenes and depictions of the Buddhist mythology, which revolves around rebirth, death and the circle of life. The artist works voluntarily and free of charge at the temple, whose construction is financed by donations.

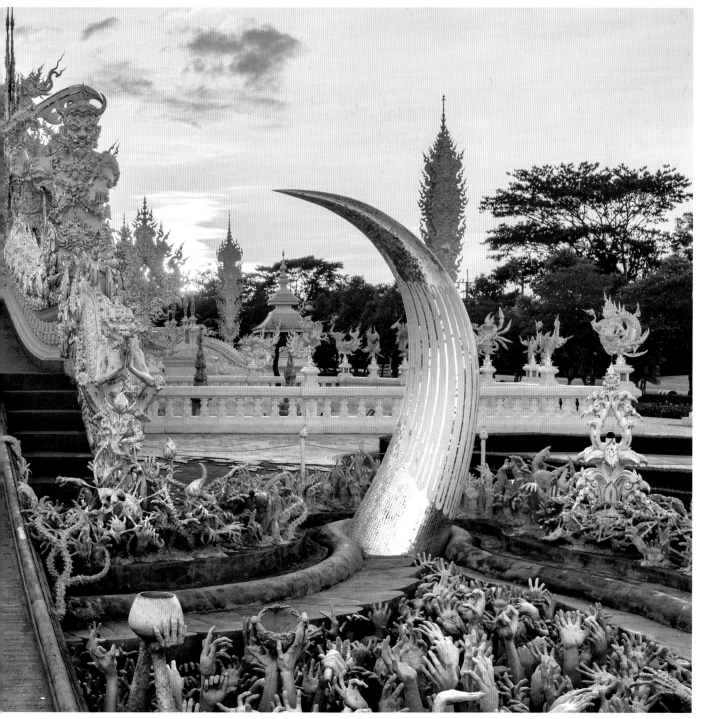

NORTHEAST THAILAND (ISAN)

The Mekong stretches like a blue and sometimes brown band through this remote region of Thailand, which is also known as Isan.

In the north-east of the country many Laotian influences are evident, whether in the kitchen or in the arts; most of the inhabitants belong to the Lao or Isan communities.

Many areas are still relatively unknown to tourists, but this is changing, as the area is becoming a popular destination for hikers and outdoor enthusiasts due to its seemingly untouched forests.

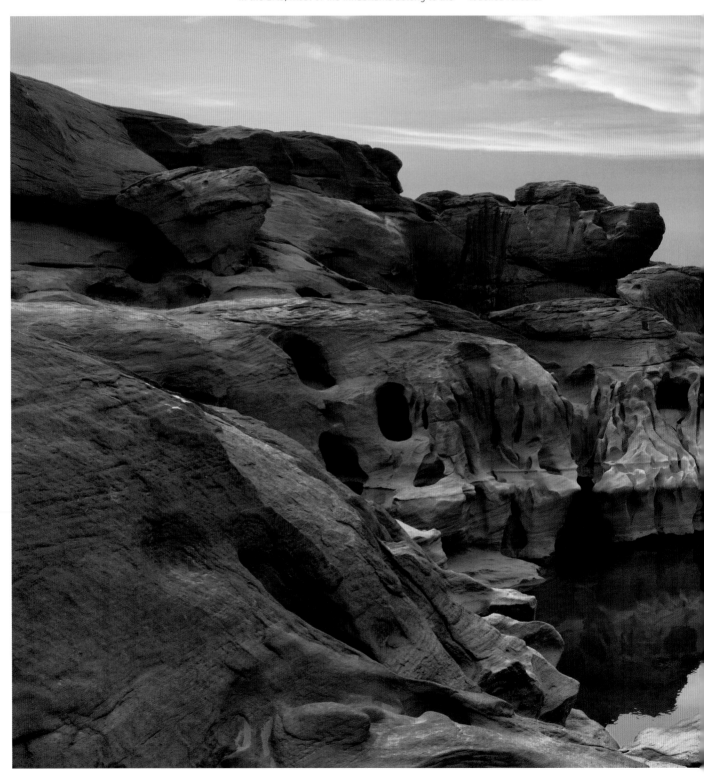

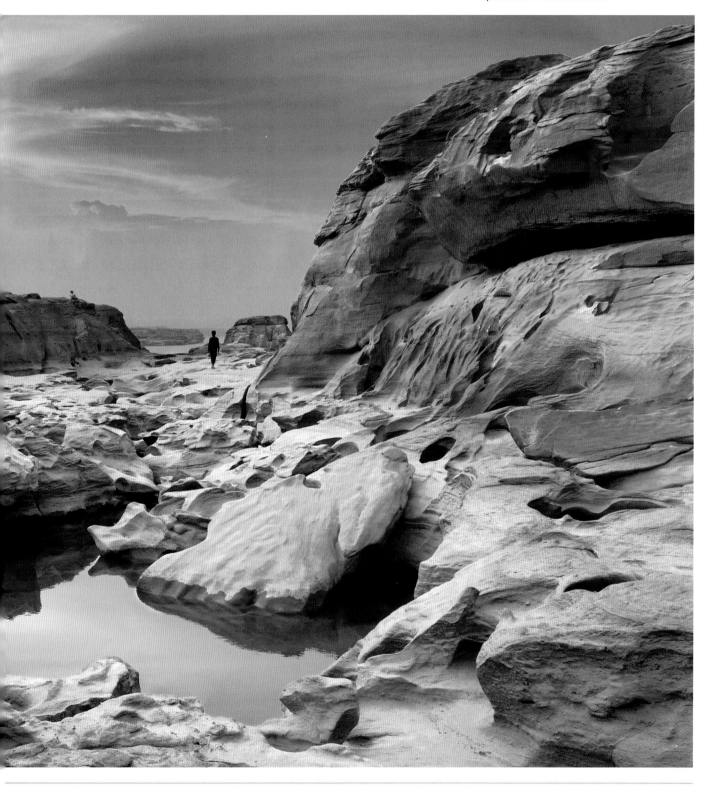

In Sam Phan Bok, a fascinating canyon landscape in Isan, the sun, wind and water have created spectacular rock formations.

KHAO YAI NATIONAL PARK

The attack happens silently and usually unintentionally. Leechers find their way onto the skin, as they bite, suck, and sting your legs or arms. They are, however, harmless, do not carry any diseases, do not drain any life-threatening quantities of blood, and can be easily removed with salt. Therefore, you should always carry a stick with a sachet of salt at the top when walking through the national park, especially in the rainy season from May to October. That is when the leeches are the most aggressive and the park is magnificent, because its waterfalls are swelling with true natural beauty.

Some fall 80 metres deep into the abyss of the jungle, others form fountains with dozens of basins and bowls, and they all attract trekking tourists, who are offered much more – caves where a million bats live.

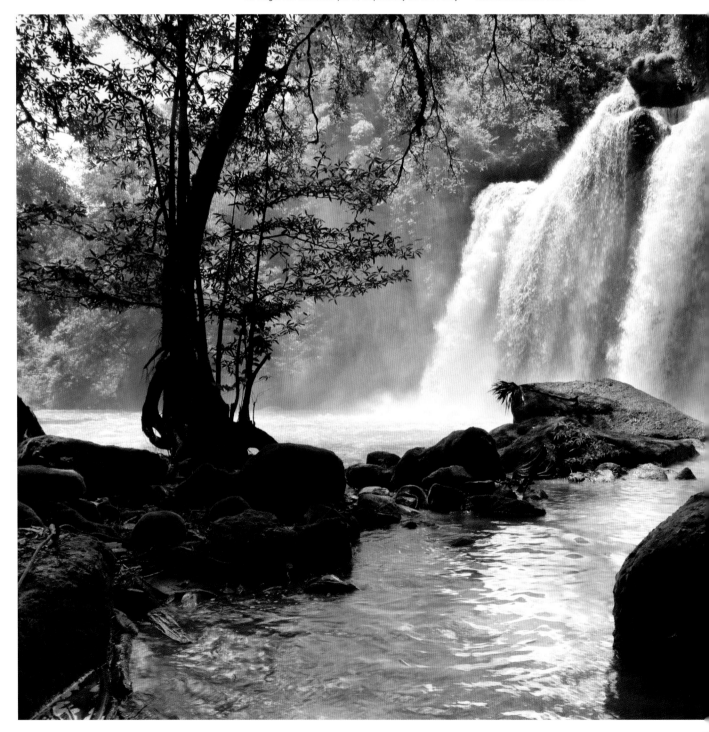

Since 2005, together with the tropical forest of Dong Phayayen UNESCO World Heritage site and a refuge of a fascinating animal world: In the Khao Yai National Park, there are about 800 species of animals, including macaques (left), white-handed gibbons, wild gaur, other gibbon species, clouded leopards, tapir and muntjac deer (small pictures clockwise from the top left). The waterfalls (large picture) are just as impressive.

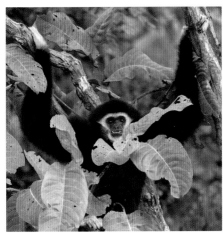

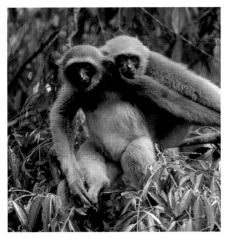

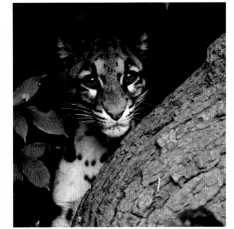

KHMER TEMPLES

What little is known about the history of the Thai people, whose origins are obscure. It begins with the 13th century, when the first historically recorded Thai kingdom was founded on Thai soil.

At the center of the kingdom, Sukhothai grew into the cradle of Thai culture. However, long before the region was settled by the Thai, three other advanced civilisations shared between them the region that is now Thailand: the Mon (Dvaravati), the Khmer and the Srivijaya from an ancient Malay kingdom on Sumatra. The Khmer, whose kingdom attained its cultural zenith in the 12th century when Angkor Wat was built in Cambodia, were the culturally dominant ethnic group. Numerous Khmer temple complexes have survived in Thailand, primarily in the north-east. These sandstone complexes are based formally on the Prasat, which developed after Indian models: a distinctive temple precinct, usually on a square ground-plan, with towers at the corners and a stepped roof leading up to a point. Other features of the Prasat complex are gates, concentric walls, arcades (further developed as quadrangles) and false (corbel) arches. Combined as they are in the Prasat, these architectural elements are intended to symbolize the mythical center of the universe in the Hindu and Buddhist cosmologies, Mount Meru.

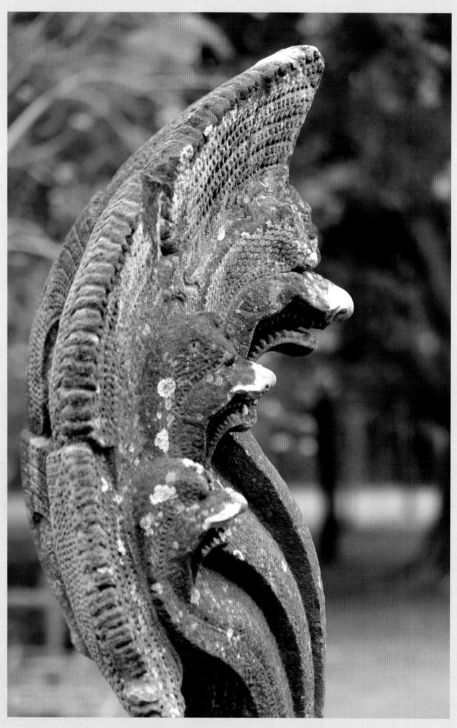

These doughty squat-looking Khmer towers are built from massive, seamlessly joined blocks of ashlar masonry (sandstone and laterite). This technique can be seen in Phanom Rung, particularly on the doorposts with fine embossing (pictures on the left). Bottom left: five-headed cobra statue in Phanom Rung; Lower right: Prasat (central temple) in Phanom Rung.

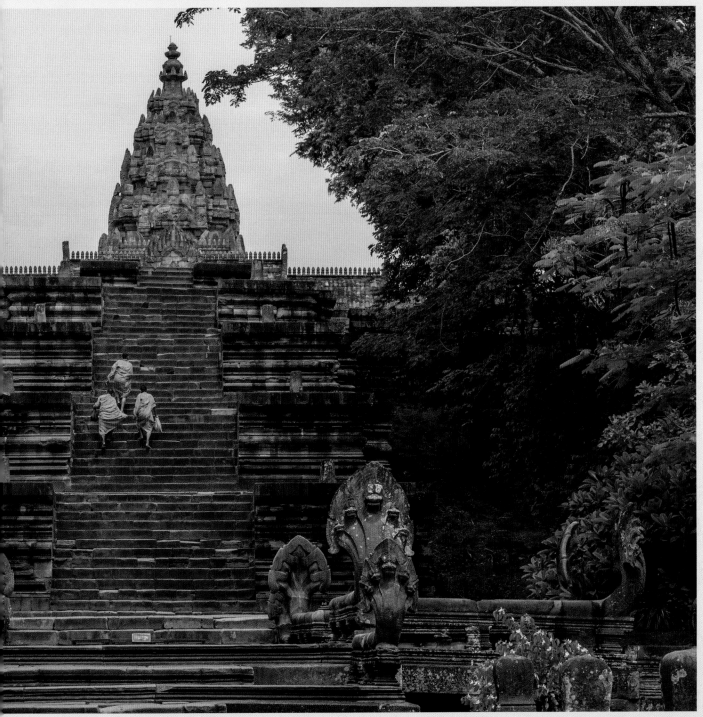

SURIN

The high point of the festival calendar in the provincial capital of Surin (population: about 41,000), which was built on the foundations of an ancient Khmer settlement on the border of Cambodia, is the celebrated "Elephant Round-up", held on the third weekend in November: many of the old elephant hunters in the Surin region are from the Suay people, who are believed to possess outstanding skills in handling pachyderms. At the Elephant Round-up, mahouts make the intelligent creatures perform tricks with logs and even let them play football. In addition, historic battles are reenacted with participants mounted on elephants. An age-old tradition associated with this enjoyable festival is the traditional custom of allowing pregnant women to walk beneath the bellies of elephants – in hopes of propitiously influencing the forthcoming birth.

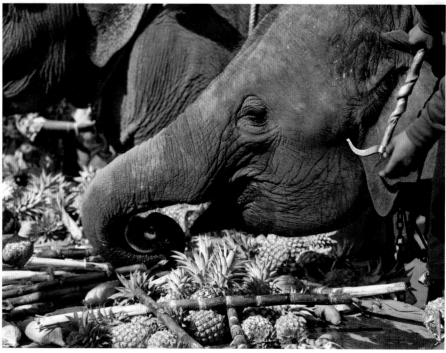

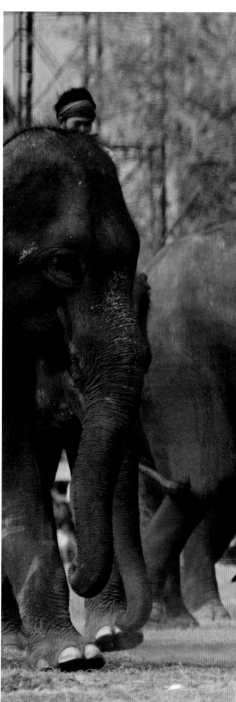

Surin belonged to the ancient Khmer lands. Here and in the nearaby area are some important Khmer temples to visit. One of the most beautiful is Prasat Sikhoraphum, 32 kilometres east of Surin, which boasts distinctive masonry All pictures: At the elephant festival in Surin, the grey giants are the main focus. After they have proved themselves in competitions, they are rewarded with fruit.

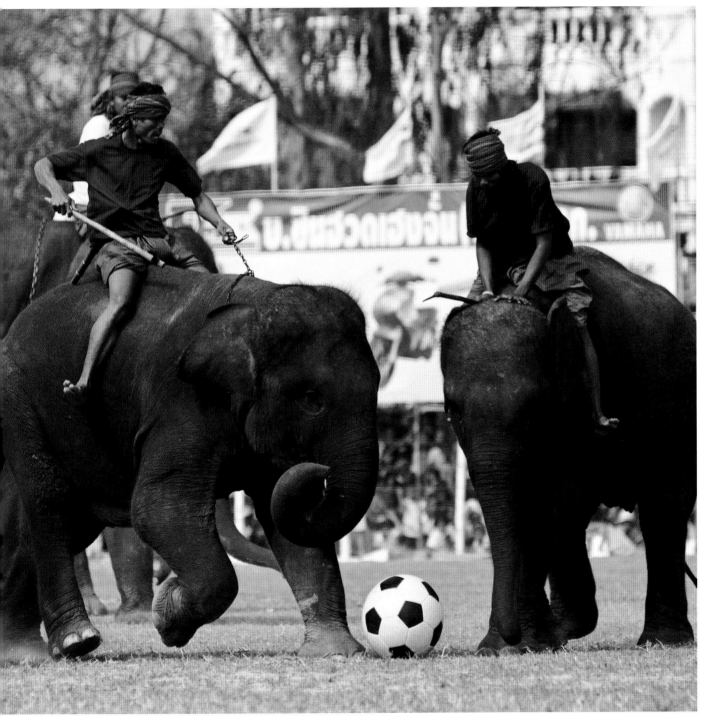

SILK FROM SIAM: GOSSAMER LIGHT

In Thailand raw silk is made, as elsewhere, from the cocoons of the silkworm, which is the larva of a species of moth (Bombyx mori). In the larval stage, they feed exclusively on the leaves of the mulberry. Silk is the filament formed from the viscous glandular secretion used by the silkworm larva to make the cocoon from which the moth later hatches. The secretion, which hardens on extrusion, has two ingredients: a horn-like protein substance (fibroin) that forms two inner filaments, and a sticky outer layer (sericin, a gum) joining them. The sericin is removed by immersing the cocoons in boiling water which gives silk its characteristic sheen. Sericulture is a viable cottage industry in the north-eastern provinces of Khorat, Chaiyaphum and Surin, where silk is also spun and woven. The silk produced in this part of Thailand is one of the finest materials in the world. The invention of synthetic fibres such as nylon for a time threatened to relegate raw silk production, which is comparatively expensive, time-consuming and labour-intensive, to minor importance. The craft of silkmaking goes back thousands of years and originated in China, where it was long a closely guarded secret. However, an American, Jim Thompson, succeeded in reviving it in Thailand in the 1940s. Thai silk is now marketed worldwide and valued the world over.

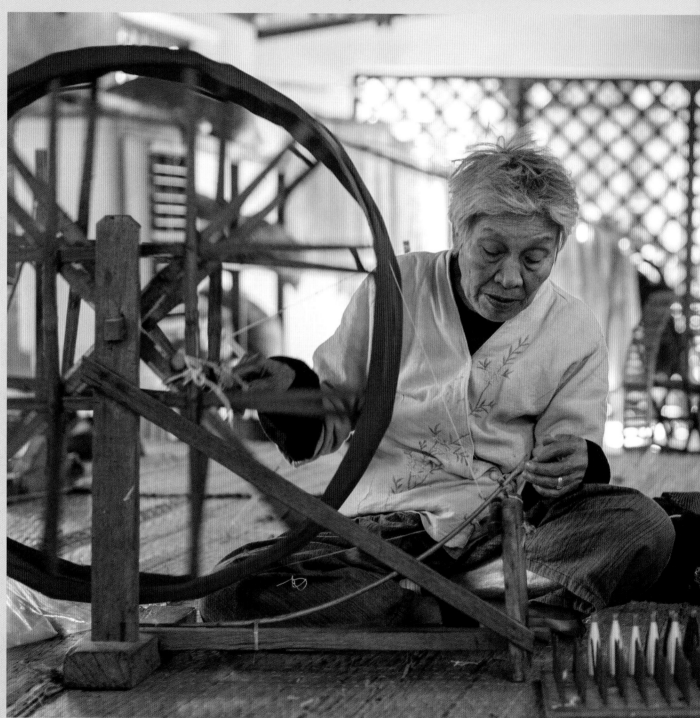

In the north-east of Thailand you can find silk farmers and looms in many villages (left, large image: weaver in Chiang Mai). (The cocoons on the far left) are made especially by mulberry silkworms. The natural silk is versatile and is used for clothing as well as for carpets. It differs from the Chinese silk by its greater strength.

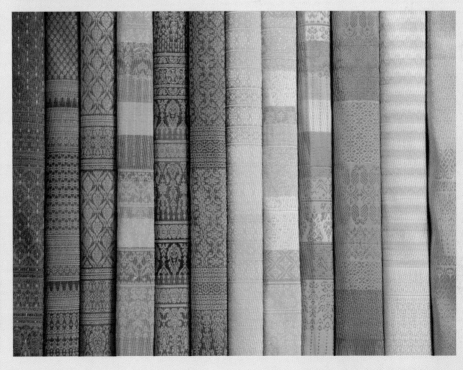

INDEX

PICTURE CREDIT/IMPRINT

MONACO BOOKS is an imprint of Kunth Verlag GmbH & Co KG
© Kunth Verlag GmbH & Co KG, Munich
For distribution please contact:
Monaco Books
c/o Kunth Verlag GmbH & Co. KG, München
St.-Cajetan-Straße 41
81669 München
Tel. +49.89.45 80 20-0
Fax +49.89.45 80 20-21
www.kunth-verlag.de
info@kunth-verlag.de
www.monacobooks.com

Printed in China
Text: Gerhard von Kapff, Andrea Lammert
Translation: Bookworm Translations Ltd.